IMPERIAL WARDROBE

Gary Dickinson & Linda Wrigglesworth

Bamboo Publishing Ltd
London 1990

Published 1990 by Bamboo Publishing Ltd
719 Fulham Road, London SW6 5UL.

British Library Cataloguing in Publication Data
Dickinson, Gary
 Imperial Wardrobe
 1. Chinese costume, history
 I. Title II. Wrigglesworth, Linda
 III. Series
 391.0220951

ISBN 1-870076-07-9

Designed by Denyer Design Associates
Typeset in England by Signal Graphics
Printed in Singapore by Toppan Printing Company

Contents

Tables

Preface

'Court dress' is rather a loose term that embraces a wide range of ceremonial garments whose colours and designs were prescribed by centrally imposed sumptuary regulations. Although these types of garment were worn for ritual occasions within the imperial palace, they were also used by officials when fulfilling similar ritual obligations outside. Readers familiar with Qing court dress will notice that *Imperial Wardrobe* places greatest emphasis on the most formal costume in the official wardrobe: *chao fu*. A great deal of scholarly attention has focused on less formal styles of court dress, particularly dragon robes, which survive in greater numbers than the robes that properly formed part of *chao fu*. This lack of material may account for the absence of detailed information regarding *chao fu* in western sources. Nevertheless, *chao fu* was perhaps the most important costume in the Qing wardrobe and we have, therefore, attempted to address this imbalance. As far as possible we have used actual examples of robes and other articles of dress worn as part of *chao fu* as well as the other costumes that formed part of the court wardrobe. These have been drawn from collections, both private and public, all over the world. Where examples of robes, hats, etc. have not come to light during the course of our research, we have turned to contemporary pictorial sources, including commemorative portraits, for illustrative purposes.

One source of illustration deserves special mention. This is a series of exquisite paintings of the various articles of court dress worn by people as diverse in status as the imperial family and graduates in the government examination system. These paintings form part of a collection of folios now held in varying numbers by public museums and private collections throughout the British Isles.

These folio paintings appear to have once formed part of a much larger manuscript work, the origins of which are discussed in the chapter 'Treasures of the Yuanmingyuan'. This work may have been associated with the looting of the imperial summer palace by British and French troops in October 1860. This has yet to be fully supported by proof that meets the criteria of the academic world and the questions as to whether a complete original work actually existed and, if it did, whether it came from the imperial collection remain open. On the basis of the existing evidence it is our belief that the folios do represent fragments of a complete work that were removed from the Yuanmingyuan prior to its destruction in 1860. However, to have pursued this line of enquiry would have taken us far outside our terms of reference for *Imperial Wardrobe*.

While the origin of the folios is still the subject of conjecture, scholarly opinion is largely agreed that there is a direct relationship between those folios related to court dress and *Huangchao liqi tushi, Illustrated Precedents for the Ritual Paraphernalia of the Imperial Court*, a work commissioned by the Qianlong Emperor in 1759. Margaret Medley was the first scholar to identify the collection of folios with *Huangchao liqi tushi*. The conclusions of her research were published in *Transactions of the Oriental Ceramic Society* in the late 1950s and again in the form of a small booklet in 1982.

Most of the folios have not been published before. The beautifully executed detail of the paintings makes them eminently suitable as illustrations, particularly as they depict articles of dress that are not known to have survived in western collections. Where a folio illustration has been used, the text of the caption reads 'painting on silk of...' Unfortunately, some of the folios have suffered damage; auctioneers have written lot numbers and, in at least one case, drawn large letters on the face of the paintings. Such surface markings are clearly visible in this book.

The chapters of *Imperial Wardrobe* that relate to individual items of dress follow *Huangchao liqi tushi* itself. For ease of reference, much of the detail has also been given in tabular form. Throughout we have referred to the various items of court costume by their Chinese names, as given in *Huangchao liqi tushi*, in order to avoid confusion over the interpretation of these terms. For example, *chao fu* can be translated as 'court dress', 'audience robes' or 'robes of state'. We have defined our interpretation of the Chinese

terms used repeatedly throughout the book in the chapter 'The Imperial Wardrobe'. A glossary of costume terms and titles of members of the imperial court has also been included at the back of the book.

Imperial Wardrobe is by no means a definitive work on late Qing costume; it was never intended to be that. However, we both hope that it proves to be a valuable contribution to the understanding of the Qing court costume and a point of reference for the collector.

We would like to express our gratitude to the many people who kindly gave their advice and encouragement during the preparation of *Imperial Wardrobe*. We would, in particular, like to thank Frances Wood of the British Library's Department of Oriental Manuscripts and Printed Books, Jean Mailey of the Metropolitan Museum of Art, New York, Jacqueline Simcox, Mrs E. Cheong, Colin James, our editor Kym Ward, and fellow enthusiasts, friends and family without whose support this project would not have been brought to fruition.

Gary Dickinson
Linda Wrigglesworth

8

Note on Spelling and Pronunciation

We have used the *pinyin* system of romanization, the only exceptions being Chinese terms and names in quoted matter and familiar place names, such as Peking. All the costume terms and titles are given by individual character rather than grouped together as a phrase; for example *gong fu guan* as opposed to *gongfuguan*. This, we hope, will make *Imperial Wardrobe* more accessible to those unfamiliar with the Chinese language. After discussion with several fluent Chinese readers, we also decided to group the lengthy title *Huang chao li qi tu shi*, in three parts, as *Huangchao liqi tushi* although this division is not typical.

The following may help those readers unfamiliar with the system to pronounce the words to themselves:

Initial *zh*, as English *j-*
Initial *x-*, as English *sh-*
Initial *c-*, as English *ts-*
Initial *q-*, as English *ch-*

Chronological Table: The Qing Dynasty

Reign-title*	Temple-name	Reign-period**
Tianming (Nurhaci)	Taizu	1616–26
Chongde (Abahai)	Taizong	1627–43
Shunzhi	Shizu	1644–61
Kangxi	Shengzu	1662–1722
Yongzheng	Shizong	1723–35
Qianlong	Gaozong	1736–95
Jiaqing	Renzong	1796–1820
Daoguang	Xuanzong	1821–50
Xianfeng	Wenzong	1851–61
Tongzhi	Muzong	1862–74
Guangxu	Dezong	1875–1908
Xuantong	—	1909–11

*After his accession to the throne, the emperor's personal name became strictly taboo, being used only in the prayers offered to Heaven. During his lifetime the emperor was referred to by the reign-title he had assumed, i.e. Qianlong. After his death, the emperor was given a posthumous title or 'temple-name' by which he was referred to during ancestral ritual.

** These dates refer to the period covered by the emperor's reign-title. Hongli became emperor on 18 October 1735, although his reign-title, Qianlong, did not become current until the following New Year. For actual dates of the accession and death of each emperor, refer to Table 1.

Introduction

The Qing dynasty (1644–1911) was the last imperial house to hold sway over China. At the height of its prestige and power, the Qing empire stretched from the eastern seaboard to the high Pamir mountains in the west, from the sub-tropical climes of Guangdong province in the south to the Mongolian steppes in the north. This vast empire was ringed by satellite states whose rulers regularly paid tribute to the Qing emperor.

However, the Qing were not native Chinese. By descent, the 10 Qing emperors were Manchu, an ethnic minority group that represented less than one per cent of the population of the empire. Their ancestors originally came from a small federation of loosely affiliated clans from the area north-east of the Great Wall known in the west today as Manchuria. Closely related to the Tartar tribesmen who had established the Liao (916–1125) and Jin (1115–1243) dynasties in the north of China, the Manchu were also cousins of the Mongols who had founded the Yuan dynasty (1279–1368).

Nurhaci (1559–1626), the founder of the Qing imperial line, was an ambitious chieftain of the Manchu Aisin Gioro, the Golden clan. Nurhaci welded the disparate Manchu clans into a people with a national identity. At the beginning of his career Nurhaci paid regular tribute to the emperors of the Ming dynasty (1368–1644). But, by 1607, he had become so powerful that the Mongols conferred upon him the title Khan, and in 1616 he proclaimed himself emperor of the later Jin or Golden dynasty, moving his capital from his ancestral manor at Hetu Ala to Mukden, today the industrial city of Shenyang.

Nurhaci died in 1626 from wounds received in battle and was succeeded by Abahai, his eighth son. Abahai consolidated the work of his father, invading Korea to safeguard his flank and even launching an attack against China and looting Peking. In 1636 he set up a civil administration based on the Chinese model and changed the name of the dynasty from Jin to Qing, which means 'Pure'.

The ascent of Manchu power in the north-east of China was in no small measure due to the formation of the banner regiments in 1601. This system cut across the old clan loyalties of Manchu society, thus strengthening ties to the ruler. The four original regiments, distinguished by their yellow, white, blue and red flags, formed the basis of the early Manchu civil as well as military organization. All Manchu men were enrolled in a banner regiment along with their families. The compulsory registration of the entire Manchu population enabled the early Qing military leaders to keep an accurate record of the numbers of troops at their disposal, and was a means of effectively administering the distribution of food and supplies.

The banner system was hereditary. There was also a strict order of precedence amongst the banners. Outstanding soldiers were often promoted to one of the senior regiments. As the Manchu army gathered strength, the number of banners was increased to eight: four new regiments were added with yellow, white and blue banners bordered with red, and a red banner bordered with white. In 1634 eight more Mongol banners were added, and finally, in 1642, another eight banners were raised composed of Chinese captured during earlier campaigns.

Abahai died in 1644 before his plans to invade China could be completed. In April of that year a rebel Chinese army captured Peking and the last Ming emperor, Chongzhen, committed suicide. In the political vacuum that this created, the commander of the loyal Chinese frontier forces in the north-east invited the Manchu regent, Dorgon, to co-operate with him and put down the rebellion. Dorgon eagerly seized the chance and the Manchu and their Mongol allies poured through the Great Wall dealing a crushing blow to the rebels. On 6 June 1644 the Manchu relieved the capital and in October Dorgon invited the Manchu court to take up residence in the Forbidden City in Peking. Abahai's ninth son, then only seven years old, was installed on the Dragon Throne as the Shunzhi Emperor.

The early Qing leaders established a policy of selectively adopting Chinese institutions in the administration of their new empire in the hope that this would win over the Confucian establishment, who regarded the new foreign dynasty as 'barbarian'. But it was feared that

Pl.1 The eight banners
Nurhaci commanded the plain yellow banner, his successors both the plain and bordered yellow banners. Other regiments were placed under the command of Nurhaci's sons, collectively called the Princes of the Iron Helmet: Dorgon, the plain white; Manggultai, the plain blue; Daisan, the plain red; Dodo, the bordered white; Yoto, the bordered red; Amin, the bordered blue.
G.W. Dickinson

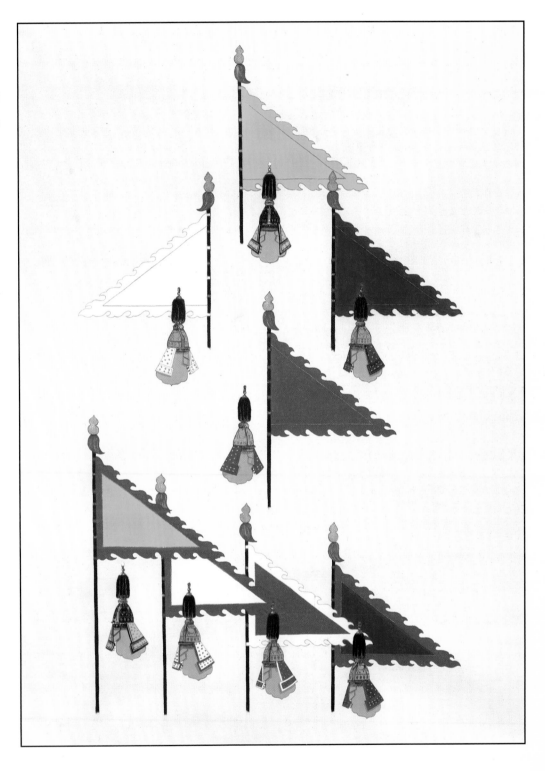

the sedentary life in Chinese cities would sap the Manchu's military strength and undermine their success. To insulate the Manchu from what they saw as the enervating effects of Chinese civilization, the Qing emperors attempted to assert Manchu cultural domination over the Chinese. The Manchu tongue became the official language of the Qing state and Manchu and Mongols were forbidden to marry Chinese.

The foreign origins of the Manchu were never far below the Confucian veneer. Throughout their 267-year rule, the Manchu emperors remained deeply alienated from their Chinese subjects who they regarded as over-sophisticated. Abahai had warned his nobles against adopting Chinese names and customs, and even the great Kangxi Emperor, steeped though he was in Confucianism, admonished his sons not to lose their Manchu traditions and get too dyed in Chinese ways. Manchu occupied all the highest positions at court and monopolized the military high command. The Qing emperors generally trusted their Manchu councillors more than their Chinese ministers, entrusting them with special assignments.

Both Nurhaci and Abahai relied on educated Chinese advisers who had been captured or had entered the service of the Manchu because of the appalling official corruption that characterized the last years of the Ming dynasty. In 1632 a Chinese adviser to the Qing recommended that both Manchu and Chinese officials should dress the same to prevent discrimination. Abahai took the opportunity to replace the court robes of the Ming period with Manchu dress. After the Manchu conquest of China in 1644, all men, with the exception of Daoist and Buddhist clergy, were required to shave their foreheads back to the crown and wear their hair in a long plait or queue, after the Manchu fashion, in token of their submission to the Manchu regime.

TREASURES OF
THE YUANMINGYUAN

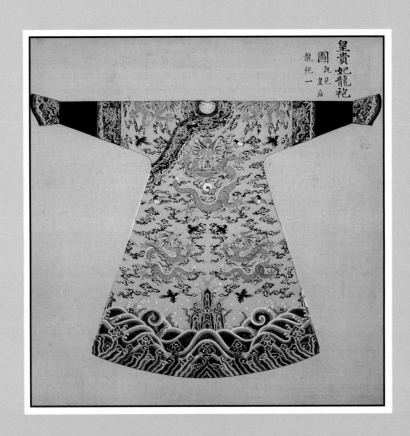

Treasures of the Yuanmingyuan

The Summer Palace

Some six miles to the north-west of the centre of Peking lies the site of the fabled Yuanmingyuan, or Garden of Perfect Brilliance, created in 1709 by the Kangxi Emperor (r. 1662–1722) as a retreat for his fourth son, Yinchen. When the latter succeeded as the Yongzheng Emperor (r. 1723–35), the Yuanmingyuan became a favourite summer residence of the imperial court. Although it was seriously damaged by an earthquake in 1730, Yongzheng and his successor the Qianlong Emperor (r. 1736–95) restored and enlarged the Yuanmingyuan, recreating there celebrated gardens and scenes of outstanding beauty from distant parts of China.

The private apartments of the imperial family occupied one island in a group of nine that were arranged in a circle in an artificial lake which fed a complex network of canals and waterways. On the opposite bank of the lake stood a magnificent audience hall. Situated elsewhere in the grounds were a shrine dedicated to the imperial ancestors and numerous pavilions. The Yuanmingyuan also contained at least two libraries including the *Wen yuan ge*, Library of the Source of Literature, built in 1774 to house the *Si ku quan shu*, *Complete Library of the Four Storehouses*, the major bibliographical project of the Qianlong period.

The Yuanmingyuan itself was but one part of a group of other similar imperial 'pleasure' parks which covered a total area of 80 square miles. Collectively, these imperial gardens and parks comprised what is now known as the Old Summer Palace. We will refer to it as the Summer Palace.

Among the foreigners to visit the Summer Palace was George, Lord Macartney, 'Ambassador Extraordinary and Plenipotentiary from His Britannic Majesty King George III to the Emperor of China'. Macartney arrived in Peking in 1793 bearing gifts to the Emperor that included a large planetarium, clocks, an English-style carriage, several cannons and a portrait of the king. While a guest at the Summer Palace, Macartney became embroiled in a dispute with Chinese officials over court etiquette. Refusing to perform the obligatory kowtow or nine-fold obeisance before Qianlong, he offered instead to pay the same respect to the Emperor as he would to his own king.

During the dispute, Qianlong was in residence at the imperial reserve at Jehol on the southern slopes of the Manchurian hills where he was receiving birthday congratulations from his Mongol vassals. He was then a sprightly 82 years old. Although somewhat piqued by Macartney's refusal to kowtow, after being advised that the British envoys were physically incapable of performing the ritual on account of their cumbersome knee buckles and garters, Qianlong relented. Summoning Macartney to Jehol, the Emperor received him in audience on 30 September 1793. Macartney fell on one knee before the throne and presented the Emperor with George III's letter in a golden case. The British diplomats in Macartney's party were entertained in imperial style at a formal banquet during which Qianlong personally poured each a cup of wine, which was taken to be a mark of great favour. The Emperor also removed one of the embroidered purses suspended from his court belt and gave it to Macartney's young page, George Thomas Staunton.

Macartney returned to the Summer Palace several days ahead of the Emperor's court. In anticipation of a further interview with Qianlong, he set about displaying his gifts. However, the Emperor refused to grant the British ambassador another audience or allow a permanent British representative to be stationed in Peking. Macartney returned to England without achieving his goal of opening China to trade with Britain. In an edict that epitomized the Chinese notion of foreign relations, Qianlong informed King George III that: 'We set no value on objects strange or ingenious and have no use for your country's manufactures. It is incumbent on you to respect my sentiments and to display even greater devotion and loyalty in future, so that, by perpetual submission to Our Throne, you may secure peace and prosperity for your country.'

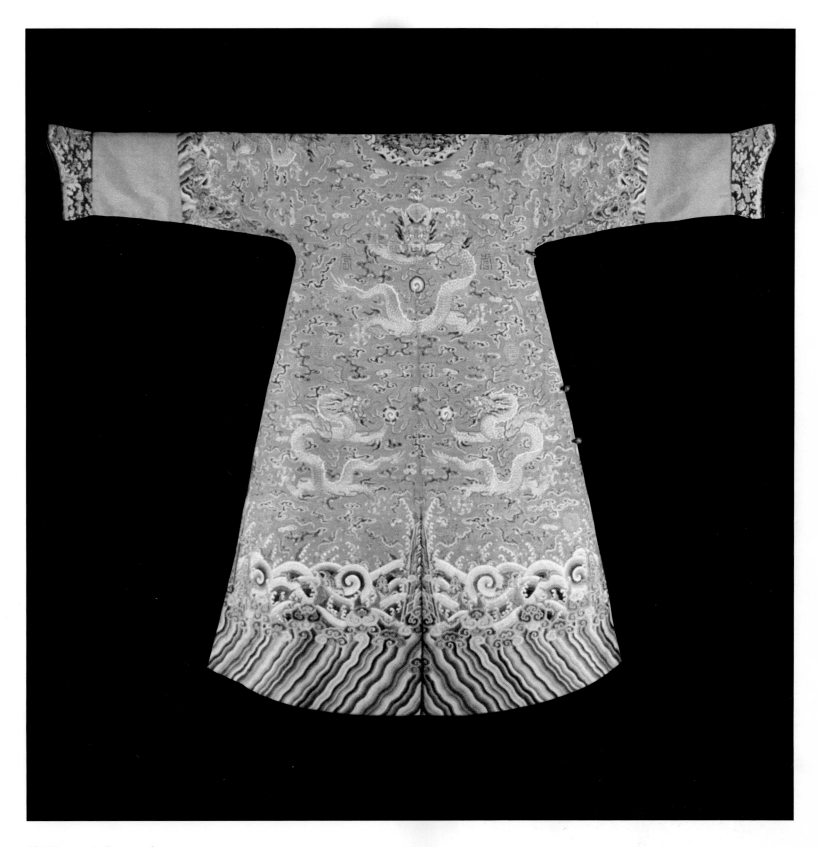

Pl.2 Emperor's dragon robe
This example of an emperor's summer dragon robe,
made of red gauze over-embroidered in yellow
counted stitch, may once have been worn by the
Qianlong Emperor.
Metropolitan Museum of Art

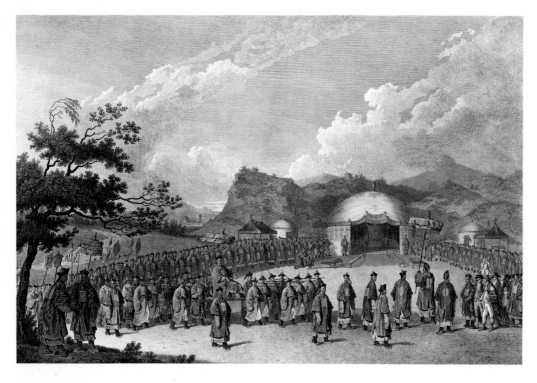

The failure of Macartney's mission, and all subsequent attempts to establish diplomatic
relations with the Chinese, ultimately led to open conflict between the western nations
and the recalcitrant Qing court. By October 1860 an expeditionary force of allied French
and British troops was advancing on Peking. Fearing for his safety, the Xianfeng Emperor
(r. 1851–61) and his court had fled the capital in panic. The allies encountered only token
resistance from the 400 eunuchs left behind to guard the Summer Palace.

At the head of the expedition was Lord Elgin (1811–63), British Plenipotentiary and son
of the Lord Elgin of Parthenon fame. Lord Elgin had at his disposal 11,000 British troops
under the command of his brother-in-law, General James Hope Grant, and some 6,700
French troops under General de Montauban. After almost two weeks of systematic
pillage, Lord Elgin ordered the destruction of the Summer Palace as a reprisal against the
Xianfeng Emperor for mistreating British hostages held there. On 18 October Sir John
Michel put the buildings to the torch. The wood-frame pavilions burned easily and even
the marble palaces were reduced to ruins. For two days a pall of thick, black smoke hung
over Peking as the Summer Palace burned. The great throne hall of the Yuanmingyuan,
in which the most illustrious emperors of the Qing dynasty had held audience, was the
last building to be destroyed. The imperial throne itself was unceremoniously pitched
into the lake by French troops. It is said to have been retrieved by Charles Gordon
(1833–85) who, two years later, was to lead Qing troops against the Taiping rebellion
(1851–64).

The memoirs of those who took part in the destruction of the Summer Palace are full of
references to the treasures they discovered in its many halls and pavilions. In his *Narrative
of the North China Campaign of 1860*, Robert Swinhoe, the staff interpreter to General
Grant, recalled that 'one French officer had a string of splendid pearls, each pearl being
the size of a marble'. This was probably a court necklace belonging to a member of the
imperial family. Swinhoe tells us that a number of British officers and many ordinary
soldiers were disgruntled because their duties had prevented them from participating in
the looting. To make a more equal distribution of the spoils, Grant appointed a
commission of prize agents to collect treasures and curiosities. Orders were also given
requesting officers to surrender any loot they had already acquired.

The articles collected by the prize agents and the surrendered booty were displayed in a

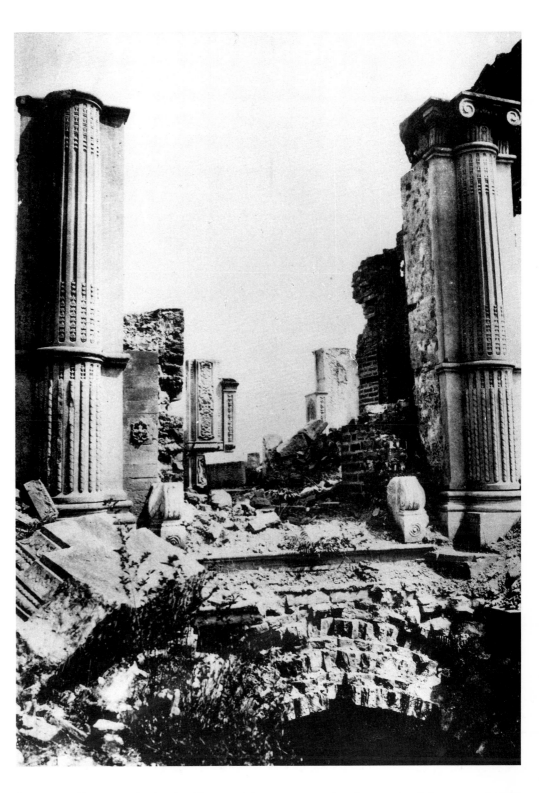

large Buddhist temple that had become the temporary headquarters of the general staff. Among the treasures, Swinhoe remembered, were 'two or three of the Emperor's state robes of rich yellow silk, worked upon with dragons in gold thread, and beautifully woven with floss-silk embroidery on the skirts, the inside being lined with silver fur or ermine, and cuffed with glossy sable.'

A sale of the items began on 11 October 1860 and took three days to complete, the officers bidding against each other. One of the emperor's court robes fetched £120. Swinhoe commented that 'had the Emperor been present he would doubtless have felt

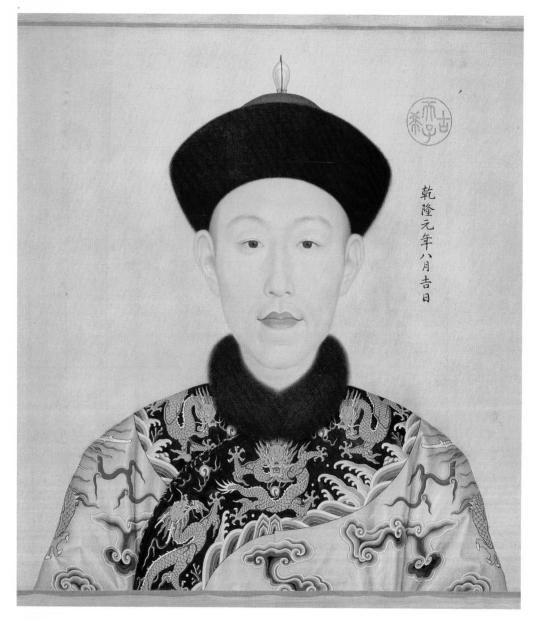

flattered at the value set by the foreigners on any object solely because it had belonged to him'. Two-thirds of the proceeds from the sale were distributed equally among the troops while the other third went to the officers. A number of the spoils taken from the Summer Palace were later presented to Napoleon III and Queen Victoria.

The *Inauguration Portraits*

Several works of art reputed to have been saved from destruction at the Summer Palace are valuable sources of information regarding court dress during the Qing period. One such is a handscroll attributed to a Jesuit priest named Guiseppe Castiglione (1688–1766), known to the Chinese as Lang Shining. Castiglione is the most famous of the several Jesuit fathers employed by the Imperial Office of Painting during the reigns of the Kangxi and Qianlong Emperors. The handscroll, known as the *Inauguration Portraits*

Pl.7 Inauguration Portraits
Detail of one of the Qianlong Emperor's secondary
imperial consorts wearing an orange-coloured
dragon robe.
Cleveland Museum of Art

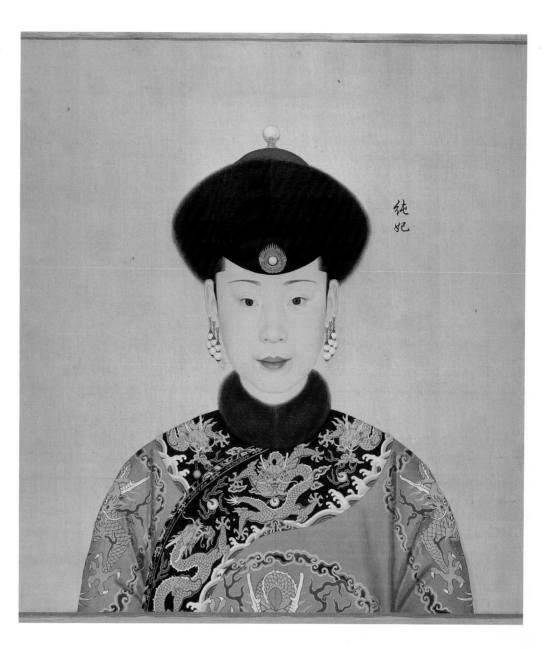

of the Qianlong Reign, depicts the Emperor with his first Empress, Xiaoxian, and 11
secondary imperial consorts in their order of rank.

Castiglione is thought to have painted only the portraits of the Emperor, the Empress and
the senior imperial consort. Qianlong's other wives were most likely painted by pupils of
Castiglione at the palace studio. The handscroll is dated, 'An Auspicious Day of the
Eighth Moon of the First Year of Qianlong'. The Emperor acceded on 18 October 1735
but his reign title, Qianlong, did not become current until the following year. The
Inauguration Portraits were therefore probably painted in 1736. The term 'an auspicious
day' may be a reference to the Emperor's twenty-fifth birthday which, in the Chinese
calendar, fell on the thirteenth day of the eighth moon.

The *Inauguration Portraits* handscroll was kept in a magnificent red lacquer case bearing
the inscription 'In My Heart Is the Power to Reign Peaceably'. The Qianlong Emperor is
said to have examined the work only three times during his reign: once when the paintings
were completed, again on his seventieth birthday in 1781, and finally at the time of his
abdication in 1795. This is evidenced by the presence of three imperial seals marking
of these events.

Castiglione's portrait of the young Emperor reveals a sensitive face with an alert expression, benign smile and slightly large ears. Qianlong was emphatic that the artist should not flatter his subject but paint a faithful likeness. However it was only permissible to depict facial defects 'in such a way that one does not notice it unless forewarned'. The young Emperor was already conscious of his image and Castiglione was advised to make the imperial head 'very large'.

Qianlong and his consorts are shown in the *Inauguration Portraits* handscroll wearing dragon robes, a type of garment worn at court for important celebrations such as the emperor's birthday. Qianlong was very concerned that Castiglione precisely copy the colours and patterns of his costume and even ordered a palace eunuch to put on the imperial robes so that the artist could reproduce the design detail at his leisure. This was considered even more important than accurately portraying the sitter's features.

In the portrait, Qianlong is wearing a yellow-coloured dragon robe, an exclusive privilege of the emperor and his immediate family. Mounted on the top of his fur-trimmed hat is a large baroque pearl, possibly the fabulous 'Azure Dragon', a pearl reputed to have strange powers. According to the palace eunuchs, Qianlong discovered the Azure Dragon at the Yuanmingyuan. Strolling by a stream one day, the Emperor noticed something gleaming beneath the surface of the water, and shot an arrow into the stream, but the mysterious light disappeared. When the stream was dredged, a large freshwater mussel was discovered with the pearl inside. The Azure Dragon was reputed to be able to fly until it was mounted on the imperial hat.

The Empress and the senior imperial consort are also shown wearing yellow, a privilege they enjoyed by virtue of their close relationship to the Emperor. The Emperor's third, fifth, ninth and tenth consorts are depicted wearing orange-coloured dragon robes. The irregular sequence in which they are shown suggests that the colour was conferred on them as an honour rather than as a privilege of rank. The Emperor's other secondary wives are shown wearing maroon-coloured dragon robes.

Pl.9 Detail of endpaper
Several endpapers in the collections of folios thought to have originated from the Summer Palace bear this seal impression, which reads 'Treasure of the Yuanmingyuan'.
V&A

The 'Summer Palace' Manuscript

Many of the spoils from the Summer Palace subsequently came under the hammer at sales put on by auction houses in London and Paris. The sacking of the Palace was an event that would inevitably seize the popular imagination and, no doubt, this may have enhanced the value of those *objets d'art* thought to have once been the property of the imperial household. It is quite likely, however, that the sales also included items that were not part of the haul taken from the Summer Palace.

On 4 February 1863, less than three years after the destruction of the Summer Palace, Messrs Puttick & Simpson of Leicester Square offered for sale Lots 172 and 173: 'two volumes of Chinese drawings of beautiful execution, one a map, the other a series of delineations of Court Costume, £45'. Both were said to have come from the Summer Palace. The sale catalogue described Lot 173 as follows:

A series of thirty most exquisite drawings in colour, and heightened with gold, upon silk, representing the gorgeous State Costume of the Empress of China, with about as many pages of illustrative text, also upon silk, powdered with gold.

A matchless example of its kind, exhibiting head-dresses, jewels, and the magnificent embroidered and decorated robes of the Empress, with the most brilliant effect, and, doubtless, the most exact truthfulness. This volume was also taken from the Emperor's Summer palace at Pekin[g]. A kind of seal or official stamp is at the commencement.

Lot 173 was purchased by Sir Thomas Phillipps (1792–1872), an eccentric collector of oriental art. The collection comprised 34 leaves, each of which was folded down the centre. We shall refer to these folded leaves as folios. These folios included 36 painted

Pl.10 Detail of endpaper
This seal impression reads 'Treasure of the Septuagenary Son of Heaven and the Five Generations in the Hall of Five Happinesses' and commemorates the Qianlong Emperor's seventieth birthday in 1781.
V&A

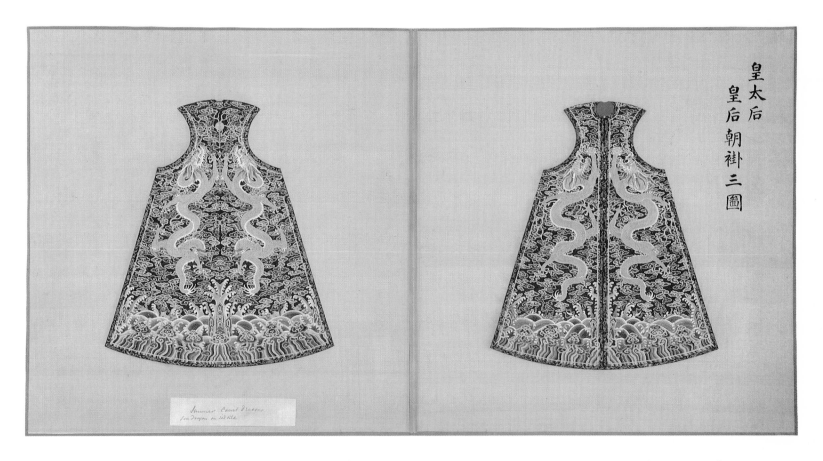

皇太后
皇后
朝褂
三圖

Pl.8 An empress' *chao gua*
This illustration, showing front and back views of a sleeveless vest appropriate to an empress dowager or empress, formed part of a collection of folios reputed to have been taken from the Yuanmingyuan and subsequently purchased by Sir Thomas Phillipps at the Puttick sale of 1863.
Sotheby's

illustrations of the most formal court costumes appropriate to an empress dowager or empress, 27 pages of descriptive text and four pale-blue, gold-spangled endpapers. One of the endpapers bears the impression of a large square seal with the inscription 'Treasure of the Yuanmingyuan'. Although many palace buildings are known to have possessed official seals, this one has yet to be properly authenticated. However, its presence may account for the association of these folios with the sacking of the Summer Palace.

Another endpaper carries the impression of a seal inscribed 'Treasure of the Septuagenary Son of Heaven and the Five Generations in the Hall of Five Happinesses'. This seal is a variant of an authenticated one commemorating the Qianlong Emperor's seventieth birthday in 1781. On this occasion the Emperor is said to have received congratulations from five generations of the imperial family: his consorts, sons, grandsons, great-grandsons and great-great-grandsons.

The first folio in the collection, which shows front and back views of the empresses' winter court hat, also carries the impression of a small oval seal inscribed 'Treasure having been examined by Qianlong'. This is a particularly well-known seal which appears on many important Chinese paintings thought to have originated in the imperial collection. The Qianlong Emperor was particularly fond of liberally applying his seals to works of art, although by doing so he has not endeared himself to subsequent generations of art historians.

In 1895 the Victoria and Albert Museum (V&A) in London purchased 290 folios, similar in size and format to those in the 1863 Puttick sale. The folios included paintings of the court costumes of the emperor and his secondary consorts. Some of these have 'From the Summer Palace, Pekin[g]' written on the back and two of the endpapers in the collection bear the seal inscribed 'Treasure of the Yuanmingyuan'. Another carries the seal commemorating Qianlong's seventieth birthday. A fourth endpaper bears the impression of another large square seal inscribed 'Treasure of an Octogenarian Recalling Eighty Distinguished Years'. This is a variant of a known seal commemorating the Qianlong

Emperor's eightieth birthday celebrations in 1791, which were even more elaborate than those held in the previous decade. A number of the folios in this collection also bear the small oval seal inscribed 'Treasure having been examined by Qianlong'.

The V&A's purchase of 1895 was divided among two other museums: 65 folios went to the Royal Scottish Museum in Edinburgh and 61 to the Dublin Museum of Arts, now the National Museum of Ireland. This was the first of a number of acquisitions of similar folios by the V&A over the next 60 years. In 1900 the Museum bought a second lot of 72 folios and in 1904 it acquired another 34. Finally, in 1953 a further 128 folios were obtained.

The V&A's 1900 acquisition of folios included one with a bookplate affixed to it bearing the coat of arms of Lord Macartney. This bookplate has led to speculation that Macartney acquired some, if not all, the folios during his visit to China in 1793. Macartney's journal is very detailed but surprisingly he has not recorded obtaining any such folios while in China. He died in 1806 without issue but his library remained intact until 1854 when the bulk of his estate was auctioned by Puttick & Simpson. However, the folios do not appear in the inventory of effects at that sale.

Other folios are known to exist. In 1926 Sir Harry Knollys donated 33 to the British Library. Knollys was the editor of the journals of General Grant, who was the commander of British forces at the looting of the Summer Palace. In fact Knollys was working on Grant's memoirs, *The China War of 1860*, when the General died. At least four other folios are held in private collections. Two of these are accompanied by a handwritten note that reads: 'This pattern belonged to the Chinese Emperor and was looted from the Summer Palace at Pekin[g] in 1861. It has been in my possession ever since (58 years)'. In fact the Summer Palace was looted and then razed in October of the previous year. The statement, dated 21 November 1919, is signed by a M. J. Paige who is believed by his descendants to have been a merchant seaman. Other folios were held by the family at one time.

The evidence presented by the folios themselves strongly suggests that they all originated from a single manuscript. All of them measure 420 x 409 mm. The illustrations and text are all painted on silk, mounted on stiff card and are edged by a thin strip of brown-coloured paper, presumably for protection. Although they are now separated, the folios appear to have been bound together back to back. There are no indications that they were sewn together but the reverse side of each one has traces of what was probably an adhesive substance and there are signs of damage where the folios have been detached from one another.

The reverse side of the right-hand opening of most of the folios is marked with Chinese numerals. For example, all the folios purchased by Sir Thomas Phillipps at the 1863 Puttick sale are marked 13 while a series of numerals, written below the first figure, runs sequentially through the 34 folios that comprise the lot: the illustration of the empresses' winter court hat is marked 13.1, the text describing this hat is 13.2, the illustration of the empresses' summer court hat is 13.3, the description of that hat is 13.4, and so on through the various articles of dress illustrated. Only one other folio illustrating a garment appropriate to an empress dowager or empress is known to exist outside of the lot bought by Phillipps. Now in the British Library, this depicts a semi-formal court robe and is marked 14.21 on the reverse.

The numeral that remains constant on groups of related folios is most likely to have been a volume number while the sequential numbers probably indicate the arrangement of the folios within each volume. The court costumes of the empress dowager and empress would, therefore, have been covered by Volumes 13 and 14 of the manuscript. As all the articles of dress worn by the empresses as part of their *chao fu* are included in Volume 13 and their less formal dress apparently formed part of Volume 14, we can estimate that each volume comprised approximately 30 folios.

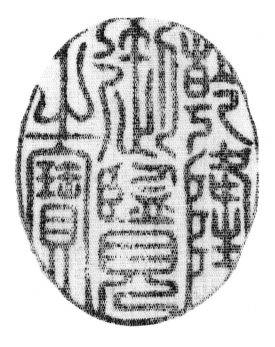

Pl.11 Detail of folio
A number of the folios thought to have originated from the Summer Palace bear this seal impression, which reads 'Treasure having been examined by Qianlong'. This was one of the Qianlong Emperor's personal seals which he affixed to paintings he particularly appreciated.
V&A

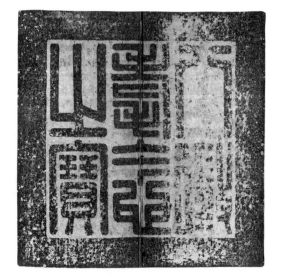

Pl.13 Detail of endpaper
This seal impression reads 'Treasure of an Octogenarian Recalling Eighty Distinguished Years'. The Qianlong Emperor celebrated his eightieth birthday in 1791.
V&A

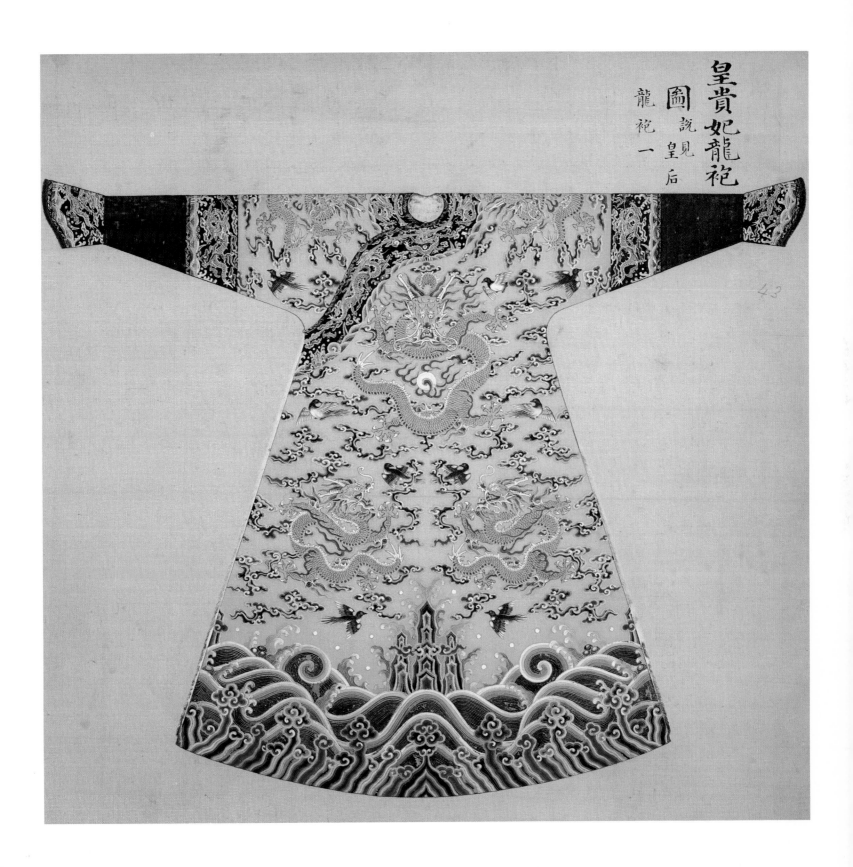

皇貴妃龍袍圖　說見皇后

龍袍一

Pl.12 Woman's dragon robe
Painting on silk of an imperial consort's winter
dragon robe from an album of paintings purchased
by the V&A in 1895 and thought to have originated
from the Summer Palace.
V&A

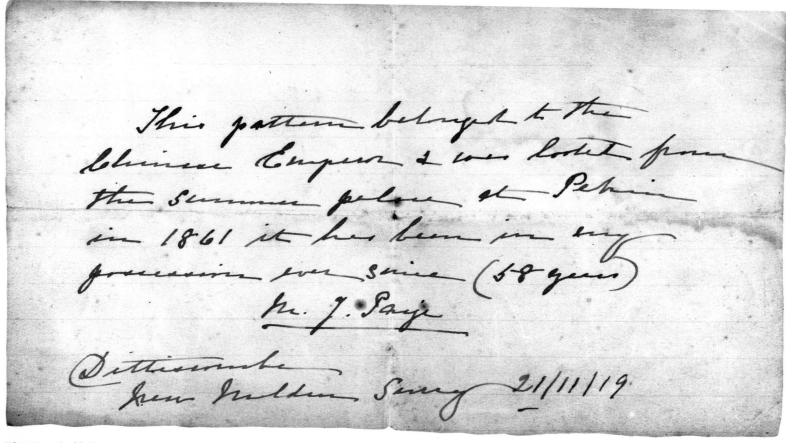

Pl.15 Detail of folio (reverse)
This handwritten note accompanies two folios that
remain in private hands. It is signed by a M. J. Paige
and is dated 21 November 1919. Mr Paige's
descendants say that, at one time, the family had
other plates from the same manuscript.
Private collection

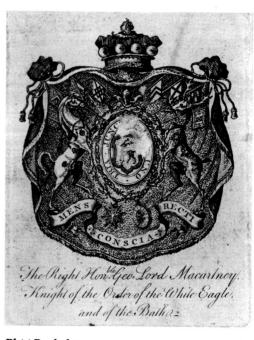

Pl.14 Bookplate
The coat of arms of George, Lord Macartney, on a
bookplate affixed to one of the folios thought to have
originated from the Summer Palace.
V&A

We can thus begin tentatively to reconstruct the costume section of the manuscript:
illustrations of the emperor's most formal court dress apparently came from Volume 2,
an illustration of the dragon robe appropriate to one of the emperor's sons from Volume
5, a court robe of a third-rank prince from Volume 8, and several articles of dress
appropriate to an imperial duke from Volume 9. Various folios relating to the court
costumes of officials seem to have come from Volumes 9 and 10, while an illustration of
the ceremonial robe of a graduate in the government examinations is apparently from
Volume 12.

We have already seen that Volumes 13 and 14 comprised the costumes of the empress
dowager and empress. The court dress of the senior secondary consorts of the emperor is
well represented in the existing collections of folios, which appear to have come from
Volume 15. Illustrations and descriptions of several articles of dress appropriate to an
imperial daughter-in-law also exist and suggest that the costume section alone came to
more than 20 volumes.

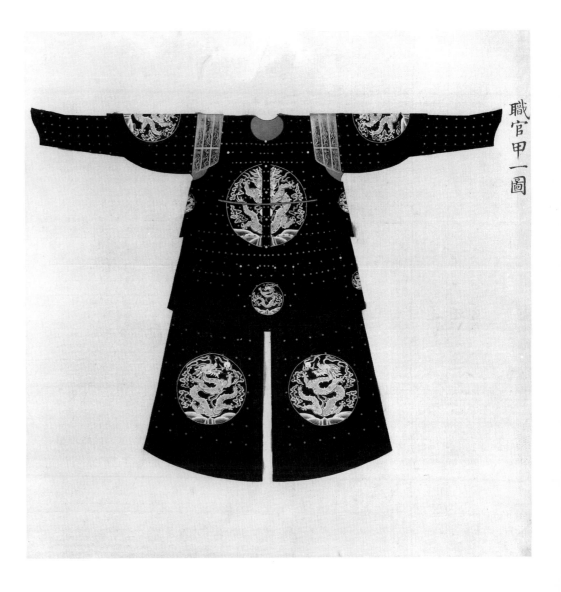

Pl.16 Ceremonial armour
Painting on silk of the ceremonial armour of an officer in the Imperial Guard thought to have originated from the Summer Palace.
V&A

職官甲一圖

The numerals are written in a cursive style normally used where there was no need for precaution against fraud. If all the folios had originally been bound together back to back, these numerals would have been completely hidden and they may, therefore, have been used simply as a guide by the binders.

In addition to court costume, the manuscript also covers military uniforms and an extensive range of ritual paraphernalia including banners, flags, musical instruments and the sacrificial vessels used at the great imperial altars in Peking. Although probably incomplete, the existing folios illustrate every type of garment in the official wardrobe, some of which are not represented in any western collection of Qing period costume. In many cases there is a descriptive text on the opposite leaf to the painting. On some folios the front view of the article of dress appears on the right-hand leaf of the folio with the corresponding back view on the left-hand side. In this instance only the front view is captioned and the descriptive text is given on a separate folio.

One of the most remarkable features of the folios is the amount of detail. For example, the first of the emperor's two styles of winter *chao fu* were heavily decked with furs. The text tells us that they 'are edged with undyed sable' except for the cuffs which 'are made of smoked sable'. The colour of the robes is given as yellow except 'when praying at the Southern Altar when blue is worn'. The robes are shown in both colours and the artist has

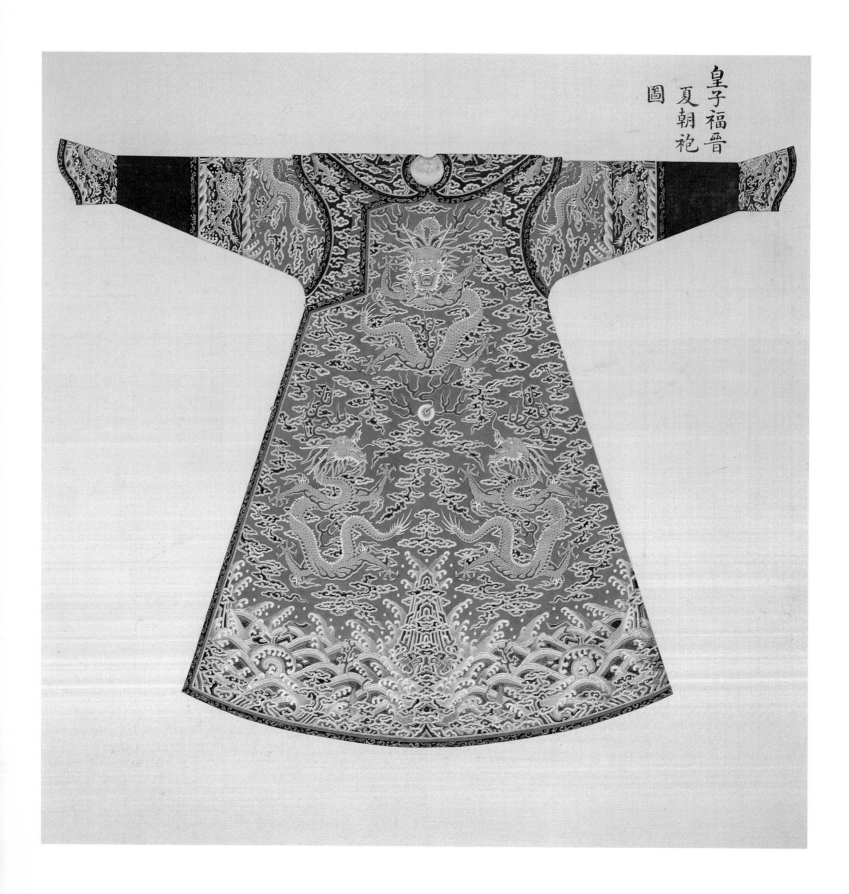

皇子福晋
夏朝袍
圖

Pl.17 Woman's summer *chao pao*
Painting on silk of the summer *chao pao* of an
imperial daughter-in-law.
British Library

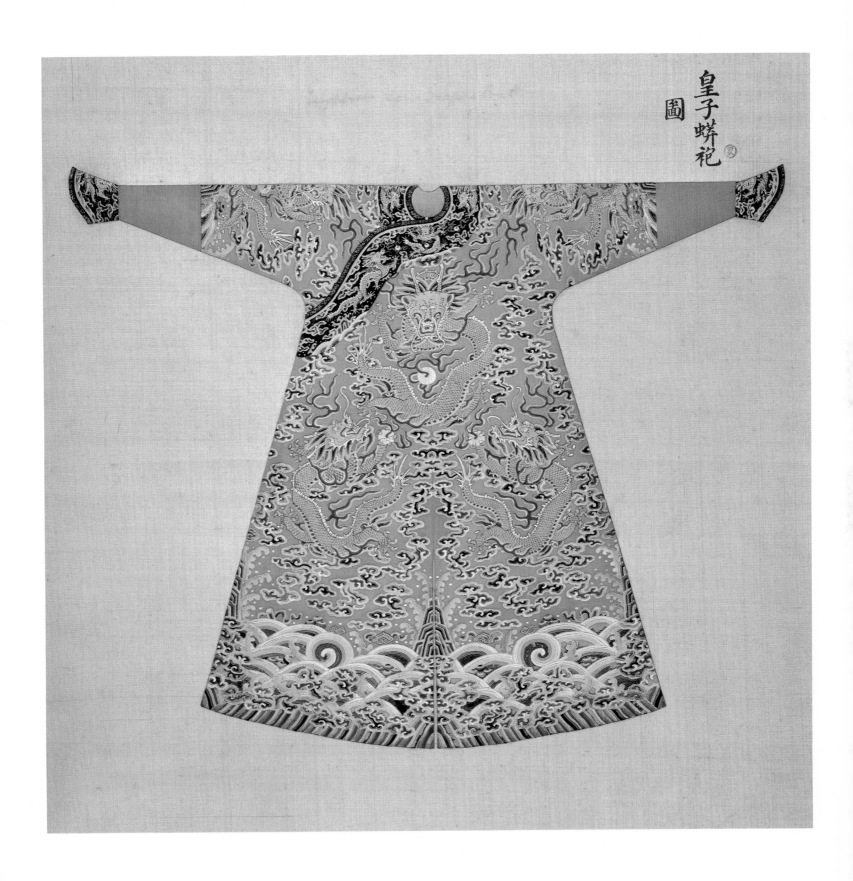

皇子蟒袍
圖

Pl.19 Prince's dragon robe
Painting on silk of the dragon robe appropriate to
the son of an emperor. The text states that its orange
ground is *jin huang*, golden-yellow.
V&A

王福晉縣主皆同

皇子福晉夏朝袍用
香色片金緣餘俱
如冬朝袍下至郡

本朝定制
皇子福晉夏朝袍
謹按
皇子福晉夏朝袍

Pl.18 Detail of folio
The text accompanying the illustration of an
imperial daughter-in-law's summer *chao pao* states
that the greenish-yellow hue is *xiang se*, 'incense
colour'.
British Library

attempted to differentiate between the two types of fur, depicting the smoked sable cuffs
as darker than the undyed sable trimming. Other folios seem to indicate that the
manuscript originally included illustrations of front and back views of all of the emperor's
different styles of court robe in each of the colours specified in the accompanying
descriptive texts.

Similarly the two illustrations of the emperor's most formal style of winter court hat, *chao
guan*, are identical, except that one has a slightly lighter coloured fur facing on the
upturned brim. This probably represents an attempt on the part of the artist to show the
two species of fur (sable and black fox) worn by the emperor during different times of
winter. Elsewhere, if the text indicates that an article of dress could be made of 'either
satin or gauze with a single lining, each according to its season', the item is shown twice,
even though there is no visual difference between the illustrations. The numbering on the
reverse of these plates seems to confirm that this repetition was an intentional feature of
the manuscript and that these are not duplicates taken from another copy of the same
work.

The manuscript is particularly valuable for the information it provides about the various
colours that different members of the imperial court were permitted to use, since the
paintings give a visual definition of each colour. For example, imperial consorts of the two
lowest degrees, the emperor's daughters, and the wives of his sons were allowed to wear
a colour described in the court's sumptuary regulations as *xiang se*. The dictionary
translation of this term is 'incense colour', which is little help to the uninformed.
Fortunately, one of the folios donated to the British Library by Sir Harry Knollys depicts
a court robe appropriate to the emperor's daughters-in-law and shows *xiang se* as a
greenish-yellow colour.

The folio bearing the Macartney bookplate describes the dragon robe of an emperor's son
as having a ground colour of *jin huang* or golden-yellow. The illustration on the facing leaf
shows this to be a mid-orange colour. Another folio shows the court belt of an emperor's
son in the same colour.

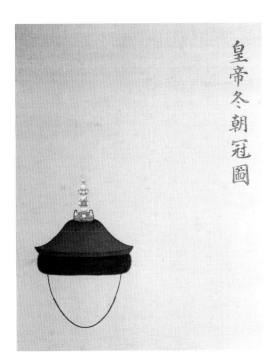

皇帝冬朝冠圖

Pl.20 Emperor's winter *chao guan*
Painting on silk of the emperor's winter *chao guan*.
V&A

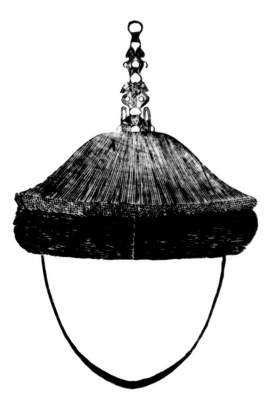

Pl.21 Emperor's winter *chao guan*
The close correspondence between the manuscript
and the 1766 Wu ying dian edition of *Huangchao liqi
tushi* is clear from a comparison of this block-printed
illustration and the painting on silk of the emperor's
winter *chao guan*.
SOAS

Huangchao liqi tushi

In 1759 the Qianlong Emperor commissioned a work entitled *Huangchao liqi tushi*, the *Illustrated Precedents for the Ritual Paraphernalia of the Imperial Court*. This was to provide a comprehensive, illustrated catalogue of all the ceremonial trappings of the court. The Emperor selected his uncle, Prince Zhuang (1695–1767), a prominent figure at his court, to undertake this enormous task. The sixteenth son of the Kangxi Emperor, Prince Zhuang had been appointed in Yongzheng's will as a regent to assist the young Qianlong with affairs of state, even though the Prince was best known for his mathematical expertise and musical accomplishments. As one of Qianlong's tutors, he was also responsible for instructing his nephew in the use of firearms.

The commission was very prestigious and included the president of the Board of Ritual as well as editors from the five other government boards. The names of seven compilers from the Hanlin Academy, a chief writer with a staff of eight copyists and at least four painters are recorded in the introduction to *Huangchao liqi tushi*, which was written by Prince Zhuang. The artists employed by the commission appear to have been drawn from a list of 'expectant' officials who had qualified in the government examinations and were waiting for a posting.

The Emperor himself is supposed to have written the long preface, but like many other official documents bearing the emperor's name it was probably composed by one of his councillors. The imperial preface, however, is in a style of calligraphy affected by Qianlong which he called *yu bi* or 'imperial hand'. The references to costume in the preface will be discussed in the next chapter.

We do not know when the commission finally completed its work on *Huangchao liqi tushi*. However, Margaret Medley points out in her article (see Bibliography) that it cannot have been completed before 1760 at the earliest since an edict on musical instruments, quoted in the relevant section, was issued in March of that year. Regardless, the first block-printed edition was produced by the Wu ying dian, the imperial printers, in 1766.

This edition of *Huangchao liqi tushi* comprised an estimated 6,000 illustrations and 5,000 pages of text. Some 18 volumes covered such topics as sacrificial vessels, astronomical instruments and timepieces used in calculating dates for the imperial ceremonies, court dress, the musical instruments of the court orchestra, the state insignia of the emperor and empress, and the military uniforms and weapons used by the emperor and imperial princes. The last section included over 60 different types of arrow used in hunting various game.

A comparison of the illustrations in *Huangchao liqi tushi* and the manuscript folios discussed earlier reveals a close affinity between the two works. Almost every section of *Huangchao liqi tushi* is represented in the collections of folios said to have come from the Yuanmingyuan. Only the prefatory material and the chapter on astronomical instruments have not come to light during our research.

Furthermore, there are similarities between the style of calligraphy in the manuscript and the text of the block-printed edition. Margaret Medley has also observed that both texts contain several variants in a number of characters concerned with decoration; this she attributes to the personal idiosyncracies of different writers. However, the manuscript folios contain a number of errors not found in the block-printed edition. Several illustrations are incorrectly captioned and in one instance associated with the wrong descriptive text. In this particular case, the illustration depicts a pair of cymbals but the accompanying text describes a gong.

It was not uncommon for illustrated works published by the Wu ying dian to be copied in other media. In 1712, for example, the Wu ying dian produced a work entitled *Imperial Pictures of Ploughing and Weaving*, illustrated by Jiao Bingzhen with poems attributed to

the Kangxi Emperor. The illustrations, which depict the various stages in the cultivation of rice and the production of silk, were reproduced in many forms including paintings and embroidered pictures. The manuscript edition of *Huangchao liqi tushi* is unusual in that, if it were ever completed, it would have contained more illustrations than the Wu ying dian block-printed edition.

Although opinion differs as to the origin of the manuscript, one possibility is that the folios formed part of a special edition of *Huangchao liqi tushi* in the imperial collection. We believe, however, that the manuscript was the work of the commission appointed by Qianlong in 1759. Because the block-printed edition includes the lengthy preface attributed to the Emperor, we consider it likely that this 1766 edition was based on an earlier manuscript that was submitted to the throne for approval. In this connection it is interesting to note that all existing first folios from each volume of the manuscript bear the seal inscribed 'Treasure having been examined by Qianlong'. We must be cautious, though, in offering the presence of seals as conclusive evidence since it is possible that these seals, as well as others like them, were applied at a later date.

The original justification for the beautiful paintings of the manuscript must remain a subject of speculation, since the kind of investigative study needed to establish the reasons is beyond the scope of this book. The value of the folio paintings, as they are presented here, is that by virtue of being in colour, they provide us with information about Qing court dress that the block-printed edition of *Huangchao liqi tushi* cannot.

THE IMPERIAL WARDROBE

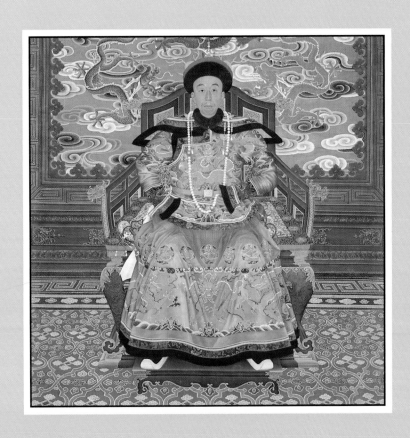

The Imperial Wardrobe

Court Dress

Chinese court dress had been regulated by sumptuary laws since the feudal Zhou period (1122–255 BC). Successive imperial dynasties issued their own regulations regarding the colours and designs of official costume. The first basic rules relating to Qing court dress were set down by Abahai as early as 1636. After the Manchu conquest of China in 1644 these were revised and augmented by new regulations. In 1748 the Qianlong Emperor ordered a complete review of the changes made to ceremonial costume by his predecessors, which he then published in the *Collected Acts of the Dynasty*. This was a prelude to the more comprehensive *Huangchao liqi tushi*, which finally established the form of Qing court dress.

Court robes destined for the wardrobes of the imperial family were manufactured by the official silkworks in the heart of China's silk-producing region. A large factory in Nanjing produced brocades, the tapestry known as *kesi* or 'cut silk', and also the satins, twills and gauzes to be embroidered by another official workshop at Suzhou, a city renowned for its needlework. Imperial robes were commissioned on an annual basis by the Board of Ritual, one of the most important of the six government ministries. Occasionally, the official workshops had to work night and day to complete orders for the court. After finishing imperial commissions, the official silkworks were allowed to execute private orders from wealthy courtiers.

As each section of an imperial robe came off the loom or embroidery frame it was carefully inspected by the *si fu*, the superintendant of the silkworks, to ensure that there were no defects in the pattern. This was then sent as uncut yardage to the imperial silkstore in the palace where the bolts of material were examined a second time by the officials there. They were finally tailored on the orders of the *Yi ku*, the Imperial Wardrobe, another department of the imperial household.

The Dyeing and Weaving Office in Peking provided all the necessary dyestuffs and pattern drawings for imperial robes. The importance of the work of this office is reflected by the fact that it was under the nominal supervision of an imperial prince. During the Qing period certain colours were restricted to use by the imperial family and the formulas for these dyes were probably closely guarded to prevent their misuse.

The pattern drawings themselves were life-sized cartoons drawn in ink on silk. Part of the design was painted to show the colours that were to be employed by the weavers and embroiderers. The Nelson Aitkins Museum in Kansas has an example of a pattern drawing for a nineteenth-century empress' dragon robe. The left-hand side of the robe has been painted to show the colours of the ground, the dragons, clouds and other symbols in the design. Where a particular motif on the right-hand side does not correspond exactly with that on the left, the detail has also been coloured. This pattern drawing is illustrated on p. 158 of *The Art of Oriental Embroidery* (see Bibliography).

The gift of a full set of court robes from the emperor was an exceptional honour accorded to very few people. Most officials had to purchase their own court dress, the cost of which often represented several times their annual stipend. Officials stationed in the capital received additional allowances to cover such expenses.

In his journal Lord Macartney noted that a 'complete robe of ceremony of a high mandarin' cost between 100 and 1,000 taels. One tael, the unit of currency, represented one Chinese ounce of pure silver. In 1793, a tael was worth six shillings and eight pence in English currency. It is difficult to assess what the cost would be today, but Macartney also noted that the complete dress of a peasant cost a mere two taels. By the end of the nineteenth century, the cost of providing a set of court robes had risen to between 3,000 and 4,000 taels, an amount roughly equivalent to a middle-ranking official's salary for three years.

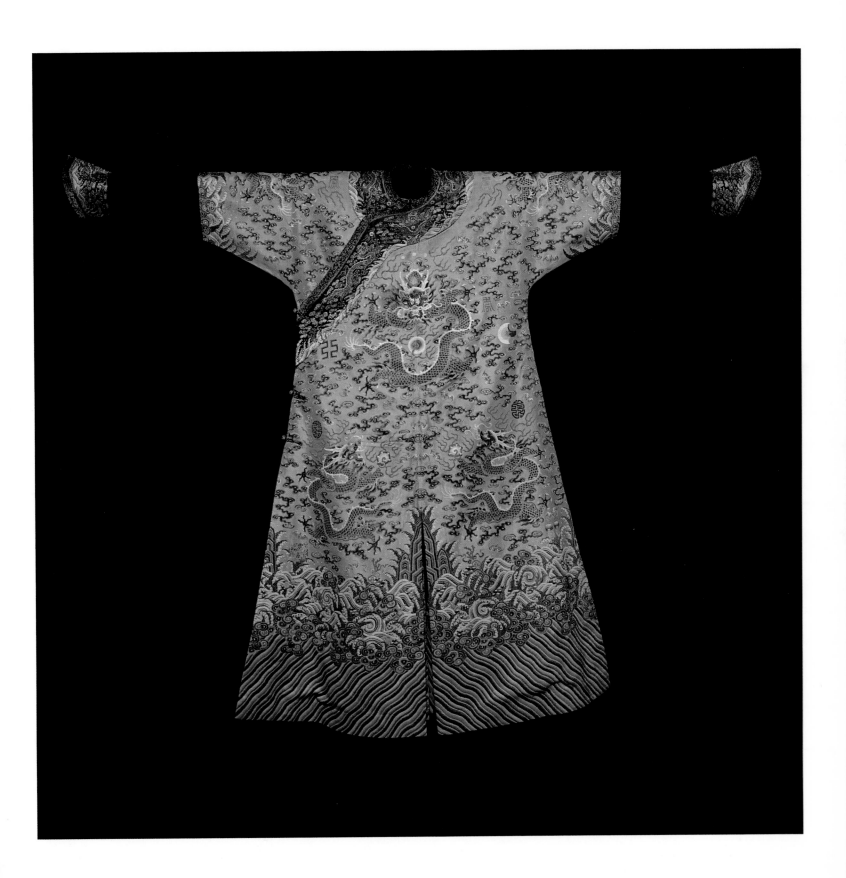

Pl.23 Emperor's dragon robe
The emperor's court robes were manufactured at the
imperial silkworks to designs based on patterns laid
down in sumptuary laws.
Linda Wrigglesworth

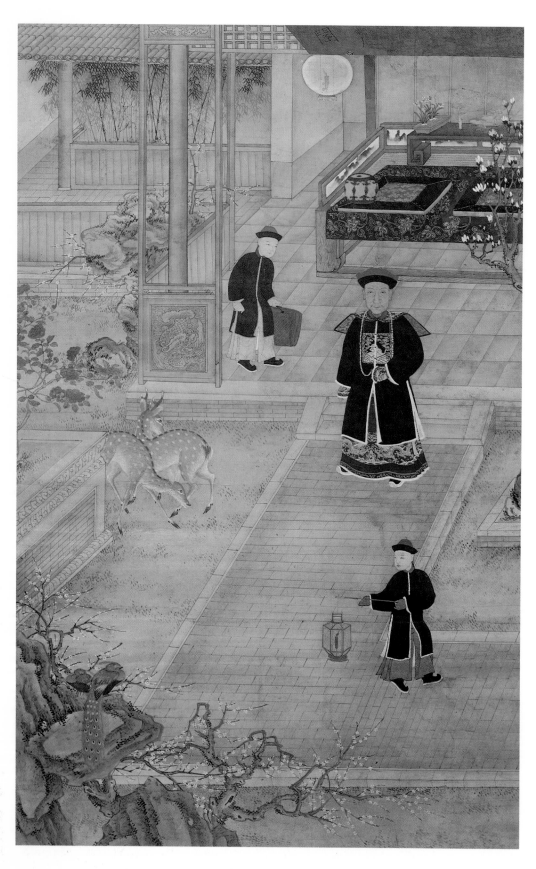

Pl.24 Scroll painting
The badge of rank applied to the dark-coloured surcoat worn by the figure wearing court dress indicates that he was a military official of the fourth rank. This painting may depict his departure to the palace for an early morning audience. He is guided through the garden by an attendant carrying a lantern and accompanied by another holding a red portfolio.
Spink & Son Ltd

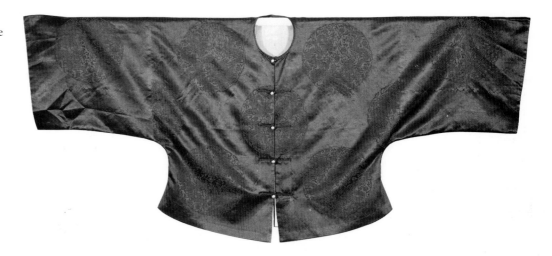

Pl.26 *Ma gua*
The *ma gua* or riding jacket was a waist-length type of surcoat worn over the *nei tao*.
Linda Wrigglesworth

Pl.27 Winter hat
The upturned brim of this winter hat is reversible to protect the neck and ears.
General Gordon's Boys School

Pl.28 Summer hat
The long tassel of this summer hat is made of animal hair, probably that of yak or horse.
Private Collection

Qing Garments

The garments and dress accessories that made up court costume were elaborate forms of the articles of dress worn every day by members of the educated élite of Qing society. Ordinary dress or *chang fu* consisted of a *nei tao* or inner tunic, a *wai tao* or outer tunic, a hat and a pair of boots.

The *nei tao* was a full-length robe with a right-hand closure, front and rear vents, tapered sleeves, and *ma ti xiu*, horsehoof cuffs. Some examples of *nei tao* also have a detachable section at the bottom of the right-hand side which, when removed, allowed the wearer to mount a horse easily. This feature is usually found only on robes worn by officials when travelling. The *nei tao* was always worn girthed with a cloth belt or *dai*. According to J. J. M. De Groot in his book *The Religious System of China*, during winter this belt was wound around the waist three times and secured at the back with a knot. In summer the *dai* went around the waist once only and was secured at the back with a metal clasp.

The *wai tao* was a very simple three-quarter-length, front-opening coat with straight sleeves and back and side vents. Some surviving examples of *wai tao* also have buttons at the hem on either side of the back vent fastening into loops at the top of the side vents. This opens up the back vent, allowing the wearer to sit comfortably in the saddle when riding a horse. The *ma gua* or riding jacket, a waist-length type of *wai tao*, was another common garment.

Both the *nei tao* and *wai tao* were normally made of silk. During winter they could either be lined with fur or padded with silk or cotton floss. Quilted garments were often also trimmed with fur. In spring and autumn both inner and outer tunics were simply lined with silk, and in summer either left unlined or made of gauze. In winter, the *ma gua* was often completely faced with fur.

During the winter months this outfit was worn with the *hong ying mao*, hat with a red tassel, a close-fitting cap with a wide, upturned brim and a decorative tassel of silk cords. The crown of the hat was usually quilted and the upturned brim was sometimes faced with fur. Some examples of winter hat also have buttons on the side of the brim which allowed it to be turned down at the back to protect the ears and neck from the wind.

In summer this type of hat was exchanged for a so-called 'warm weather hat', a conical sunshade made of woven straw or bamboo with a decorative tassel made of silk, yak hair or horsehair. The tassel often extended over the brim of the hat and may have been designed to keep flies out of the wearer's eyes. The province of Gansu in the far west of China was the main producer of yak hair tassels.

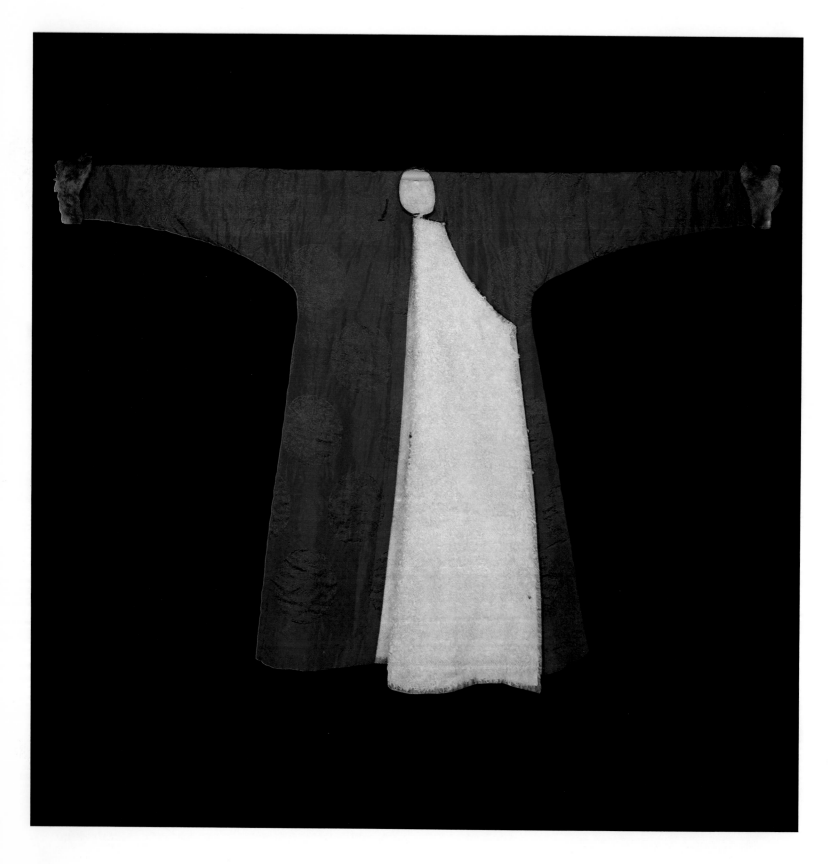

Pl.25 *Nei tao*
Nei tao or inner tunic made for use during winter.
The body of the garment is lined with fleece and the
horsehoof cuffs with mink.
Private collection

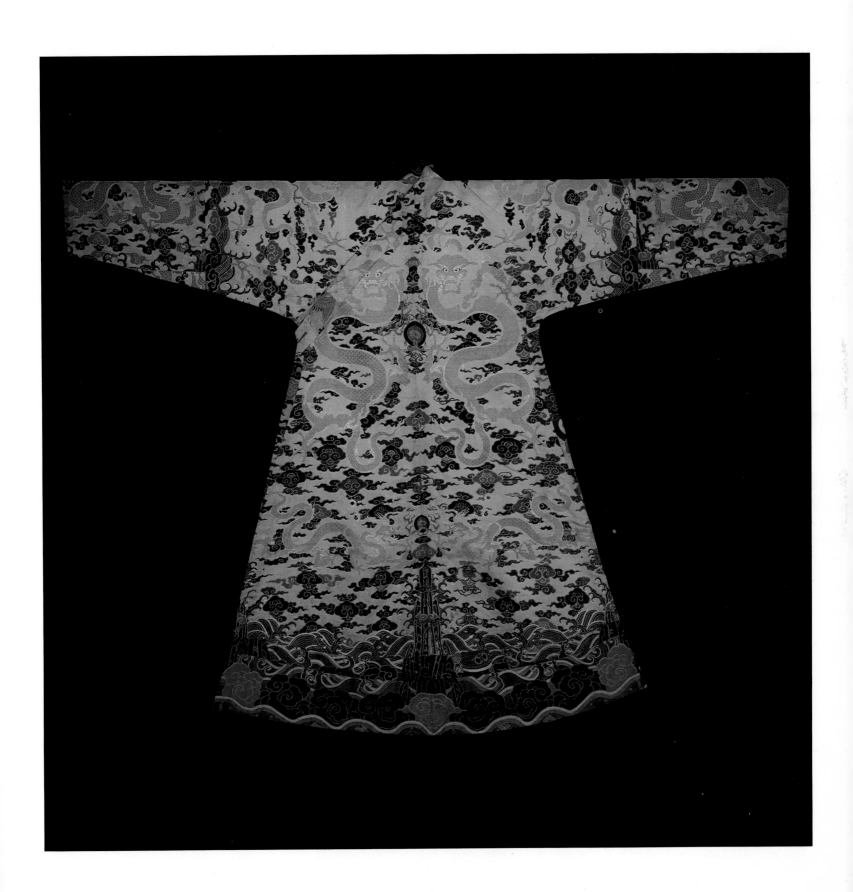

Pl.30 *Chuba*
Several early Qing court robes have been used in the
making of this *chuba*, a Tibetan-style garment.
Spink & Son Ltd

Knee-high riding boots or *ma xue* were invariably worn with this costume, both in winter and summer. They were made of black silk satin and had squared toe-caps and thick, whitened soles. The inflexible soles were built up of layers of cotton and leather sewn together. In winter the boots were lined with either felt or the fleece of unborn lambs and, in summer, with a coarse cotton material.

Scholars are generally agreed that many of the design features of the costume described above derived from the functional riding gear of the Manchu horseman and, therefore, probably pre-date the foundation of the Qing dynasty. As we have already seen, the front and rear vents of both the *nei tao* and *wai tao* and other features of these garments allowed the wearer to mount a horse with ease. The narrow sleeves of the *nei tao* also insulated the arms without restricting mobility while the horsehoof cuffs protected the hands. The inflexible soles of the *ma xue* allowed the wearer to stand in the stirrups when firing a bow. Many of these characteristic features are also found on court dress.

The early Manchu chieftains obtained their first dragon-patterned robes as gifts from the Ming court. But, as the Manchu gained ascendancy in the area north-east of the Great Wall, they were able to exact robes from the Ming emperors as tribute. However, the Manchu considered the voluminous cut and exaggerated sleeves of traditional Chinese garments not only effete but also impractical, and re-tailored them to suit their own tastes.

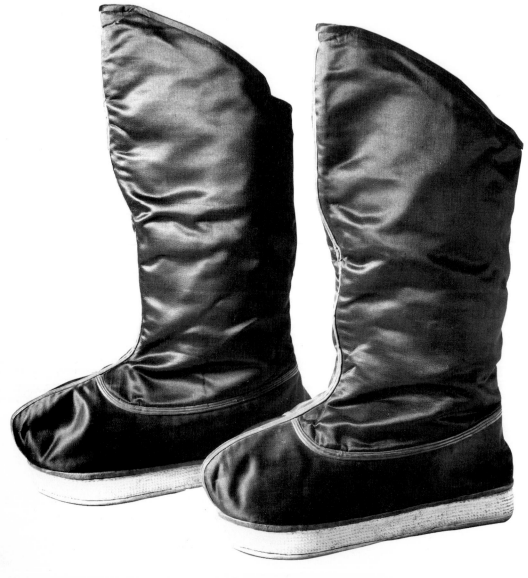

Pl.29 *Ma xue*
Pair of knee-high riding boots made of black satin with thick inflexible soles.
Linda Wrigglesworth

Pl.31 Detail of canopy
This canopy, designed to hang over a religious image, has been made from the material of an early Qing court robe. The Manchu characters in the cartouches over the dragons' heads read 'good luck' and 'wishes for a long life'.
Spink & Son Ltd

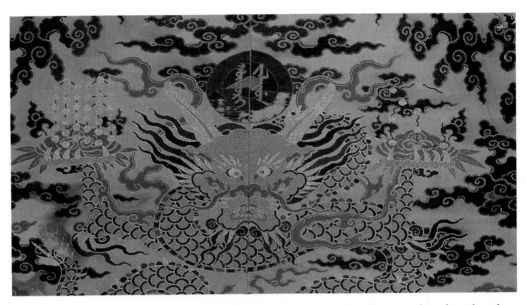

The extremely wide sleeves were probably cut just above the elbow and replaced with insets of silk and horsehoof cuffs. The result of this can be seen in the composite sleeves of Qing court robes.

The alteration of court robes is not a phenomenon unique to the Manchu. During the Qing period, when imperial robes had outlived their usefulness at court they were donated to large Buddhist monasteries. Many of these court robes found their way to Tibet where they were re-tailored into Tibetan-style garments called *chuba*. Often several robes appear to have been used to make up a single *chuba*.

Some of the earliest Qing textiles have survived in this way. These exhibit an almost endless variety of dragon patterns. The designs seem to have been directly copied from, or at least based on, traditional Chinese patterns inherited from the Ming period. However, there is some evidence of purely Manchu influence. A fragment of a yellow, brocaded court robe, probably dating from the beginning of the eighteenth century, bears characters in Manchu. Contained in cartouches above the heads of the dragons are the Manchu words *huturi* and *jalafun*, which mean 'good luck' and 'wishes for a long life'.

The importance the Qianlong Emperor attached to the origins of both his dynasty and Qing court costume are clearly stated in the imperial preface to *Huangchao liqi tushi*. With regard to costume the Emperor had this to say:

As for the hats and robes, each dynasty sets forth its own regulations. In ancient times, the shou hats of the Xia dynasty [mythical c.2205–1818 BC] and the xu hats of the Yin dynasty [or Shang 1766–1154 BC] were not passed down to their successors. We accordingly have followed the established practices of Our Dynasty and have not dared to change them fearing that We would offend Our Ancestors and that posterity would hold Us responsible for this and criticize Us regarding the hats and the robes. This We certainly should not do. Moreover, disaster befell the Northern Wei dynasty, the Liao, Jin and Yuan dynasties within one generation of adopting Chinese robes and hats. Those of Our sons and grandsons who would take Our Will as theirs will not be deceived by idle talk. In this way the continuing mandate of Our Dynasty will receive the protection of Heaven for ten thousand years. Do not change Our native traditions.

The Emperor cites ancient precedents to justify the continued use of Manchu dress as court costume, recalling the fate of previous foreign dynasties that had adopted traditional Chinese dress. This is probably intended to rebut Chinese patriots who wanted to see their traditional costume restored.

With the possible exception of the appearance of the Twelve Symbols in the design of imperial court robes (see The Twelve Symbols), *Huangchao liqi tushi* included few innovations. It was largely based on previous laws, although it appears to have incorporated long-standing conventions that would otherwise not have been recorded.

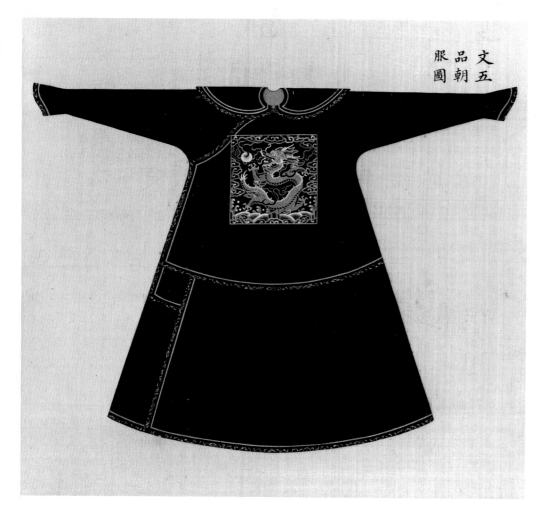

文品服
朝五圖

Pl.32 *Chao fu*
Painting on silk of the *chao fu* of a low-ranking
official or an imperial guardsman.
British Library

For example, *Huangchao liqi tushi* required low-ranking officials and imperial guardsmen
to wear formal court robes decorated with square badges displaying profile, four-clawed
dragons. The ground of these robes was plain except for a damasked cloud pattern. This
is the first time that this style of court robe appears in court dress regulations. However,
a fragment of an early Qing robe has a square badge showing the profile dragon on a
cloud-figured ground. This seems to indicate that this design of court robe pre-dates the
eighteenth century. We cannot therefore be certain that the Twelve Symbols were not
used by the Qing emperors before 1759.

The costume section of *Huangchao liqi tushi* sets out, in order of precedence, the court
costumes of every member of the imperial hierarchy from the emperor down to the lowest
grade of official. Ceremonial dress is classified into two categories: *chao fu* and *ji fu*. In
each case the individual items of dress that comprised these costumes are illustrated in the
following order: hats, surcoats, robes, belts, and necklaces. Those items for use in winter
are shown before summer attire.

As we shall also be following the same order in the chapters of this book related to
individual items of dress, it may be helpful to the reader if, at this point, we briefly
examine the classification of court dress and the structure of the imperial court as it is
demonstrated by *Huangchao liqi tushi*.

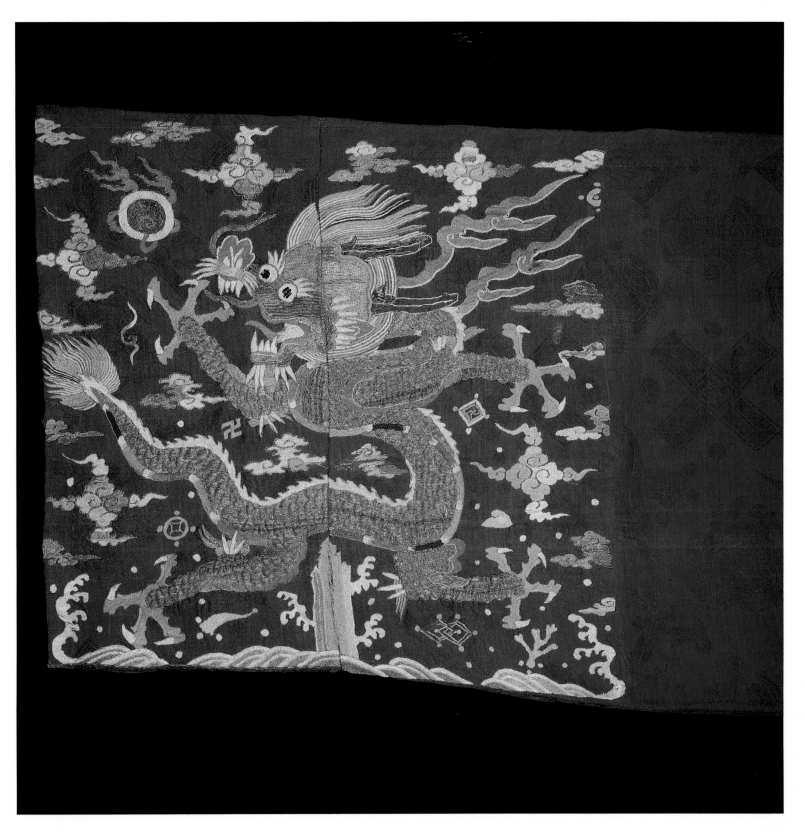

Pl.33 Fragment of court robe
Although the design of this fragment of a Qing court
robe appears for the first time in *Huangchao liqi
tushi*, it appears to date from the late seventeenth or
early eighteenth century.
Spink & Son Ltd

Chao fu

Chao fu was the most formal costume in the Qing wardrobe. The character *chao* means 'court' or 'dynasty'. The right-hand side of the written character depicts the moon and the left-hand side symbolizes the rising sun. The overall impression of the character is one of light in the early morning, the time at which the Chinese believed the mind to be at its greatest clarity and when the most important court ceremonies took place. *Chao fu* literally means court dress but 'robes of state', evoking the majestic pomp of the most solemn court ceremonies, is probably a more meaningful interpretation of the term *chao fu*.

To be consistent with its use in *Huangchao liqi tushi*, throughout this book we have used the term *chao fu* only when referring to the complete costume. This is because *Huangchao liqi tushi* uses the term *chao fu* to describe a man's most formal court robe, which it illustrates with a detachable shoulder cape called a *pi ling*, while, for a woman, the same combination of a formal court robe and a collar is referred to as *chao pao* (*pao* meaning 'robe'). The character *pao* is not specifically a feminine noun as it is also used to describe a man's less formal court robe.

Although detachable, the *pi ling* appears to have been considered an integral part of the most formal court costume. The robe could not be worn by itself. But the robe could be worn by men with the *pi ling* collar without any other garment. Women appear to have always had to wear the loose sleeveless garment called a *chao gua* over their very formal court robes. *Huangchao liqi tushi* illustrates this garment separately. Only when the robe, collar and *chao gua* are combined can a woman be described as wearing *chao fu*. The term *chao fu* does appear to refer to a complete suit rather than any single article of court dress and we have, therefore, described the robe that formed part of *chao fu* as a *chao pao* when referring to that garment in isolation.

A man's complete suit of *chao fu* consisted of a hat with an ornate apex, a side-fastening robe with a fully gathered skirt and tapered sleeves with horsehoof cuffs, a belt or girdle with ornamental plaques, and a necklace of 108 beads. The names of all these articles of dress are prefixed by the character *chao*. The *pu fu*, a dark-coloured front-opening surcoat decorated with insignia badges, could also be worn with this costume.

As we have already stated, these individual items of dress are elaborations of basic everyday garments in the Qing wardrobe. While they retain many of their original design features, each item has been adapted to serve another function, that of indicating the status of the wearer in the imperial hierarchy. The ornate apex of both winter and summer hats and the ornamental plaques of the belt were set with semi-precious stones or glass imitations, the colour of which was determined by the rank of the wearer. Insignia badges were applied to the otherwise plain *wai tao*, which became the *pu fu*.

The *chao pao* itself has many of the characteristics of the *nei tao* or inner tunic of ordinary dress: a right-hand closure, tapered sleeves, and horsehoof cuffs. However, some features, such as the pleated skirt, indicate that it might have been based on Ming court robes. A number of robes recovered from recently excavated tombs dating from the Ming period also have fully pleated skirts, probably to increase the impressiveness of the garment. It is also interesting to note that the *chao pao* is the only male garment in the Qing wardrobe without vents, which seems to confirm that it was not originally a Manchu garment.

Pl. 34 *Chao fu*
Diagram demonstrating the order in which the
articles of dress that make up *chao fu* are illustrated
in *Huangchao liqi tushi*: winter and summer hats, fur
coats and surcoats, winter and summer court robes,
belts, and court necklaces.
G. W. Dickinson

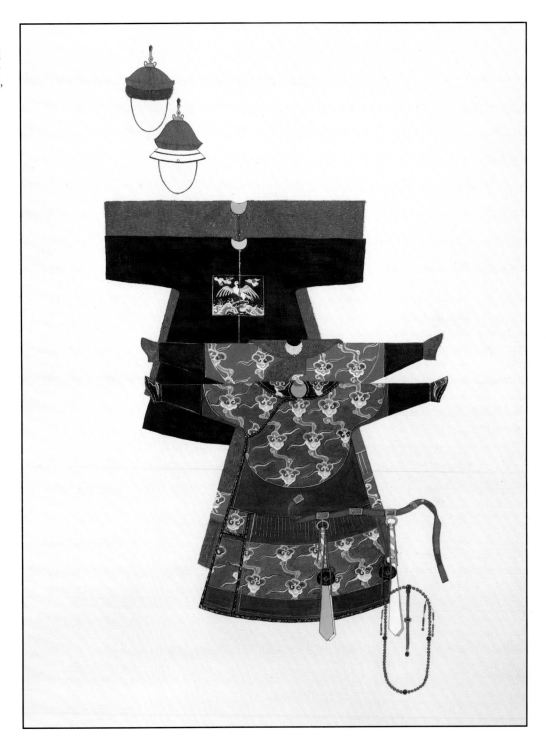

Ji fu

At the beginning of the Qing period there was a clear-cut distinction between state ceremonial and routine administration. But, as the Manchu dynasty began to assimilate purely Chinese concepts about the function of government and the role of the emperor, court ritual became increasingly more elaborate. Subtle distinctions in formality were drawn between ceremonial occasions, necessitating the development of a secondary form of court dress.

Huangchao liqi tushi brought this less formal style of court costume, *ji fu*, within the scope of sumptuary law, prescribing the various colours and patterns that different members of the imperial hierarchy were permitted to use. The definition of *ji* is 'lucky', 'happy' or 'auspicious'. The term *ji fu*, festive dress, therefore, implies a different usage to *chao fu*.

Ji fu consisted of a hat with a simple apex, a full-length, side-fastening robe with tapered sleeves and front and rear vents, and a belt. The robe itself is described by *Huangchao liqi tushi* as either a *long pao* or *mang pao*. *Long* and *mang* refer to species of dragon with, respectively, five and four claws. *Long pao* were, in theory, restricted to use by the highest-ranking members of the imperial family. However, many officials disregarded this rule. Although decorated with five-clawed dragons, it would be misleading to call an official's less-formal court robe a *long pao* and technically incorrect to describe it as a *mang pao*. To avoid confusion we have called these garments 'dragon robes' except where referring specifically to *long pao* or *mang pao*. The construction of the dragon robe is identical to that of the *nei tao*. It was completely covered with a pattern that included dragons, clouds and other cosmological motifs. In this respect it is quite different from the *chao pao*, the pattern on which is confined to a four-lobed yoke extending over the chest, back, and shoulders, and a band around the bottom part of the skirt.

Women's Court Dress

The court costumes of the empress dowager, the empress and the emperor's other consorts together with those of the wives of the nobles and officials are dealt with in a separate section of *Huangchao liq tushi*. Women's court dress, particularly *chao fu*, was more elaborate than that of their male counterparts. Although their costumes consisted of the same basic elements as male dress, garments such as the sleeveless *chao gua* took the place of the dark-coloured surcoat as the outer covering. Nevertheless, women were also assigned a form of surcoat, called a *long gua* or dragon coat. However, this seems to have been worn independently as a separate article of dress. Women's court costume also included various dress accessories not found in the male wardrobe. The complete female wardrobe, including articles such as hats and surcoats, is described in the chapter 'Women's Court Dress'.

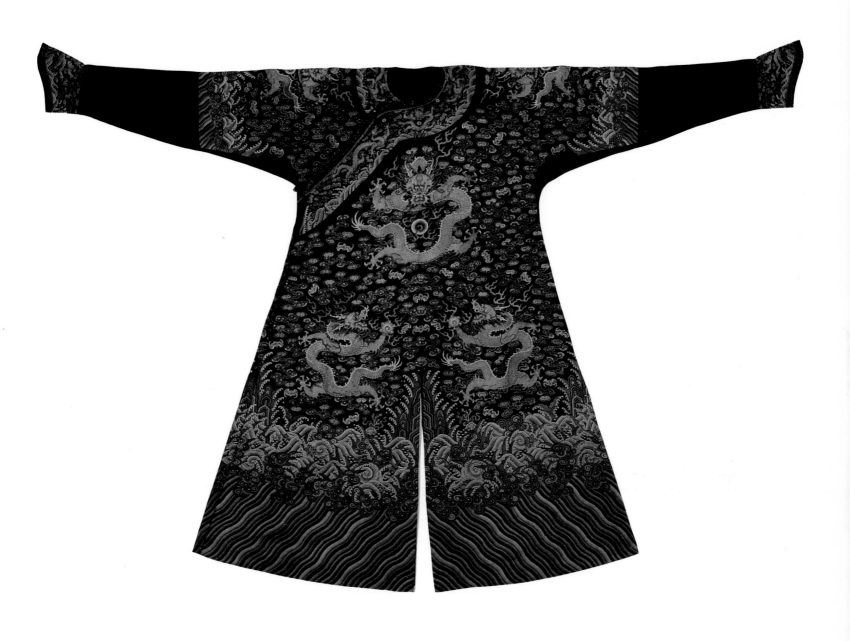

Pl.35 Dragon robe
Unlike the *chao pao*, the dragon robe was completely
covered with a cosmological design.
Linda Wrigglesworth

The Imperial Court

The Chinese court embraced all those people who held a title or an official rank in the imperial hierarchy. *Huangchao liqi tushi* made provision for both *chao fu* and *ji fu* of each member of this hierarchy. Naturally, the court costumes of the emperor are illustrated first.

The emperor

The emperor is referred to as *huang di* or supreme lord. In common with other contemporary official documents, these two characters are elevated above the ordinary level of the text in *Huangchao liqi tushi*. At court, the emperor was usually addressed as *Wan sui ye* or 'Lord of ten thousand years'. At his accession, the emperor's personal name became taboo even to his closest relatives. The period of his reign was known by a specific title (i.e. Qianlong or 'Universal Abundance'). After his death the emperor was canonized with a so-called temple name. The Qianlong Emperor was given the title Gaozong, which means 'Exalted Ancestor'.

The Chinese regarded their sovereign as *Tian zi* or 'Son of Heaven', a divinely appointed intermediary between Heaven and Earth. The country is called *Zhongguo*, which means 'middle kingdom'. All other nations were seen as merely satellite states that would enjoy the benefits of peace and civilization only if they paid regular tribute to the Son of Heaven. Although not a native Chinese dynasty, the Manchu emperors assumed this traditional guise and legitimized their regime by claiming Heaven's mandate.

The empresses

The wardrobe of the *huang tai hou*, or empress dowager, and her junior colleague, the *huang hou* or empress, are the first to be illustrated in the section of *Huangchao liqi tushi* dealing with women's court dress. As a member of a senior generation of the imperial line, the *huang tai hou* took precedence at court over even the emperor himself. Theoretically it was she who selected the emperor's wives and determined their rank. In practice, however, political considerations determined the choice of the empress. Normally, imperial marriages were alliances between the imperial house and other powerful Manchu or even Mongol clans.

Imperial consorts

Apart from his empress, the emperor also took numerous other consorts. All these secondary consorts were legal wives and their male offspring were potentially legitimate heirs to the throne. They were graded into five ranks: *huang gui fei, gui fei, fei, pin* and *gui ren*. *Huangchao liqi tushi* only makes provision for the court costumes of the principal wives of nobles and officials, who take their order of precedence from that of their respective husbands.

The emperor's sons

In the order of male precedence established at court, after the emperor came his sons or *huang zi*. During the Qing period, it was customary for each succeeding generation of the imperial line to share the first character of their name. Although the imperial succession passed through the direct male line, unlike previous Chinese dynasties, the house of Manchu did not practise primogeniture. The emperor was free to select whichever of the *huang zi* he wished to succeed him. The identity of the *huang tai zi*, literally the 'greatest son' or crown prince, was a closely guarded secret during the lifetime of the reigning emperor. The emperor inscribed the name of his chosen successor in a testament which was then sealed in a yellow case to prevent anybody tampering with it and deposited in the Palace of Heavenly Purity in the Forbidden City. It was not opened again until the emperor was *in extremis*.

Pl.36 Commemorative portrait
Full-length study by Castiglione showing the
Qianlong or 'Universal Abundance' Emperor
wearing his *chao fu* or court dress.
Palace Museum

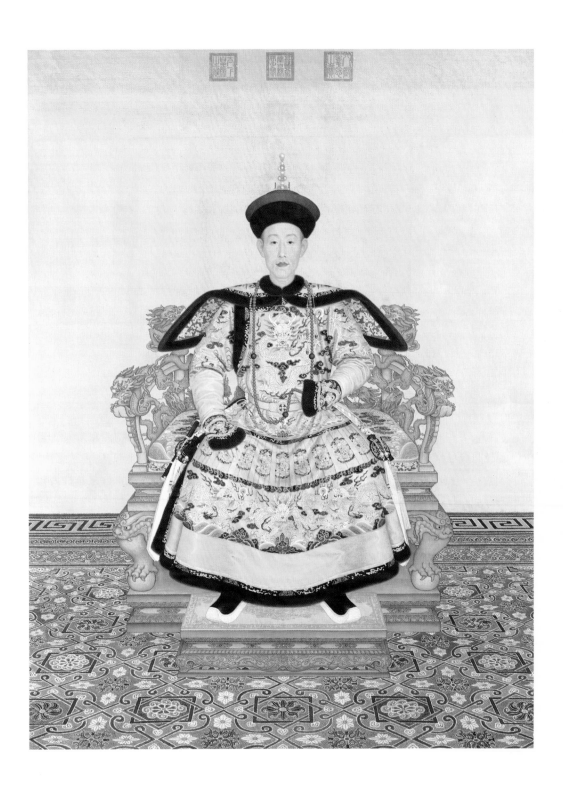

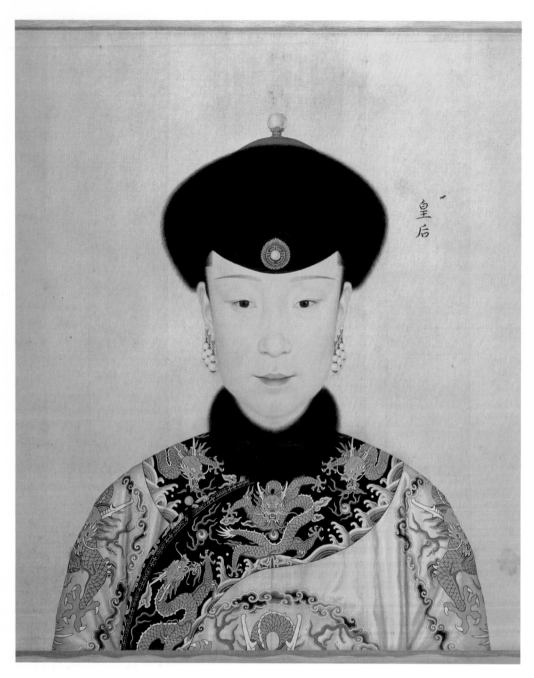

皇后

Pl.37 Inauguration Portraits
Detail of Empress Xiaoxian, first principal consort
of the Qianlong Emperor, shown here wearing *ji fu*
or festive dress.
Cleveland Museum of Art

Pl.38 Imperial prince
Commemorative portrait of an unknown imperial
prince wearing winter *chao fu*.
Spink & Son Ltd

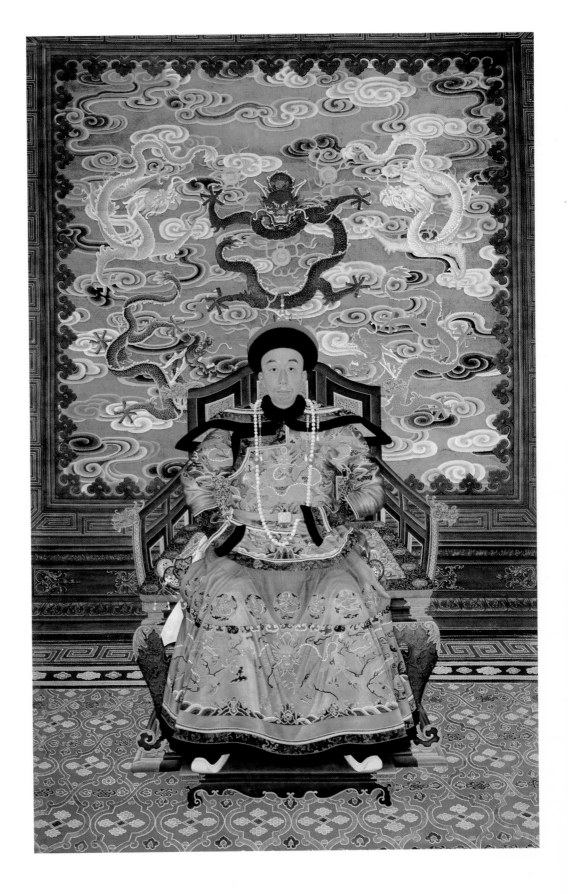

Table 1: The Imperial Succession

Reign-title	Proclaimed Crown Prince	Date of Accession	Date of Death
Shunzhi	—	8 October 1643	5 February 1661
Kangxi	—	17 February 1661	20 December 1722
Yongzheng	—	20 December 1722	8 October 1735
Qianlong	7 October 1735	18 October 1735	7 February 1799
Jiaqing	15 October 1795	9 February 1796	2 September 1820
Daoguang	2 September 1820	3 October 1820	25 February 1850
Xianfeng	25 February 1850	9 March 1850	22 August 1861
Tongzhi	21 August 1861	11 November 1861	12 January 1875
Guangxu	15 January 1875	25 February 1875	14 November 1908
Xuantong	15 November 1908	2 December 1908	1967

From: A. W. Hummel, *Eminent Chinese of the Ch'ing Period*

In the first year of his own reign, the Qianlong Emperor secretly nominated Yonglian, his first-born son by his Empress, as the *huang tai zi*. Unfortunately the child died prematurely at the age of eight. Qianlong refused to make further provision for the succession for over 35 years, trusting in his own longevity. Finally, in 1795, Qianlong publicly nominated his successor. Having completed a full cycle of 60 years on the throne, he decided to 'abdicate' in favour of his fifth son, Yongyan. In October 1795 Yongyan was proclaimed *huang tai zi* and ascended the throne during the following New Year as the Jiaqing Emperor (r. 1796–1820). In fact, far from relinquishing real power, Qianlong elevated himself to *tai shang huang di* or 'grand exalted emperor', taking precedence over his less than fortunate successor.

It seems unlikely that in 1759 Qianlong could have foreseen that he would publicly nominate his heir during his own lifetime. In fact, several times during his reign Qianlong apparently felt obliged to defend the secret method of nominating the crown prince. However, he conceded that his own successors could revert to primogeniture in good conscience. This may have been one reason why designs for the court costumes of the *huang tai zi* were included in *Huangchao liqi tushi*.

Imperial nobles

After the court costumes of the emperor and his sons, *Huangchao liqi tushi* illustrates those of the imperial nobility. During the Qing period there were four degrees of imperial prince of which *jin wang* was the highest. *Wang* means 'prince' and the character *jin* indicates a blood relative. However, not all *jin wang* were directly related to the imperial house by blood. In some exceptional cases the title was conferred as an honour on Manchu and even Mongol nobles allied to the emperor by marriage.

Princes of the second degree were called *jun wang*. The character *jun* represented a division of land. In fact, *jun wang* had no territorial jurisdiction and, like all imperial nobles, were not even permitted to leave the capital without express permission from the emperor.

Imperial princes of the third degree were called *bei le*, a Chinese transliteration of *beile*, a Manchu term for 'prince'. The fourth and lowest degree of prince was called *bei zi*, which means 'son of a *bei le*'.

The emperor's sons were normally appointed to one of these princely ranks on attaining their majority, though they appear to have continued to enjoy the distinction of being *huang zi*. Although the rank of a princely house normally declined by one degree every generation, *shi zi*, the sons of first-degree princes, were ranked below their fathers but above *jun wang*.

Pl.39 Civil official
Oil on canvas portrait of an official wearing the
badge and hat insignia of the fourth civil rank.
Martyn Gregory Ltd

Below the princes were four degrees of *guo gong* or imperial duke. Imperial sons-in-law, married to the emperor's daughters by his empress, were ranked above imperial dukes but below fourth degree princes, *bei zi*.

Titular nobles

Immediately following the costumes of the imperial nobility come those appropriate to the five grades of non-imperial title: *gong, hou, bo, zi* and *nan*. These titles are normally translated as duke, marquis, earl, viscount and baron. However, they should not be taken as literal equivalents to European titles. They were conferred on the heads of families who traced their descent directly from the great sages of antiquity, including Confucius. Outstanding soldiers were also often given one of these titles for their services.

Civil officials

The nine ranks of civil official formed the backbone of the imperial bureaucracy. They enjoyed a number of privileges, including protection from insult by commoners and immunity from prosecution unless impeached by another official.

The emperor's councillors, the heads of the six government boards, senior officials of the imperial household, and provincial viceroys and governors were drawn from the top two civil ranks. The third and fourth ranks included directors of the subdepartments of the six boards and the most senior provincial officials below the governors. Magistrates with jurisdiction over several districts and minor court officials (such as the director of the Board of Sacred Music, which provided the accompaniment to imperial ceremonies) were drawn from the fifth and sixth ranks. The seventh rank included district magistrates, the key provincial post at local level, as well as the ceremonial ushers and heralds at court. The two lowest civil ranks comprised the host of minor functionaries both in the capital and out in the provinces.

Military officials

The Chinese traditionally regarded a military career with some disdain and military officials were considered inferior to their civil counterparts. A first-rank military official appears to have been roughly equivalent to a second-rank civil official and this is reflected in *Huangchao liqi tushi* by the privileges they were allowed.

The Qing military machine had two arms: the Manchu banner regiments and the Green Standard Army, a standing force of Chinese soldiers. However, the most prestigious military positions were in the Imperial Guard. The first military rank included lieutenant-generals of banner regiments, chamberlains of the Imperial Guard and commander-in-chiefs of the Green Standard Army. Colonels in the Chinese army and captain-generals of the Imperial Guard were drawn from the second military rank. The third and fourth military ranks comprised officers in the Imperial Guard, colonels and captains in the banners, and majors in the Chinese army. The lowest ranks of military official included captains of the guards at the imperial tombs, lieutenants in the banners and corporals in the Green Standard Army.

Graduates

Immediately following the ceremonial costumes of civil and military officials, *Huangchao liqi tushi* illustrates those of graduates in the government examinations. Civil office was open to the holders of degrees attained in examinations based on the canon of Confucian classics. Provincial examinations were held in the eighth moon of every third year. Of the 12,000 *sheng yuan* or government students only some 300 successful *ju ren* or promoted men from each province went forward to the metropolitan examination held in Peking in the spring of the following year. Graduates from this examination, about 350 *jin shi* or advanced students, were enrolled on a waiting list of candidates for appointment to a senior position in the imperial hierarchy. Prospective military officials also had to attain similar degrees in examinations based on archery and other displays of martial prowess.

RITUAL USE OF
COURT DRESS

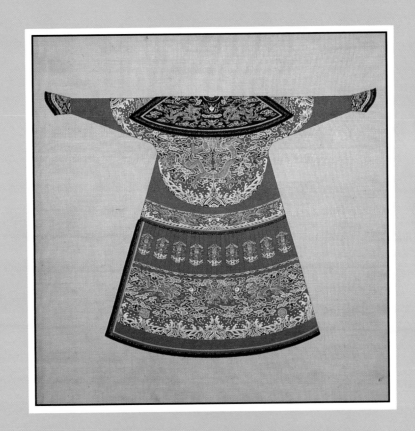

Ritual Use of Court Dress

Imperial Sacrifices

Court dress was worn by the ruling élite on ceremonial occasions only. It was not used every day, even within the palace. Artists at the Imperial Office of Painting, a studio in the palace, produced scroll paintings of important court ceremonies. These pictures are extremely valuable as records of the ritual context in which court dress was used, their incredible detail clearly showing the style of dress worn by the participants. Given the importance that was attached to the correct depiction of costume in commemorative portraits, it is most likely that these scroll paintings are also accurate portrayals.

The annual sacrifices were the emperor's most important ceremonial duties. At the winter solstice burnt offerings were sacrificed to Heaven and at the summer solstice offerings were interred in honour of Earth. Around the time of the spring and autumn equinoxes, he offered sacrifices to She and Qi, the Guardians of Soil and Grain. In the first month of spring, the emperor also offered prayers to Heaven for a good harvest, and, in the first month of summer, prayers for rain. Sacrifices to the imperial ancestors were offered in each quarter of the year on selected days.

One scroll painting in the Palace Museum in Peking depicts the sacrifice to Shennong, the mythical emperor credited with the invention of the plough. This sacrifice took place each year on a selected day of the second moon at the Altar of Agriculture, a square marble platform in the extensive grounds of the Temple of Agriculture to the south-west of the Forbidden City. One section of the scroll painting shows the Altar of Agriculture prepared for the ritual. A tabernacle has been erected on the Altar. Inside this is a table on which are placed the porcelain vessels containing the food offerings, lanterns and wine cups. Whole bullocks, sucking-pigs and sheep are placed in large trenchers before the table.

The Board of Ritual, through its subdepartments, managed the sacred herds of cattle, pigs and flocks of sheep, and procured the ingredients for the food offerings. The sacrificial victims had to be of uniform colour. Several days before the event the emperor or an imperial prince in full *chao fu* inspected the animals to ensure that they were without blemish. The animals were inspected a second time, closer to the date of the sacrifice, by the President of the Board of Ritual. Their ritual slaughter prior to the sacrifice was itself an important ceremony.

The painting shows, outside the tabernacle on the left- and right-hand sides, smaller tables on which were placed the prayers and offerings of silk and jade. At the head of the flight of steps leading up to the top tier of the Altar is the yellow silk awning where the emperor made his act of worship.

In the courtyard surrounding the Altar we see the court musicians, the choirs and the ceremonial dancers. All the sacrifices offered by the emperor himself were accompanied by music, hymns and slow, rhythmic dancing or posturing. A host of officials, invited to assist the emperor, have taken up their respective positions. The nobles and officials attending the ceremony are all wearing *chao fu*. The emperor, who can be seen approaching the Altar in another section of the scroll, is depicted wearing a yellow *chao pao* beneath his dark-coloured surcoat.

The ceremony began once the emperor had been ritually purified by rinsing his hands in a basin of water. He would then be conducted to the yellow pavilion on the terrace where a master of ceremonies requested him to worship. As the musicians began to play the emperor would be escorted by ceremonial ushers before the tabernacle. Kneeling on a yellow cushion, the emperor offered incense to the spirit. When he had returned to his place at the top of the steps, he then performed a nine-fold kowtow.

After the formal reception of the spirit, the emperor would offer the jade objects and pieces of silk. Hot water was then brought in and poured over the whole beasts in the trencher before the tabernacle. A libation of wine ladled into wine cups was the signal for the military dancers or posturers to perform the martial dances with battle-axes and

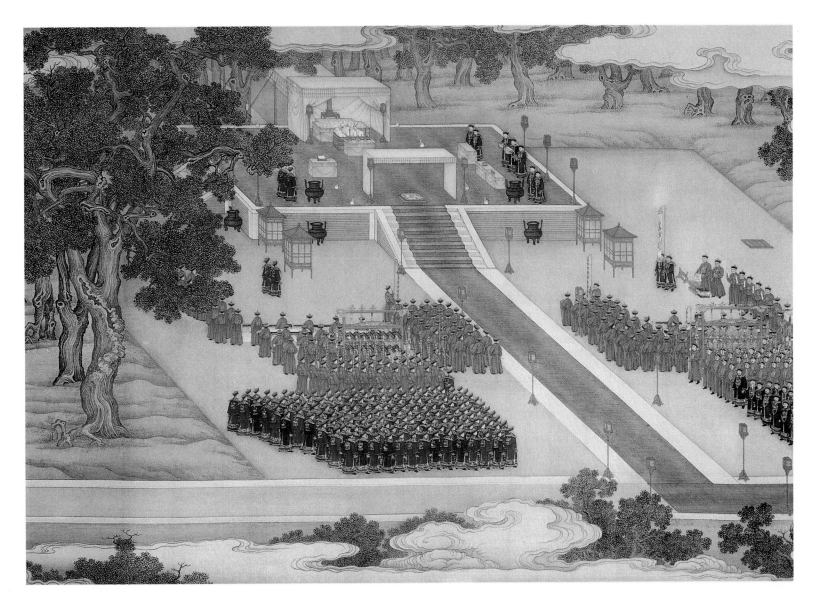

Pl.40 Altar of Agriculture
Detail of a scroll painting depicting the Altar of Agriculture prepared for the sacrifice to Shennong. Palace Museum

shields. After this the emperor would again prostrate himself while an official reciter read the prayers aloud. When the military posturers had retired, the civil posturers would perform their dances waving long argus feathers as a second libation of wine was offered.

After the libations had been made the Director of the Court Banquets would ask the emperor to partake of cooked meats and wine. The master of ceremonies would then request the emperor to perform another nine-fold kowtow as the spirit was about to retire. Once the spirit had been formally sent off, the emperor watched as a whole bullock and the silk offerings were either incinerated in a furnace or interred in the earth. The other offerings were then distributed amongst the officials who had participated in the ceremony.

The Ploughing Ceremony

A short distance from the Altar of Agriculture lay a sacred field consecrated to Shang di, the supreme deity of the official pantheon. Having offered the obligatory sacrifice to Shennong, the emperor proceeded to this field to perform the ceremony that inaugurated the agricultural year. This ceremony is the subject of another detailed scroll painting.

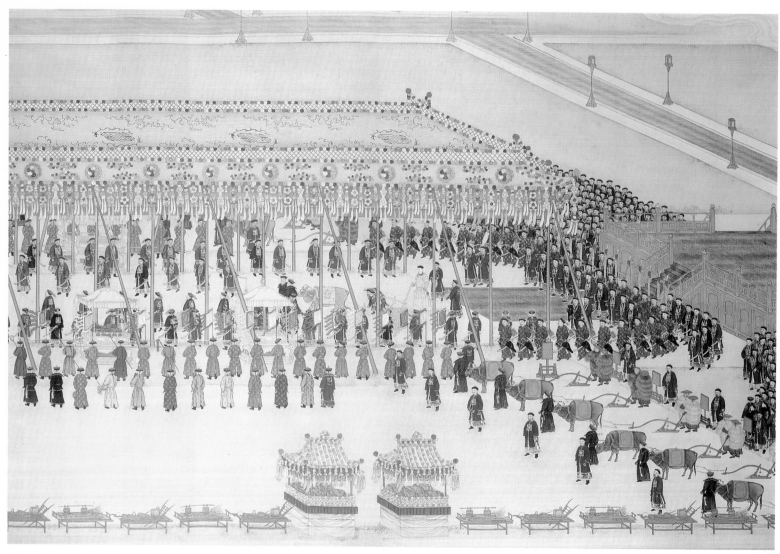

The scroll shows the sacred field decorated for the occasion with a richly festooned awning. At the edges of the field are lines of officials wearing dragon robes beneath their surcoats and gentlemen from the Imperial Equipage Department in their scarlet livery. Some officials, those apparently directing the proceedings, are shown wearing *chao fu*. The emperor himself is depicted guiding a yellow ox-drawn plough which turns a furrow in the central section of the sacred field. He has exchanged his *chao fu* for a less formal dragon robe, which he is wearing without a surcoat. He is accompanied by two high-ranking officials, holding yellow bags of seed corn, who are also dressed in dragon robes but with surcoats.

Huangchao liqi tushi made special provision for the insignia to be worn by these 'gentlemen who accompanied the plough'. Instead of their usual badges of rank, these officials had attached to the front and back of their surcoats squares decorated with a triple-peaked mountain surmounted by a solar disc. The oxen that pull the imperial plough are led by two graduates from the government examinations wearing their ceremonial robes or *gong fu*. The ploughshare is guided and obstacles removed from its path by two officials again dressed in dragon robes but without surcoats. The imperial plough is preceded by a file of military officials in *ji fu* and followed by an escort of imperial guardsmen. A host of imperial nobles and officials, wearing *ji fu*, stand nearby watching the proceedings.

The emperor was required to turn just three furrows. Once he had accomplished this task, three imperial nobles and nine high officials then opened five and nine furrows

Pl.41 Ploughing ceremony
Detail of a scroll painting depicting the annual ploughing of a sacred field in the grounds of the Temple of Agriculture by the emperor.
Musée Guimet

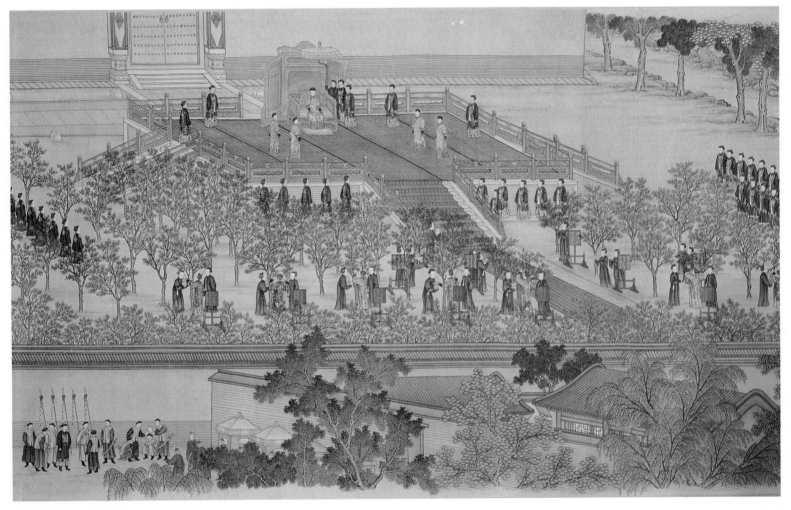

Pl.42 Mulberry-picking ceremony
This scroll painting illustrates the ceremonial picking of mulberry leaves by the empress and her ladies.
National Palace Museum

respectively in the strips of land either side of the central section, this time using red ploughs. These nobles and officials are depicted in the scroll painting wearing dragon robes concealed beneath *pu fu* bearing their rank badges. Every year a number of elders from the farming communities in the metropolitan district would be invited to witness the ceremony. They added a rural flavour to the proceedings. In the scroll painting some are dressed in plain blue robes and carry brooms, hoes and other agricultural implements; others are dressed in the traditional straw waterproofs of the peasantry. After the ceremony was concluded they would be presented to the emperor and entertained at an imperial banquet.

The Mulberry Leaf Ceremony

Many of the court's ceremonial duties were associated with agriculture. Another scroll by the Imperial Office of Painting depicts the empress and the ladies of the court gathering leaves from a sacred grove of mulberry trees at the Hall of Sericulture. This stood on the shore of an artificial lake in the imperial park on the western side of the Forbidden City.

The mulberry trees are planted in a grid pattern around a raised dais on which the empress sits enthroned. At a signal given by a mistress of ceremonies, the empress would descend from the dais and strip the leaves from branches of the first mulberry in the first row of trees on the eastern side. She then crossed to the western side and stripped the leaves from the corresponding tree. A golden sickle was used to remove the leaves, which were collected in a yellow basket.

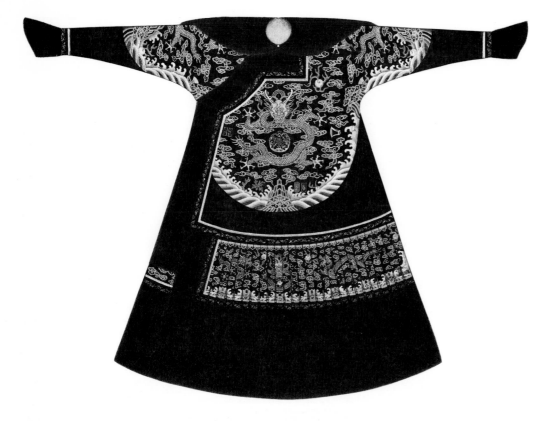

The empress would then return to her seat on the dais while the other imperial consorts took leaves from three branches of the second tree in the rows either side of the dais using silver sickles, also collecting the leaves in yellow baskets. The imperial princesses followed suit, stripping leaves from five branches of the third trees but using gilt sickles and red baskets. The Manchu noblewomen then collected leaves from nine branches of the fifth tree on each side using red-lacquered sickles and red baskets.

After the ceremony was over the leaves were finely shredded and fed to young silkworms reared at the Hall of Sericulture by women called 'silkworm mothers'. The empress hosted a banquet for the silkworms' appointed 'guardians', an honorary office held by noblewomen who had gained the empress' favour. In ancient times the silk produced by the sacred silkworms was woven to make the emperor's sacrificial robes. During the Qing period, the silk produced at the Hall of Sericulture was offered by the emperor at the state sacrifices.

Sacrificial *chao pao*

Colour played an important role in imperial ritual. The colours of the porcelain sacrificial vessels, the silk offerings and the emperor's sacrificial *chao pao* varied according to which altar was being used. The prayers were also written in coloured inks on papers of different colours. The use of different coloured *chao pao* by the emperor on these occasions was introduced by Yongzheng in 1723. The Qianlong Emperor introduced porcelain sacrificial vessels with glazes matching the colours of the robes in 1748.

The different colours of *chao pao* to be worn by the emperor at the various imperial altars are set out in *Huangchao liqi tushi*. In addition, he was obliged to wear dragon robes of the appropriate colour during the days of fasting that preceded these important rituals. As imperial sacrifices were offered by the emperor or in his name, only he used different coloured robes. All other members of the court, whether deputizing for the emperor or assisting him, wore *chao pao* of the colour specified for their respective rank.

Pl.44 Emperor's summer *chao fu*
Painting on silk of the emperor's blue summer *chao fu* for the prayers to Heaven for rain and good harvests.
V&A

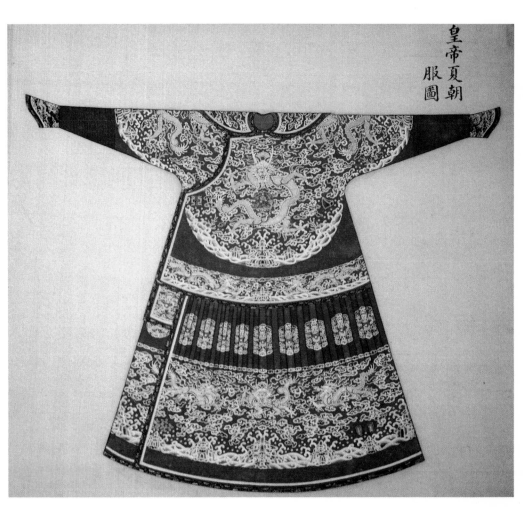

皇帝夏朝
服圖

Blue

Huangchao liqi tushi specifies that the emperor was to wear a blue coloured *chao pao* when 'praying at the Southern Altar'. This refers to the Altar of Heaven (which still exists today), a triple-tiered, circular structure in the southern suburb of Peking. It was here that the emperor offered sacrifice to Shang di on the night of the winter solstice. On this occasion the emperor wore a blue *chao pao* trimmed with sable and completely lined with other furs. The lavish use of fur on this occasion was not simply for show. It should be remembered that the sacrifice to Heaven took place on the longest night of the year during the early hours of the morning. Soothill, in *The Hall of Light*, quotes one official who attended the rite as saying it was so cold that 'even the thickest furs failed to keep strong men from chilling to the marrow and, in some cases, from going to their graves'.

There were at least two other occasions on which the emperor was obliged to wear blue-coloured robes: at the prayers offered for rain at the Altar of Heaven during the first moon of summer, and the prayers for a good harvest offered at the beginning of spring in the Hall of Annual Prayers, a magnificent triple-roofed circular building a short distance from the Altar of Heaven.

Red

On a selected day in spring, a sacrifice was offered at the Altar of the Sun in the eastern suburb of Peking. The emperor rarely attended this ceremony. On the few occasions he did, the emperor was obliged to wear a red-coloured *chao pao*, although the Manchu emperors largely avoided wearing red. The red robes worn for the sacrifice to the Sun were the single exception to this rule. The reason for this aversion was the association of the colour with the previous dynasty, the Ming. The name of the Ming imperial clan was Zhu, which is also a character for red.

Pale Blue

The sacrifice to the Moon was offered on a selected day in autumn. Although this was also rarely attended by the emperor himself, *Huangchao liqi tushi* made provision for his ritual dress on this occasion. It specifies that the emperor should wear a *chao pao* of 'moonlight' colour. The silk offerings and ritual jades used at this sacrifice were white. White was a colour associated with mourning, however, and therefore inappropriate for imperial use since anybody who was observing the period of mourning for a close relative was expressly forbidden to attend an imperial sacrifice. For this reason, the emperor wore palest blue instead of white.

Yellow

The emperor wore a yellow-coloured *chao pao* for the great sacrifice to Earth each year at the summer solstice. The Chinese have associated yellow with the earth ever since the first Neolithic settlers began tilling the loess soil of the Yellow River basin. Yellow robes were also worn for all other rituals connected with the worship of the earth, including the sacrifices to She and Qi and to Shennong, the Patron of Agriculture.

Huangchao liqi tushi indicates that the emperor should wear yellow robes for ceremonies at which the colour of his dress was not otherwise specified. The most important of these occasions was the *da chao* or 'grand audience'. The *da chao* took place at dawn in the Hall of Supreme Harmony, the largest of the three main throne rooms in the imperial palace. *Da chao* were normally held following imperial sacrifices of the highest order, at New Year, and on other important occasions in the emperor's reign such as his enthronement, marriage and the celebration of great victories.

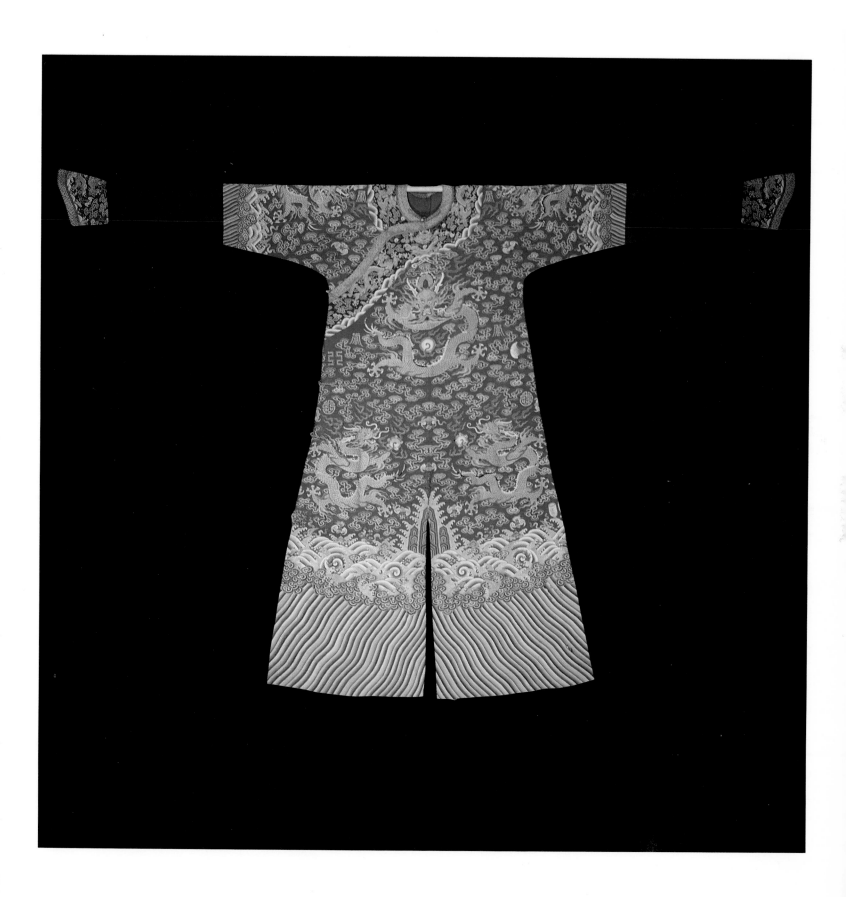

Pl.46 Emperor's *long pao*
This blue imperial *long pao* may have been used in
connection with a sacrifice at the Altar of Heaven.
Linda Wrigglesworth

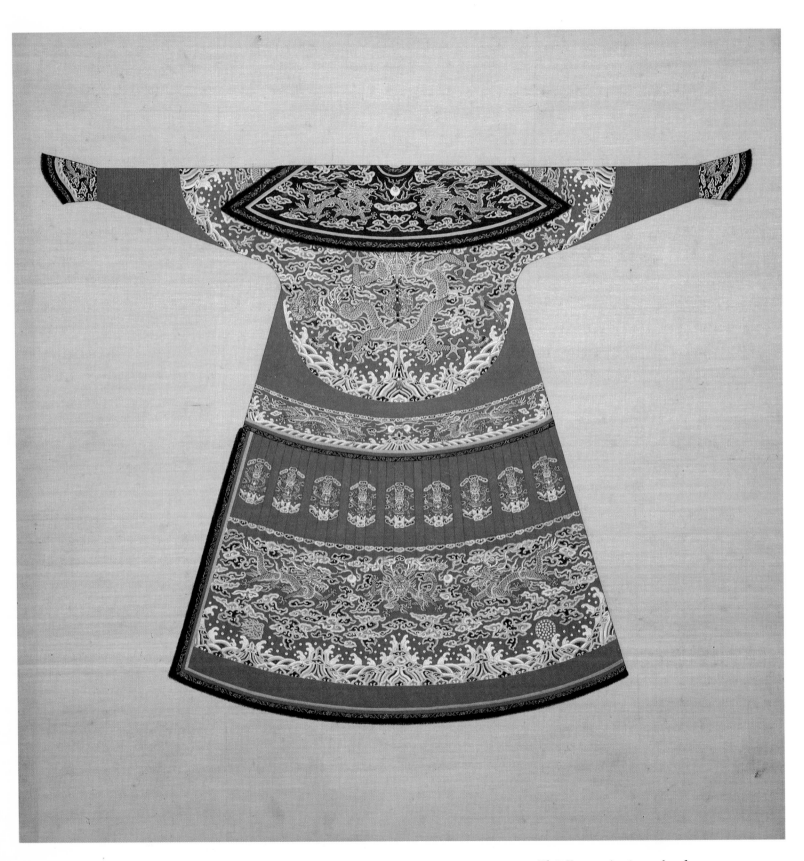

Pl.47 Emperor's winter *chao fu*
Painting on silk showing a back view of the
emperor's red winter *chao fu* for the sacrifice to
the Sun.
V&A

Seasonal Changes of Court Dress

The outlook of the first black-haired settlers in the Yellow River valley was conditioned by the progression of the seasons, the consequent changes in the weather and patterns in the rainfall. They believed that there was order and symmetry in the laws of nature. By imitating these processes they hoped to live in harmony with the forces that caused the seasons to change from one into another. Seasonal changes of dress therefore assumed great significance in China.

These seasonal changes were strictly regulated. All court dress was divided into two categories, winter and summer costume, with minor variations in weight to compensate for the arrival of spring and the onset of autumn. The point at which the change-over between winter and summer dress was made was considered to be very important. It was marked by the transfer between the type of hats worn during these seasons. The Board of Ritual decided on the day the exchange of 'warm' and 'cool' hats was to take place and advised the imperial household. The master of ceremonies then formally requested the emperor to name the date, which was announced well in advance by an imperial edict. The public followed suit as far as possible.

Huangchao liqi tushi proposes a number of dates when these changes should take place to ensure that the emperor wore the appropriate weight of dress for the season during which each of his most important ritual duties occurred. It tells us that, from the first day of the eleventh moon until New Year's Day, the emperor wore his black fox hat with fur-lined robes. Lighter fur-trimmed dress was worn with the sable hat until the fifteenth or twenty-fifth day of the third moon, when the court exchanged winter for summer dress.

Summer robes were either lined with silk or made of gauze. Silk-lined robes were worn during late spring and early autumn. *Huangchao liqi tushi* does not give us a date when gauze summer robes were worn. However, at the beginning of the fifth moon the emperor presented all high officials in the capital with bolts of 'grass linen' or ramie, a lightweight material made from a stingless nettle. This material was tailored into the long white undergarments worn beneath summer gauze. Silk-lined dress probably came into use during the seventh moon with the onset of autumn. Fur-trimmed winter dress was donned on either the fifteenth or twenty-fifth day of the ninth moon, and the annual cycle of seasonal changes began all over again on the first day of the eleventh moon (see Table 2).

The dates *Huangchao liqi tushi* proposes for the seasonal changes of court dress are full of significance. The major changes were made during months with odd numerical values. In Chinese numerology odd and even numbers represented *yang* and *yin*, the dynamic and static, or bright and dark factors in the cosmic equation. The period between the winter solstice and summer solstice was dominated by *yang*. During the remaining months of the year, *yin* gained ascendancy.

The exchanges of court dress indicated an active response to the passage of the seasons and were probably, therefore, considered more appropriate during odd-numbered months. The changes between summer and winter dress were fixed in the third and ninth moons respectively. Both three and nine (three times three) were particularly significant numbers. The sum of three and nine is, of course, 12, the number of moons in an ordinary year. During a 'long' year with an intercalary month, the extra moon was double-counted with another month. However, the intercalation always had to be made in such a way that the solstices, the points at which the polarity of the year changed, always fell in the odd-numbered fifth and eleventh moons.

The choice of either the fifteenth or twenty-fifth days of the third and ninth moons for the adoption of summer and winter court dress is also interesting. Both were odd-numbered days. The fifteenth day of a lunar month roughly corresponds with the time of the full moon and, because of the fluctuations in the length of the lunar cycle, the twenty-fifth day is invariably the last odd-numbered day before the 'dark' of the moon. Which of these

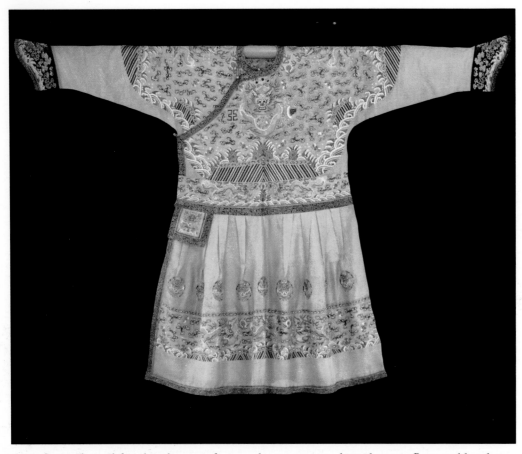

Pl.48 Emperor's summer *chao pao*
During the height of summer the emperor wore
court robes made of gauze.
Metropolitan Museum of Art

dates was selected for the change of court dress seems to have been influenced by the division of the year into 24 periods called the 'joints and breaths'.

The 24 joints and breaths of the year were the basis of the ancient agricultural calendar on which the farming community relied implicitly for sowing and harvesting. People who have lived in the north of China say that this almanac predicts with remarkable accuracy changes in the weather patterns. This may be one of the reasons why the changes of winter and summer dress appear to be linked with the 24 joints and breaths. However, there may have been other symbolic reasons.

Each joint and breath corresponded with the sun's progression through 15 degrees of each zodiacal sign (see Table 3). Some of the 24 joints and breaths have descriptive names that give some indication of the weather conditions prevailing under their aegis. Others mark the solstices and equinoxes or the beginning of the four seasons. As it would have been considered quite inappropriate for the Son of Heaven to have continued wearing one season's dress after the advent of another, the periods called *Li xia* or 'Beginning of summer' and *Li dong* or 'Beginning of winter' are of particular interest to us here.

Because the official calendar was based on the variable cycles of the moon and the 24 joints and breaths were calculated on the sun's motion, the two almanacs were often out of synchronization. The choice of either the fifteenth or twenty-fifth days of the third and ninth moons allowed the exchanges between summer and winter dress to be adjusted annually so that they always fell as close as possible to *Li xia* and *Li dong*. The other exchanges of court dress in the first, fifth and eleventh moons were less vital as they were only variations in the weight of summer and winter dress. The New Year festivities were probably considered more important than *Li chun*, 'Beginning of spring', although there are some reports that provincial officials did, in fact, exchange fur-lined for fur-trimmed robes on that day. But the choice of first days of the fifth and eleventh moons would have ensured that the proper type of court dress was worn for the sacrifices offered by the emperor himself at the solstices that always fell during those two months.

Pl.49 Winter dragon robe
The use of fur as a lining was probably introduced by
the Manchu. Traditionally, during the winter
months the Chinese wore additional layers of clothes
padded with cotton or silk floss.
Linda Wrigglesworth

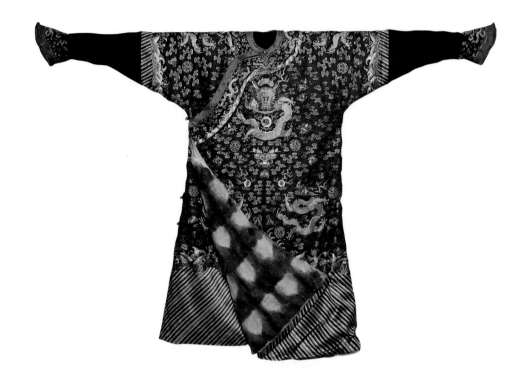

Pl.50 Detail of winter dragon robe
Robes completely lined with expensive furs were
uncommon. Normally the garment was lined with
fleece and mink was used only as an edging or a
lining for the cuffs.
Linda Wrigglesworth

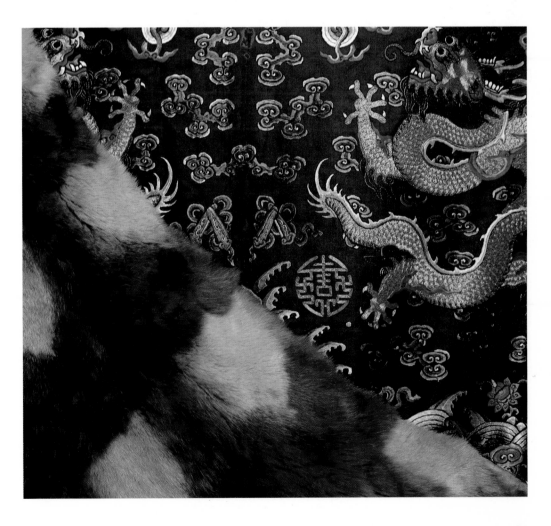

Table 2: The Seasonal Changes of the Emperor's Court Dress

Lunar Date of Change	Weight of Court Dress
First day of first moon	winter robes lined with silk and trimmed with sable; winter hat faced with sable
Fifteenth or twenty-fifth day of the third moon	summer robes lined with silk; summer hat
First day of fifth moon	summer robes made of gauze; summer hat
First day of the seventh moon	summer robes lined with silk; summer hat
Fifteenth or twenty-fifth day of the ninth moon	winter robes lined with silk and trimmed moon with sable; winter hat faced with sable
First day of eleventh moon	winter robes lined with fur and trimmed with sable; winter hat faced with black fox

Table 3: The 24 Joints and Breaths of the Year

Name		Sun's Position
Li chun	beginning of spring	15 Aquarius
Yu shui	rain-water	1 Pisces
Jing zhe	awakening insects	15 Pisces
Chun fen	spring equinox	1 Aries
Qing ming	pure brightness	15 Aries
Gu yu	corn rain	1 Taurus
Li xia	beginning of summer	15 Taurus
Xiao man	ripening grain	1 Gemini
Mang zhong	corn in ear	15 Gemini
Xia zhi	summer solstice	1 Cancer
Xiao shu	small heat	15 Cancer
Da shu	great heat	1 Leo
Li qiu	beginning of autumn	15 Leo
Chu shu	limit of heat	1 Virgo
Bai lu	white dew	15 Virgo
Qiu fen	autumn equinox	1 Libra
Han lu	cold dew	15 Libra
Shuang jiang	hoar frost	1 Scorpio
Li dong	beginning of winter	15 Scorpio
Xiao xue	small snow	1 Sagittarius
Da xue	great snow	15 Sagittarius
Dong zhi	winter solstice	1 Capricorn
Xiao han	small cold	15 Capricorn
Da han	great cold	1 Aquarius

Pl.51 Imperial prince
This commemorative or 'ancestral' portrait shows an
imperial prince of the first degree wearing winter
chao fu.
Sotheby's

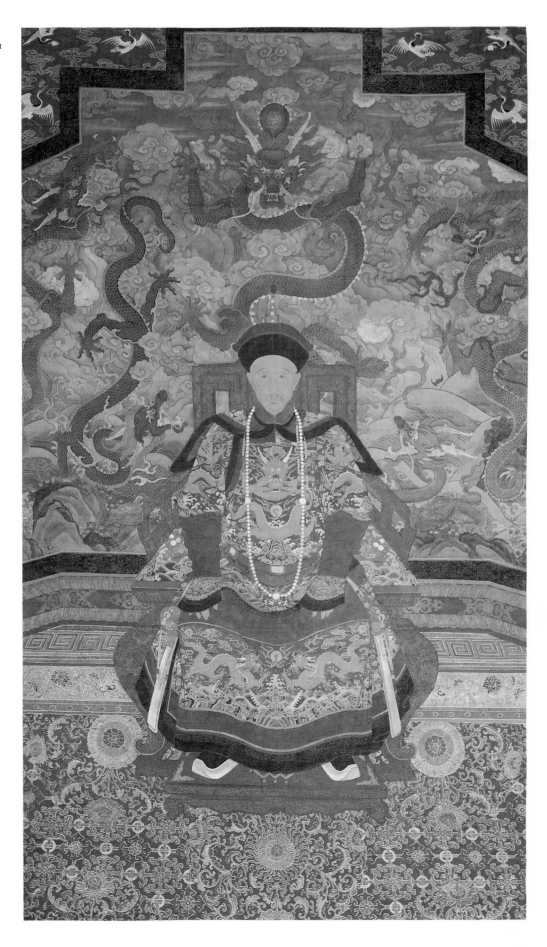

Court Dress as Cerements

In 1892, J. J. M. De Groot published the first of six volumes of *The Religious System of China*. In Chapter 3, he discusses in some detail the customs associated with burial dress, euphemistically called 'clothing laid out for old age'. Based on his experiences in Fujian province, and particularly the districts around the treaty port of Xiamen (formerly Amoy), his references to the use of court dress as grave clothes throw new light on their function as ceremonial garments outside the specific context of court ritual.

In China, common practice required that provision be made during life for burial dress. A large model of an official boot with an exaggerated high sole was the distinctive sign of shops specializing in such clothes. As well, established custom prescribed that the dead be buried wearing either brand new garments or the finest suit of clothes possessed when alive. Generally, this included a set of white undergarments, the *nei tao* or inner tunic, *wai tao* or outer tunic, a hat, and a pair of boots (see The Imperial Wardrobe). De Groot observed that the underclothes, 'garments that cover the flesh', were commonly made of a 'costly silken stuff of white colour, soft and glossy like velvet and commanding a high price in the market. This is to prevent the skin from being injured by contact with the clothes, and so to give comfort to the dead in his grave'. Some people, however, only provided the outer garments for their burial dress, leaving their relatives to procure the underclothes immediately after death. Despite the cost of the material, these undergarments were often hastily prepared and simply pasted together with starch.

Naturally, officials were interred wearing court costume. It was hoped that, dressed in this way, their appearance would continue to assure them the privileges they had enjoyed in life. De Groot notes, however, that it was 'by no means necessary to procure a brand new set of these garments. Official robes are, in fact, always made of such exquisite silk and, relatively speaking, so seldom worn, that the best suit the dead man possesses is always quite good enough to be worn to the grave.' For those without official rank, their burial dress consisted of a formal costume usually worn for the ceremony of obligatory sacrifices offered to their ancestors.

During the Qing period official rank, without entitlement to office, could be openly purchased by those wishing to increase their personal prestige. Merchants in particular, who were a despised class in Confucian society, often took advantage of this opportunity. De Groot also mentions this practice in relation to burial dress. He states that:

...nearly every man who can afford the expense permits himself the fashionable luxury of buying an official degree, and becomes thereby entitled to wear, both in this world and the next, on the breast and back of the outer cloak a square piece of silk embroidered with the insignia of his rank in the shape of a bird or quadruped. Never does the family neglect to adorn the dead with these badges, everybody being firmly convinced that they will give him also beyond the grave the mark of a man of distinction.

Taboos

There were a number of taboos relating to burial dress. For instance, although the deceased could be dressed in clothes he had already worn in life, there was a strict prohibition against the clothes being borrowed and worn by another person for the purpose of offering sacrifices to his own ancestors. This restriction was consistent with a more general ban on all forms of sacrifice to anyone but one's own forefathers. De Groot remarks on the consequences of not adhering to this regulation:

...it is not even allowed to contribute to other people's sacrifices by lending them a sacerdotal dress, and if the man who has committed such an unfilial act should venture to appear in that very dress before his ancestors, he would certainly run the risk of his crime being discovered, and be severely punished.

The winter season, being cold and dark, was associated with death and this is probably why the dead were never buried in summer clothes. This practice could be the reason that so few winter court robes, particularly *chao pao*, are found in today's collections of Qing

Pl.52 *Bai shou yi*
Persons without official rank were usually buried
wearing elaborate garments decorated with
auspicious symbols. The *bai shou yi*, 'the robe of 100
longevity symbols', takes its name from the repeated
use of the character *shou* in the design.
Private collection

69

costume, and why officials are usually depicted wearing winter court dress in their commemorative or 'ancestral' portraits.

Another taboo required that metal buttons on garments be removed from burial clothes and replaced with either cord knots or cloth ties. It was thought that metal buttons would damage the corpse and cause the dead person discomfort. As well, the number of layers of garments in which the dead could be buried was strictly regulated. Typically, the Chinese wore several layers of clothing, and in common parlance, the coldness of a winter's morning was measured by the number of layers it took to keep warm. When interring the dead, five layers of burial dress was considered very unlucky since a homophone for the character 'five', *wu*, means 'to cause evil involuntarily'. This taboo was rooted in the belief that objects placed in the tomb of the deceased could affect the lives of the surviving relatives, and this resulted in a tendency to cover grave clothes in auspicious symbols.

Shen yi

Wealthy people without official rank could also be buried wearing a *shen yi* or 'deep garment'. De Groot says that it bore this name because, when worn, 'it *deeply* concealed the body', implying that it was longer than a court robe. The *shen yi* was believed to be based on an ancient form of court robe called a *pao*. The *shen yi* was a capacious robe with bell-shaped sleeves (in contrast to the narrow, tapered sleeves of Qing styles of costume) and could have either a right-hand side or centre-front closure. It was usually dark blue in colour with a broad border of white or pale blue. The *shen yi* was always worn with a hood called a *fu jin* which completely covered the head leaving only the face exposed.

Bai shou yi

The *bai shou yi* or 'robe of one hundred longevity symbols' was a particularly elaborate form of *shen yi*. It derived its name from the repeated use of various forms of the character *shou*, which means 'long life', in the decoration of the garment. The *bai shou yi* was thought to be imbued with the power to extend life and was normally presented as a gift to an ageing parent by dutiful sons. A family would procure the finest silk from Shanghai or Suzhou and engage a well-known tailor to make the garment. De Groot says that many people had the garment cut out and sewn by an unmarried girl or a very young woman, 'wisely calculating that, whereas such a person is likely to live still a great number of years, a part of her capacity to live still long must surely pass into the clothes, and thus put off for many years the moment when they shall be required for use'. It was even more preferable if the robe were made in a long year with an intercalary month.

The *bai shou yi* could be worn by either sex. But, because of the male preference for being interred wearing court attire, it was chiefly used by women as burial dress. Such women's garments usually took the form of short jackets, rather than full-length robes, so that they could be worn with pleated skirts. Several examples of women's *bai shou yi* survive. Many of them show significant borrowings from the motifs of court dress. The ground of one such coat is decorated with 100 small *shou* characters in various styles. Arranged symmetrically on the body of the coat are also medallions composed of large circular *shou* characters in archaic seal form surrounded by stylised bats. In this respect, the coat resembles the decoration of the *pu fu* of officials' wives. Another example is perhaps more striking. In addition to the 100 *shou* characters, this coat is decorated on the front and back with insignia squares displaying a white crane. This *bai shou yi* may have been intended as a gift for the wife of a first-rank civil official.

Pl.53 Surcoat of an official's wife
Painting on silk of the wife of a low-ranking official.
Private collection

Pl.54 *Bai shou yi*
This example of a *bai shou yi* has insignia badges
appropriate to the first civil rank applied to front and
back. This garment was made for a woman, probably
the wife of a first-rank official.
Linda Wrigglesworth

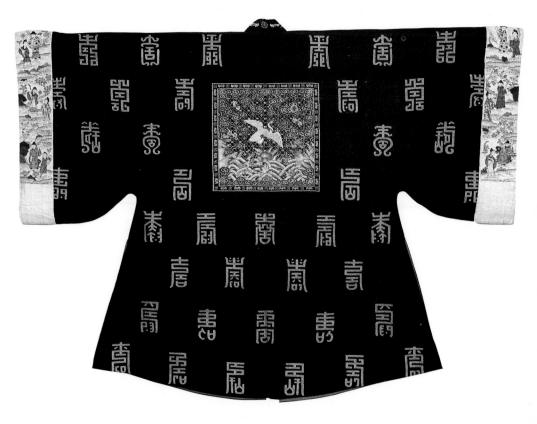

Tomb Robes

Several important collections of Qing textiles include robes believed to have been removed from tombs of the imperial nobility. Among them is the so-called Hundred Cranes Robe, one of nine garments in the Nelson-Atkins collection reputed to have been plundered from the tomb of Yinli (1697–1738), Guo Jinwang, after the revolution of 1911. This robe is deservedly one of the most famous examples of court dress dating from the Qing period and is a masterpiece of the embroiderer's art, evoking the splendour of the Qing dynasty at the height of its power and prestige. The design is embroidered onto the brocade ground which is figured with a cloud pattern. Graceful white cranes fly among the vaporous clouds and *long* writhe within roundels. Elegant pines cling to fantastic outcrops of rock which rise out of the sea of water motifs around the hem.

In 'The Kuo Ch'in-wang Textiles', Lindsay Hughes says that the Hundred Cranes Robe and others reputed to have come from Prince Guo's tomb were acquired in Peking in 1934 by Laurence Sickman, Curator of Oriental Art at the former William Rockhill Nelson Gallery and Atkins Museum of Art. The agents who showed him the textiles informed Sickman that for several years the cache had been secreted away in the homes of peasants. Other objects reputed to have come from the tomb included four fans decorated by notable contemporaries of Prince Guo. As proof of their origin, Sickman was shown the spirit tablets of Prince Guo and two of his consorts. These wooden tablets bore their names in Chinese and Manchu and would have been the focus of rituals connected with the cult of ancestors.

The imperial nobility of the Qing period constructed elaborate mausoleums with mortuary temples above ground, where the spirit tablets were kept, and subterranean 'palaces' in which the bodies were interred along with treasured personal possessions. A number of important imperial tombs were despoiled after the revolution in 1911. In 1928, a warlord by the name of Sun Tianying, robbed the Qianlong Emperor of all the treasures buried with him. The commission appointed by the Republican government to restore the damage discovered the remains of the Emperor and his consorts scattered around the burial chamber. Among the funerary objects left behind by the grave-robbers were articles made of silk so badly damaged that they were virtually unidentifiable. However, a recent Chinese publication, *The Imperial Mausoleums of the Qing Period* (see Bibliography), illustrates some well-preserved articles of court dress uncovered by archaeological excavations of the tombs.

Unfortunately, the claim that the Hundred Cranes Robe came from the tomb of Prince Guo cannot be absolutely verified. The robe has suffered from the ravages of damp, which is consistent with its supposed 200-year interment. It is also interesting to note that the robe is decorated with 100 cranes, themselves symbols of longevity. As noted above, the *bai shou yi* was a burial garment. However, the Hundred Cranes Robe would not have been used to dress the dead as it is a semi-formal type of garment. The Prince and his wives would have undoubtedly been buried in full *chao fu*. Certain features of the robe, namely its lack of front and rear vents and the additional bands of dragons between the upper and lower sections of the sleeves, indicate that it was originally tailored for a woman, perhaps one of Prince Guo's consorts.

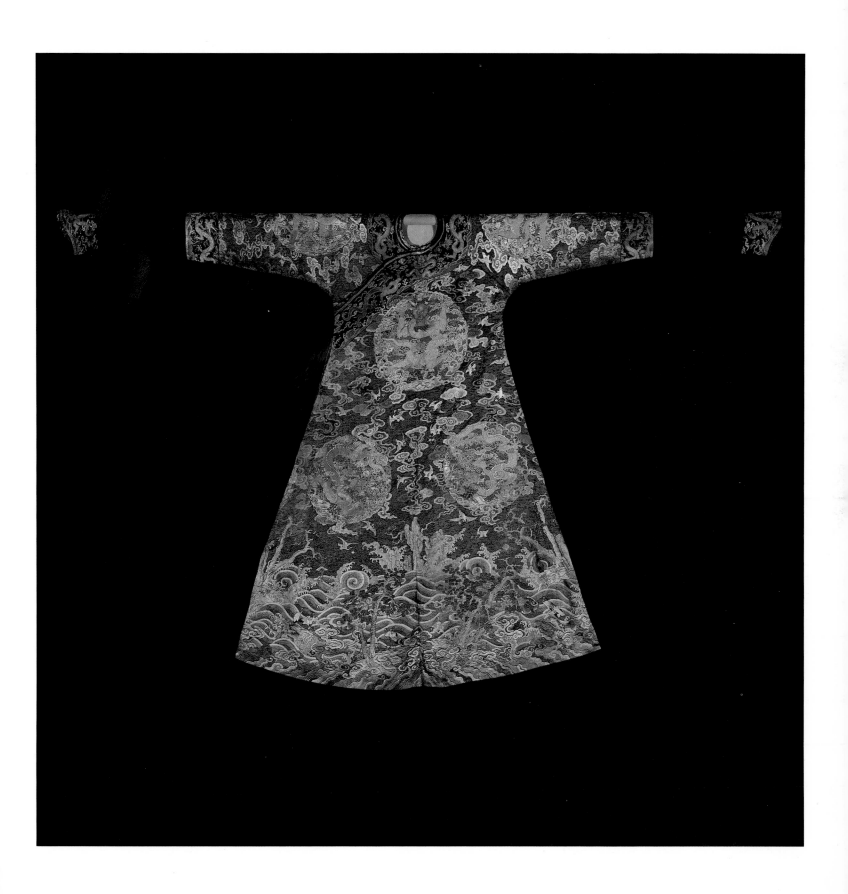

Pl.55 Hundred Cranes Robe
The so-called Hundred Cranes Robe, reputed to
have been taken from the tomb of Guo Jinwang.
Nelson-Atkins Museum

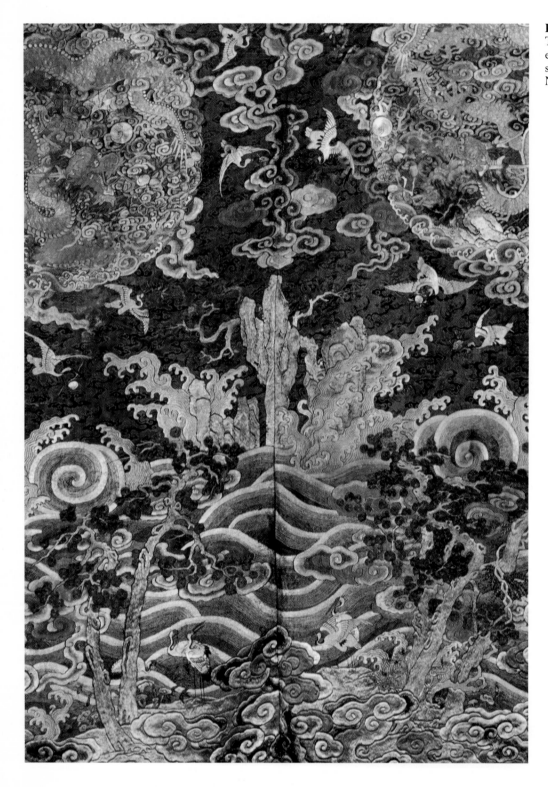

Pl.56 Detail of the Hundred Cranes Robe
The design of this magnificent robe has some exquisite features such as the musical tones suspended from the branches of the pine trees. Nelson-Atkins Museum

THE TWELVE SYMBOLS

The Twelve Symbols

The Dragon Motif

The principal motif emblazoned on almost all court robes was the dragon. The dragon was the personal emblem of the emperor; in the language of the court, the word 'dragon' was used to describe everything connected with his life and position. The emperor's face was reverently referred to as the 'dragon's countenance', his seat of power as the 'dragon throne', and even such everyday things as his writing implement became the 'dragon's brush'. Before his accession, the emperor had been a 'dragon hidden in the depths' and after his death, he 'became a dragon again'.

The dragon was originally conceived as a benevolent rain spirit who came out of hibernation in spring and manifested himself as a thundery shower. It was in their capacity as rain-makers that the ancient kings of China first became associated with the legendary creature. Even during the Qing period the emperor was considered responsible for ensuring that there was an adequate rainfall for the germination of the peasants' crops.

The Five Colours

On court robes, the dragon is found writhing amid cloud motifs. *Huangchao liqi tushi* stipulates that the clouds on an emperor's robe are to be of five colours. The same regulation seems to have applied to the robes of all members of the imperial family, and

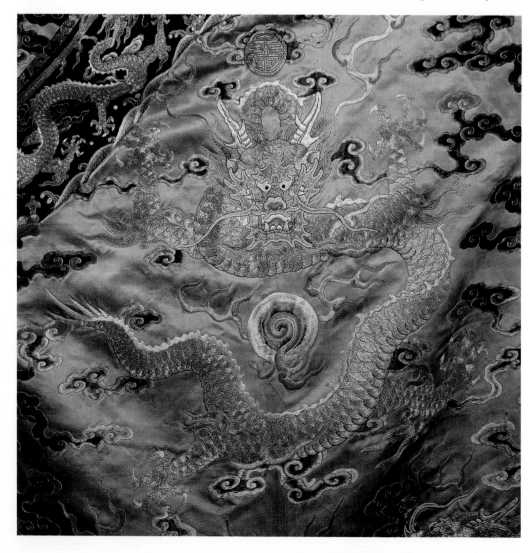

Pl.58 The Dragon
The court robes of all but the lowest ranks of official were decorated with the Dragon, a symbol of imperial power.
Linda Wrigglesworth

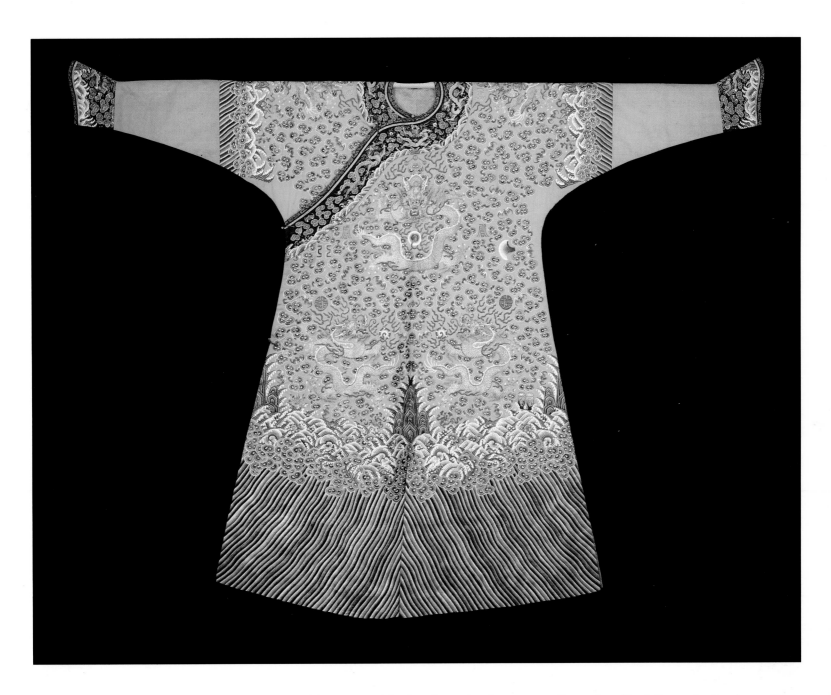

Pl.57 The Twelve Symbols
This imperial winter *long pao* is slightly padded with silk floss. Although the Twelve Symbols of Imperial Authority seem almost insignificant in the scheme of the robe's design, they were the exclusive preserve of the emperor.
Private collection

on Qing imperial robes these clouds were usually rendered in delicate shades. According to tradition, the five colours were blue, red, yellow, white and black.

The five colours represent the *wu xing* or five activities: wood, fire, earth, metal and water. Like the Platonic elements of classical western antiquity, the *wu xing* were not the commonplace materials from which they took their names; they symbolized the qualities of these substances. For example, wood indicated growth and the vitality of flourishing vegetation. All phenomenal existence could be explained in terms of the interaction between the *wu xing*.

Each of the *wu xing* was associated with a season of the year and its influence was thought to emanate from a point of the compass. Wood was associated with spring and the east, fire with summer and the south, metal with autumn and the west, and water with winter and the north. Earth was the centre of gravity, the fifth point of the Chinese compass, and was associated with mid-summer. These traditional symbolic correspondences played an important role in imperial ritual for over 2,000 years.

Pl.59 The Rock
The pinnacles of rock emerging from the water motifs around the bottom of the design of Qing court robes are shown as either highly stylized peaks or, as here, in a semi-naturalistic manner.
Linda Wrigglesworth

The Water Motif

On Qing court robes, the clouds condense to form water motifs around the lower part of the pattern. Below a band of billowing waves, foam and spray, rippling diagonal stripes represent deep water. Triple-peaked mountains rise out of this turbulent sea of water motifs at the centre-front and back, and at the sides of the robe. The ancient Chinese conceived the earth as a landmass surrounded by four oceans.

The Twelve Symbols

Qing court robes are decorated with other symbols, each of which had significance for the wearer. None have given rise to more speculation than the so-called Twelve Symbols of Imperial Authority: the Sun, the Moon, the Constellation, the Rock, the *fu*, the Dragon, the Axe-head, the Flowery Creature, the Water Plant, the Sacrificial Vessels, the Flames, and the Grain. The origin of the Twelve Symbols is shrouded in myth. According to legend, the Yellow Emperor was the first of China's sovereigns to use them. When Shun, another legendary sage-emperor, called for the 'symbols of the men of old' to be emblazoned on his sacrificial robes, he added that they were to be rendered in the 'five colours'.

Pl.60 The Constellation & The Rock
Back view of the emperor's *long pao* in the 1766
block-printed edition of *Huangchao liqi tushi*
showing the Constellation symbol above the Rock at
the nape of the neck.
SOAS

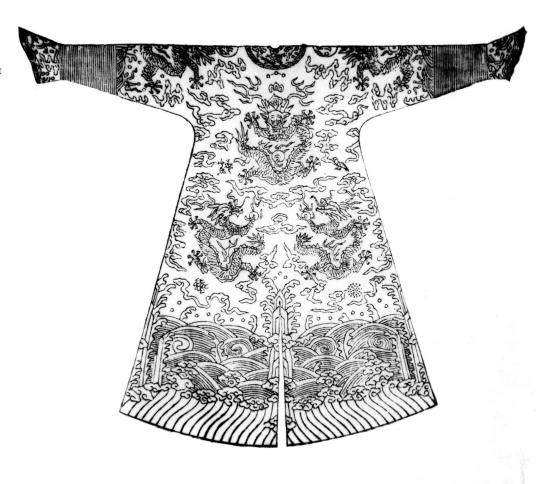

Historically, the emperors of every imperial dynasty from the great Han (206 BC–AD 220) to the Ming wore the Twelve Symbols. The early Manchu emperors appear to have avoided using them, probably because they were regarded as essentially a Chinese institution. But the symbols were restored as part of the imperial regalia by the Qianlong Emperor, appearing together for the first time on the design of Qing court robes in *Huangchao liqi tushi*.

Position of the symbols

Within the overall scheme of the robe's design, the Twelve Symbols of Imperial Authority seem almost insignificant. They are represented on Qing court robes in a slightly different form from their traditional configuration. The symbols are also shown singly, whereas the Ming emperors wore them all in pairs. Their position varies according to the type of robe. Generally, they are arranged in three groups of four. The Sun, Moon, Constellation and Rock are usually placed symmetrically around the neck opening with the Sun on the left shoulder and the Moon on the right shoulder, above the dragons' heads. On all surviving examples of Qing emperors' court robes, the Constellation and Rock are shown on the chest and back, above the heads of the principal dragons.

The illustrations of the emperor's *chao pao* in both the manuscript and 1766 block-printed versions of *Huangchao liqi tushi* depict a cloud formation above the head of the dragon on the chest where one would expect to see the Constellation. It is not possible from the illustrations to tell whether the Rock appears on the back because of the *pi ling* collar. The block-printed illustrations of the emperor's *long pao* do show both symbols on the back of the robe, the Constellation above the Rock. Unfortunately, the corresponding illustrations from the manuscript based on *Huangchao liqi tushi* have not come to light during our research.

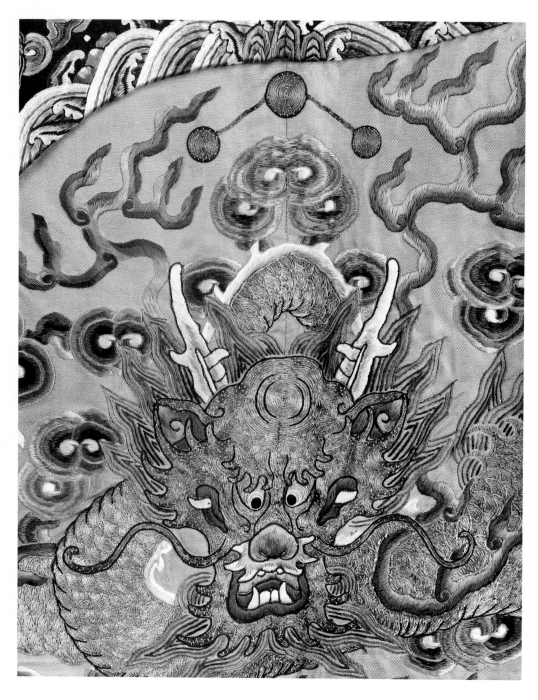

The second group of symbols is placed around the middle of the robe. Here, the surviving examples of imperial court robes and *Huangchao liqi tushi* are in agreement with regard to their position: the *fu* and Axe-head symbols are on the right- and left-hand sides at the front, a pair of little dragons appear on the left-hand side with the Flowery Creature on the right-hand side at the back.

The lowest group of symbols are arranged within the four-lobed yoke pattern on the bodice of the first style of winter *chao pao*. On the secondary form of winter *chao pao* and also on summer *chao pao*, they are dropped to the band of dragons on the skirt section of the robe (see Men's Court Robes). On an imperial *long pao*, these symbols appear on the crests of the wave motifs around the hem. In all cases, the Sacrificial Vessels and Water Plant are on the left- and right-hand sides at the front, and the Flames and the Grain are on the right and left sides at the back.

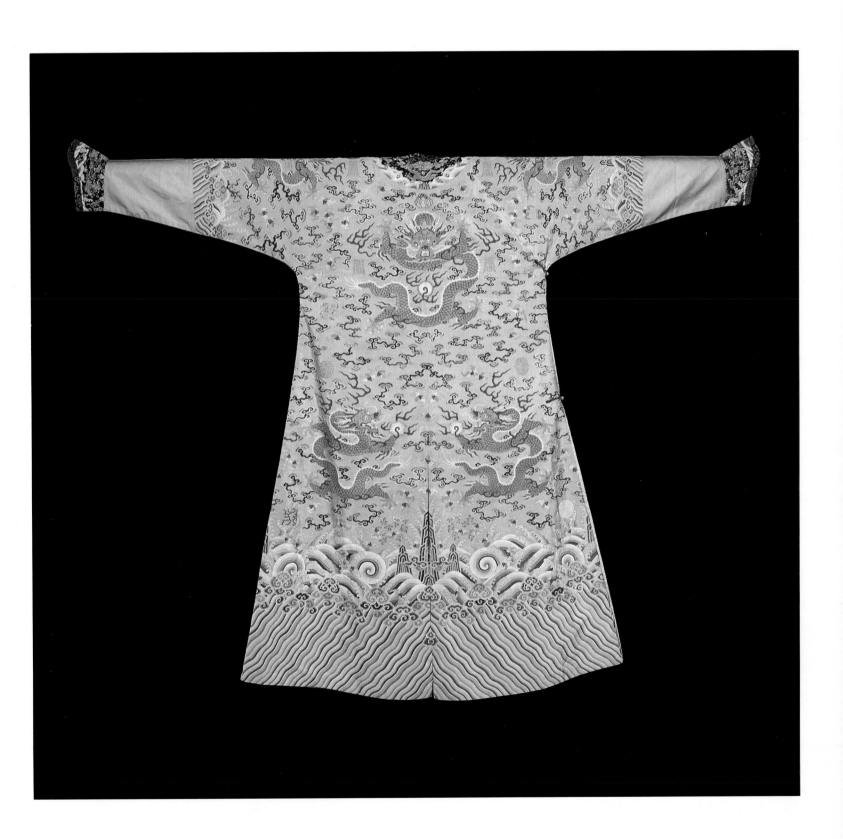

Pl.61 The Rock
Only the Rock symbol is shown at the nape of the
neck on surviving examples of imperial *long pao*. The
three stars of the Constellation symbol are invariably
placed on the chest.
Linda Wrigglesworth

Meaning of the symbols

Interpretation of this arrangement of the Twelve Symbols is extremely difficult. Although some later commentators assigned to each symbol one of the qualities possessed by an enlightened ruler, the original meaning of the symbols had been lost long before the Qing period. Considering that the Qing ritualists departed from the traditional form and arrangement of the Twelve Symbols, we must ask ourselves whether they placed a different interpretation on them.

In Chinese numerology 12 is an important number. During the Qing period, the Chinese recognized the 12 signs of the zodiac although they were named differently from those of the west. They also realized that the planet Jupiter moves through only one of these signs each year. The planet's 12-year circuit of the heavens was called the Great Year, and sacrifices to Jupiter, or the Year Star, were offered at the imperial Temple of Agriculture on the first day of the New Year. There were also 12 moons in the official calendar. Even during a long year with 13 lunations, the intercalary moon was double-counted with another month.

From ancient times, the Twelve Symbols were associated with the principal annual sacrifices offered by the emperor on behalf of the people at the great imperial altars. These important rituals were linked with the four major astronomical events in the year, the solstices and equinoxes. Scholars have long believed that the Twelve Symbols may originally have had an astronomical significance. In fact three of the first group of symbols – The Sun, Moon and Constellation – are all celestial bodies relating to the measurement of time.

The Sun and Moon

The Sun is represented on Qing robes as a red disc containing the image of a three-legged cockerel. It was this bird that heralded the dawn. Three was a prime symbol of *yang*, the active, male potency in Chinese cosmology. The Moon is depicted as a disc showing a hare pounding the elixir of life beneath a cassia tree. This refers to a popular Chinese legend that told of a white hare that inhabited the moon.

The first Chinese calendars were based on the cycles of the moon. During a period of approximately 28 days the moon waxes from crescent to full and then wanes. The sun's cycle is much longer. From the spring equinox to midsummer the days are longer than the nights. After the summer solstice the sun rises later and sets earlier until the days and nights are of equal length. After the autumn equinox the days become progressively shorter until mid-winter. At the winter solstice the sun appears to gain the upper hand and the days begin to draw out again. It is difficult for us today to comprehend the impression these natural occurrences would have made on the mind of ancient man.

The length of the moon's cycles vary. The lunar and solar terms are therefore often out of synchronization. As we have said, extra or intercalary months had to be added at regular intervals to correct the errors that occurred in the official lunar calendar. The eminent sinologist William Edward Soothill has described the history of the Chinese calendar as one of successive attempts to reconcile the movements of the sun and moon. Because of the fluctuation in the times of the sun and moon's rising and setting, the Chinese looked to the stars for a regulator with which to measure the passage of time.

The Constellation

On Qing court robes the Constellation is represented by three golden dots linked by red or gold lines. The symbol represents the handle of the Big Dipper or Ursa Major constellation. Some court robes also have the other four stars, forming the bowl of the Dipper, over the left shoulder. In ancient times Ursa Major was closer to mid-heaven than

Pl.62 The Sun
The Sun symbol is depicted on Qing imperial robes as a three-legged cockerel against a red disc.
Private collection

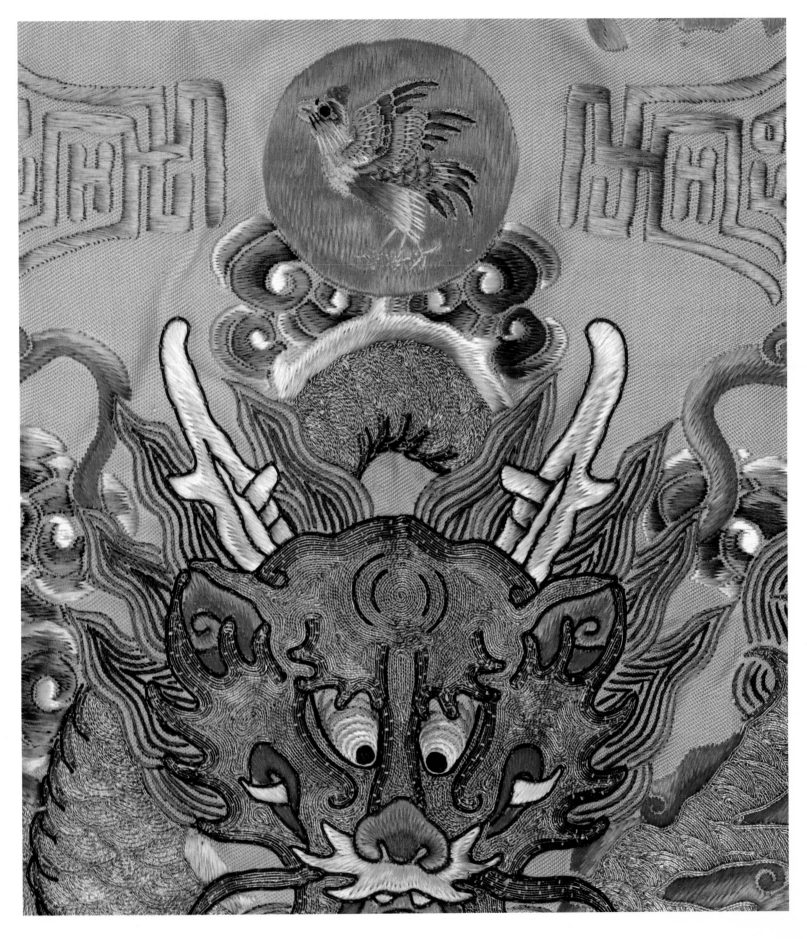

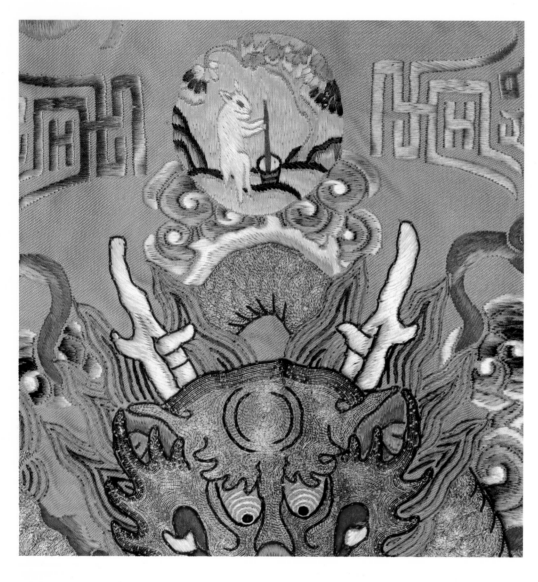

it is today and the constellation's movements were used as a kind of celestial clock. During one solar term Ursa Major turned through a full 360 degrees. At the vernal equinox the handle pointed due east, at the summer solstice the stars pointed south, and at the autumn equinox the handle pointed west. When Ursa Major pointed due north it was the winter solstice.

Since ancient times the position of Ursa Major dictated the Son of Heaven's stance during sacrificial rituals. Even as late as the Qing period, the emperor faced north when making offerings to Heaven at the winter solstice, south at the Altar of Earth for the summer solstice sacrifice, east for the Sacrifice to the Sun around the time of the spring equinox and west at the Altar of the Moon during autumn. The traditional correspondence between seasons of the year and the points of the compass also probably arose from the alignment of the handle of the Big Dipper: summer with the south, spring with the east, winter with the north, and autumn with the west.

On those ceremonial occasions when the emperor's stance was not dictated by ritual considerations, he sat facing south. In this position the four upper symbols on his robes were aligned with the points of the compass: the Sun on his left shoulder with the Altar of the Sun in the eastern suburb of the capital, the Constellation on his breast with the Altar of Heaven in the south, and the Moon on his right shoulder with the Altar of the Moon in the western suburb. The Rock at the nape of his neck would also have aligned with the Altar of Earth in the north.

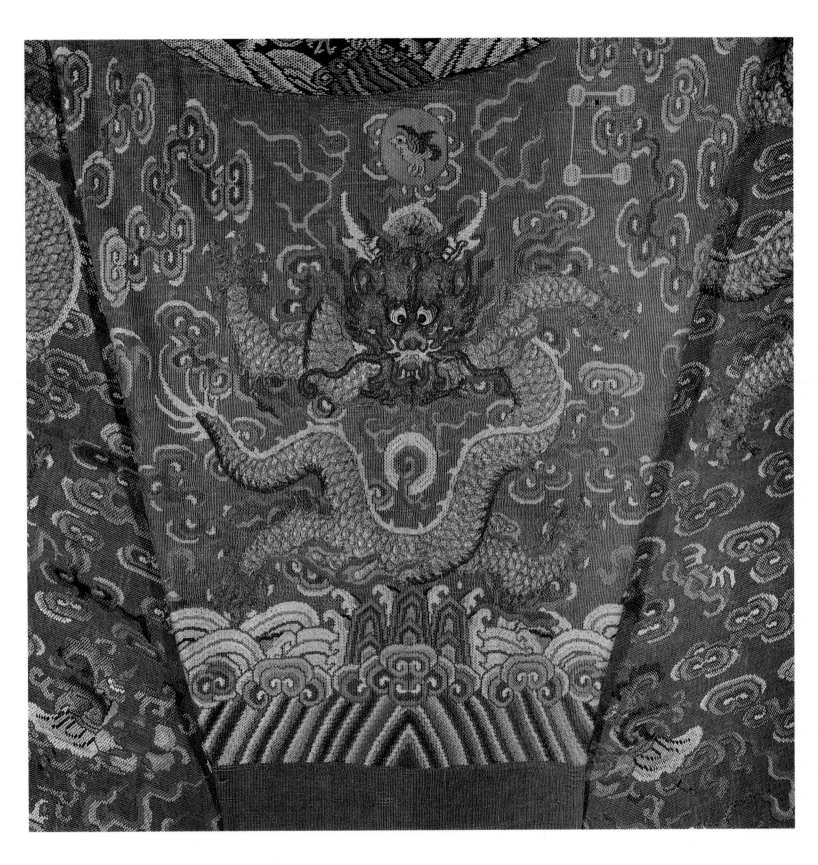

Pl.65 The Constellation & The Sun
Some rare examples of dragon robe display all seven
stars of Ursa Major. In this detail the four stars of
the bowl of the Big Dipper are shown.
Linda Wrigglesworth

The *fu*

The middle group of symbols on imperial court robes, which include the *fu*, are also four in number. They may therefore be associated with the four major astronomical events that profoundly influenced many ancient cultures: the equinoxes and solstices. The *fu* is perhaps one of the most intriguing of the Twelve Symbols. In the great Kangxi dictionary it is simply defined as the 'blue and black lines'. On Qing court robes it was always represented as two opposing blue lines. The *fu* symbol has also been linked by Soothill with a homophone meaning 'to forbid'. Another homophone on the character *fu* gives us 'return', a term used in connection with the winter solstice, when the days begin to grow longer.

The Dragon

The concept of the polarity of the year changing at a solstice is shown even more graphically by the Dragon symbol, represented as two tiny ascending and descending dragons. This symbol is placed diametrically opposite the *fu* symbol on the scheme of the robe, if we look at the pattern in plan view. When the four upper symbols are aligned with the imperial altars, there is also a correlation between the position of the *fu* and the Dragon, and the sun's rising and setting points at the solstices. At the winter solstice, the sun sets at the most south-westerly point on the ecliptic. At the summer solstice, the sun rises at the most north-easterly point on the horizon that it ever reaches during the year.

Pl.66 The *fu*
The *fu* symbol is represented on Qing robes as two
opposing blue lines.
Private collection

The Axe-head and Flowery Creature

If the *fu* and Dragon symbols relate to the winter and summer solstices, their position on the robe determines that of the symbols representing the equinoxes. These are marked by the Axe-head and the Flowery Creature, which fall exactly between the *fu* and the Dragon. The Axe-head was traditionally the symbol of the emperor's power over life and death. It is interesting to note that, in ancient times, executions were postponed until autumn. Although it is depicted as a golden pheasant on Qing court robes, some scholars believe that the Flowery Creature may represent the constellation that the Chinese called Red Bird. This group of stars dominated the southern hemisphere from late spring to summer.

Pl.68 The Axe-head
The Axe-head was traditionally an emblem of
sovereignty and the emperor's power over the life
and death of his subjects.
Private collection

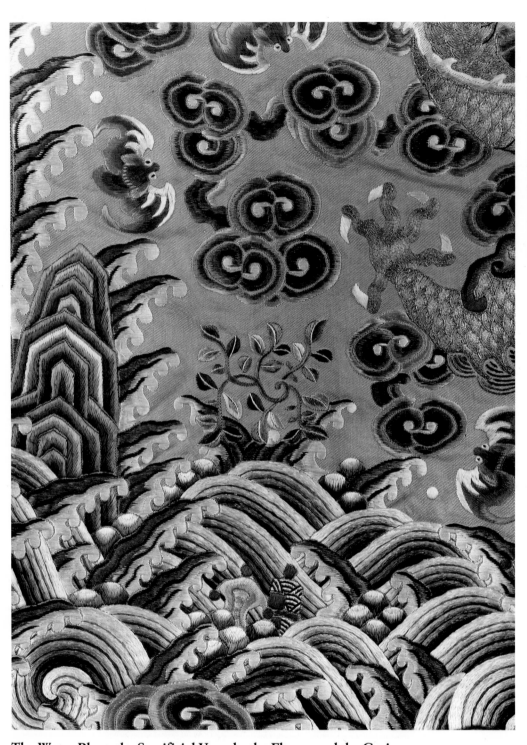

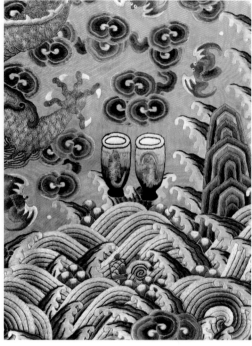

Pl.71 The Sacrificial Vessels
These are depicted on Qing robes showing two
strange tiger-like animals. The tiger was traditionally
associated with the metal element and the west. This
would support the theory that the four lowest
symbols together with the rock represent the
wu xing.
Private collection

Pl.70 The Water Plant
The Water Plant traditionally represented purity.
Private collection

The Water Plant, the Sacrificial Vessels, the Flames and the Grain

The lowest symbols on Qing robes can be correlated with four of the *wu xing*: water,
metal, fire and wood. The Water Plant, which is aligned with the *fu* symbol, may
represent water. This element was associated with winter and would appear to support
the idea that the *fu* represented the winter solstice. There should, therefore, be a similar
correspondence in the alignment of the other symbols. The Sacrificial Vessels may
represent metal and are aligned with the Axe-head, which we have associated with the
autumn equinox. The Flames would appear to represent fire and are aligned with the
paired dragons, symbolizing the summer solstice. The Grain, symbolizing wood, is
aligned with the Flowery Creature, which we have tentatively associated with the spring
equinox.

Pl.72 The Flames
This symbol probably represents the fire element.
Private collection

Pl.73 The Grain
This symbol is depicted as a dish containing 60 grains of millet, traditionally the first cereal crop raised in China.
Private collection

The Rock

The Rock, which actually appears on the back of the robe at the nape of the neck, probably represents the fifth element, earth. It should be remembered that, in *Huangchao liqi tushi*, the Rock is shown below the Constellation which may indicate that it represented the position of the wearer himself at the centre of the scheme. Earth was the centre of gravity, the fifth point of the Chinese compass. According to the great Confucian philosopher Mencius, the role of the Son of Heaven was to 'stand at the centre and stabilize the four quarters'. This would explain why the emperor wore yellow, the colour traditionally associated with earth, on those occasions when the colour of his dress was not otherwise specified.

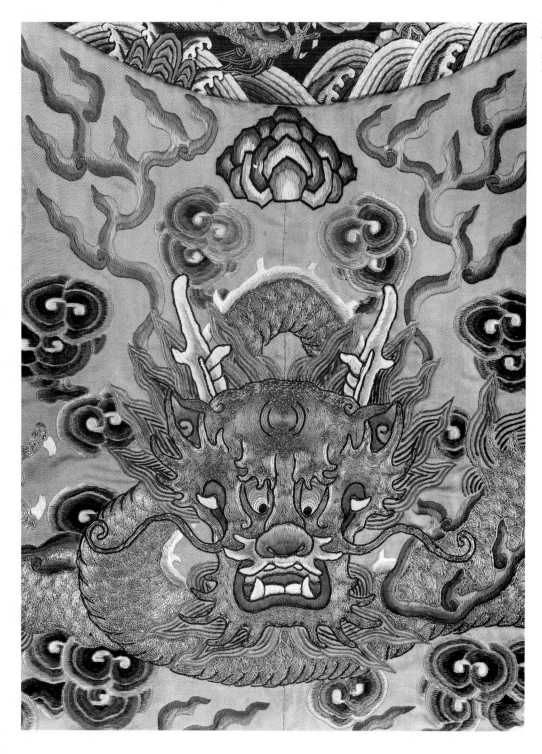

Pl.74 The Rock
The Rock symbol at the nape of the neck probably
represents the element earth.
Private collection

If we associate the Rock with the four lowest symbols on the robe and the *wu xing*, the
Twelve Symbols fall into groups of three, four and five. Three multiplied by four
multiplied again by five gives us 60. The Grain symbol itself is depicted as 60 grains
arranged in concentric circles. Sixty was the number of years in a complete ritual cycle,
representing a man's lifetime. Qianlong himself 'abdicated' after a reign of 60 years.

Pl.75 Woman's Twelve Symbol Robe
Photograph of the Empress Dowager Cixi wearing what is probably a Twelve Symbol dragon robe. The Constellation, Sun and Moon are clearly visible and the Sacrificial Vessels and Water Plant can be glimpsed above the water motifs at the bottom of the robe.
Freer Gallery of Art

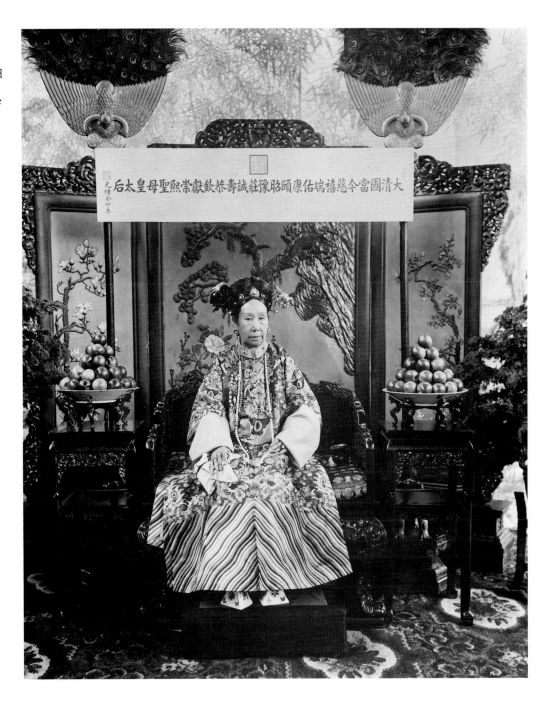

Women's Twelve Symbol Robes

It appears that *Huangchao liqi tushi* restricted the use of the Twelve Symbols to the emperor, from the absence of the symbols from the designs of the court robes of the empress and even the crown prince. We can therefore say that no other rank of noble was permitted to use all or any of the Twelve Symbols. Nevertheless, the emperor could, if he so wished, apparently confer the right to use even this highest distinction as a mark of favour.

In European and American collections, both public and private, there are a number of Qing court robes, in various colours and tailored for both men and women, which bear 12, 8, 4 or even 2 of these ancient symbols. Most of these robes date from the second half of the nineteenth century. Those that have all Twelve Symbols and were made for women

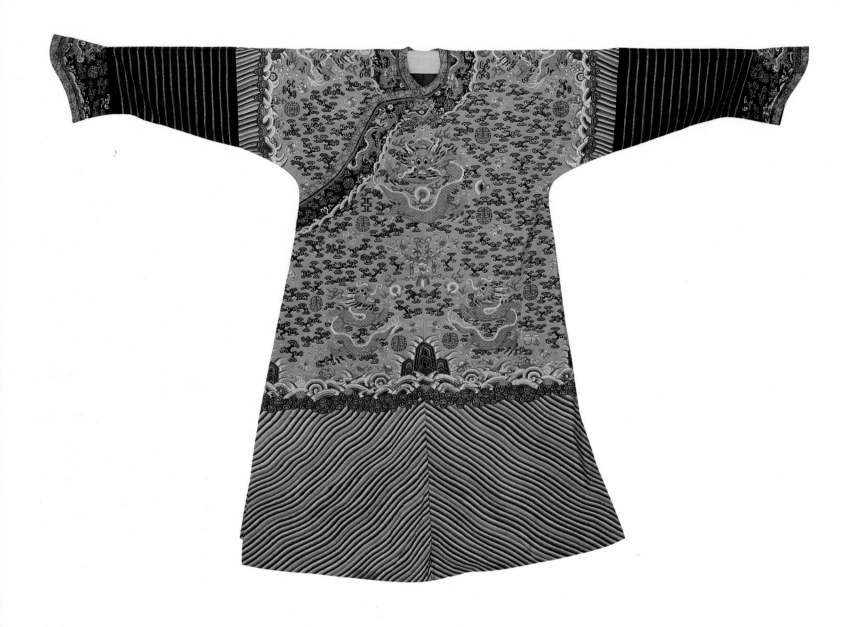

usually have a yellow ground. It seems most likely that these were worn by an empress or an empress dowager and there is some evidence to support this view. We know, for example, that the Empress Dowager Xiaoho, a widow of the Jiaqing Emperor, wore dragon robes with at least three of the four highest symbols. A portrait of this formidable Manchu matriarch shows the Constellation, the Sun and the Moon. Photographs also survive of the Empress Dowager Cixi (1835–1908) wearing what appears to be a dragon robe displaying all Twelve Symbols.

Women's orange- and maroon-coloured court robes have also come down to us bearing fewer symbols. The colours of the these robes indicate that they were probably worn by secondary consorts of the emperor. One of the most interesting has a turquoise-green ground with silver-faced dragons. The Sun and Moon appear in their usual places on the left and right shoulders. All seven stars of Ursa Major are shown on the back of the robe, split into two groups: the four stars of the Dipper itself behind the Sun and the three star handle near the Moon. The front of the robe is also decorated with the *fu* and Axe-head symbols.

Pl.77 The Twelve Symbols
This orange-ground dragon robe is unique as a non-yellow robe displaying all Twelve Symbols. Spink & Son Ltd

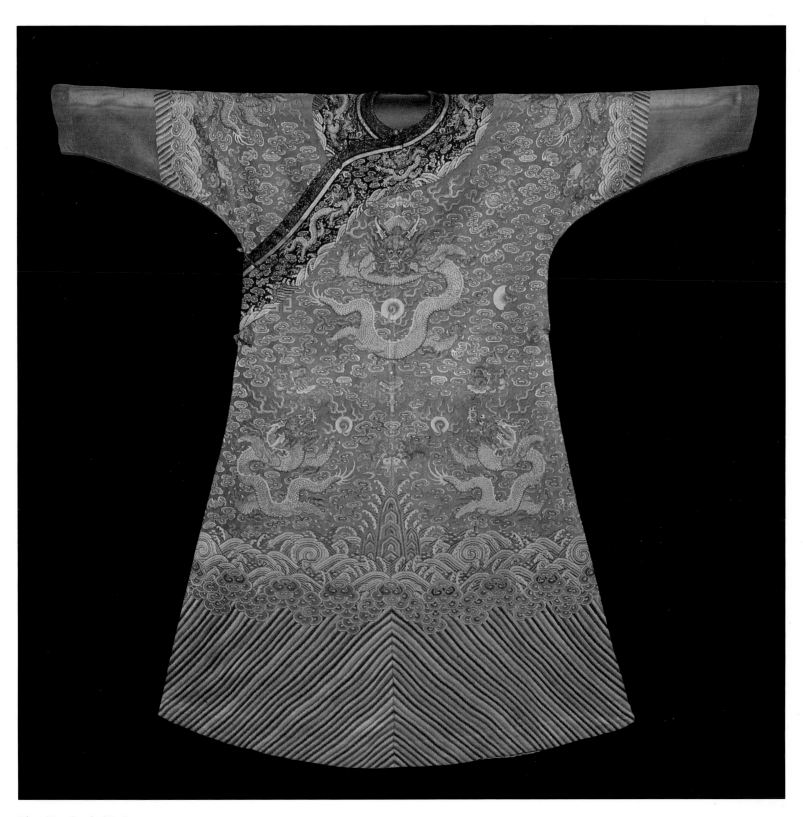

Pl.76 Five Symbol Robe
This unusual dragon robe has only five of the Twelve
Symbols: the Constellation (in two groups on the
back), the Sun and Moon on the shoulders, and the
fu and Axe-head on the front at waist level. The
turquoise ground suggests that it was probably
intended for use by an imperial consort.
Linda Wrigglesworth

Four and Eight Symbol Robes

In these collections there are also several men's orange-coloured dragon robes with various numbers of symbols on them. During previous dynasties, the nobles and officials who assisted the emperor at the principal annual sacrifices wore the ancient imperial symbols in lesser numbers. The Tongzhi and Guangxu Emperors were both small children when they acceded and their sacerdotal obligations would therefore have been delegated to one of their uncles at the beginning of their reigns. As sons of the Daoguang Emperor, these noblemen were probably already entitled to use golden-yellow (see Men's Court Robes). They may also, therefore, have been given the right to wear some of the imperial symbols in recognition of their special duties.

During the course of our research we have only encountered one orange-coloured robe tailored for a man which has all Twelve Symbols. The quality of the weave and the execution of the design place it at the very end of the Qing period. It may have once belonged to the second Prince Chun, who ruled as regent for his two-year-old son, the last emperor of China, Xuantong.

OFFICIAL HATS

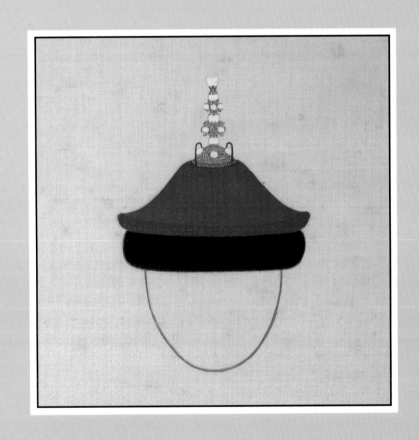

Official Hats

Winter Hats

The official hat was an indispensable article of court dress worn for the countless daily rituals connected with routine administration, as well as for the grand ceremonies attended by the emperor himself. Thus, the hat cannot be regarded simply as a costume accessory. Significantly, hats are the first item of court dress to appear in *Huangchao liqi tushi*.

There were two main types of Qing official hat: those worn during the cold months of the year and the hats used during the summer. Winter hats were adopted by the court with the approach of cold weather in the ninth moon and were put away during the third moon of the following year. The 'warm hat', as it was commonly known, was a close-fitting cap with a quilted crown and an upturned brim. The brim was faced with fur or moleskin. The types of fur that could be used were strictly regulated. From the first day of the eleventh moon to New Year's Day the emperor or the crown prince wore hats faced with black fox, while the emperor's other sons and princes of the blood could use blue fox. For the remainder of the cold part of the year, the emperor wore sable and the imperial princes sported mink. The rest of the nobility, civil and military officials were supposed to use mink. They were not allowed to wear sable unless the emperor had awarded them the right to do so. In practice, most officials wore hats faced with seal skin or, more commonly, velvet.

Pl.78 Winter hat
The fur used to face the brim of the winter hat was determined by the rank of the wearer. This example is faced with sable, which could be used by the imperial nobility only.
Royal Ontario Museum

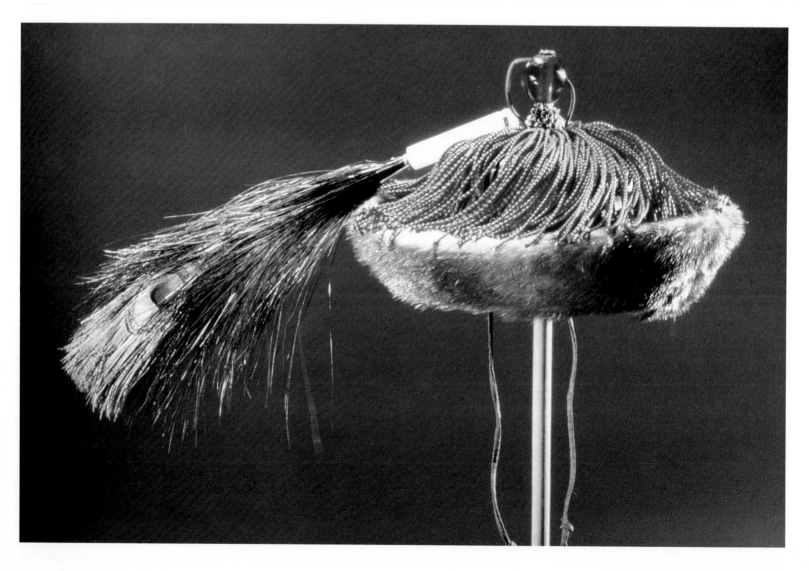

Summer Hats

The summer hat, or 'cool hat', was a conical sunshade made from finely woven split bamboo. Usually the summer hat had a taut silk covering and a thin brocade rim. It was lined with gauze and had a stiffened sweatband sewn inside. When the court adopted summer hats in the third moon, all the fan shops in Peking opened for their seasonal trade. The summer hat was not introduced into the official wardrobe until 1646, the second year of the Shunzhi Emperor's reign. An early Qing official, Ye Mengzhu, recalled that when cane hats were first introduced a shortage in the hat shops of southern China resulted and summer hats had to be improvised from baskets and straw mats.

The manufacture of official summer hats was a highly skilled craft that was passed down from generation to generation in certain areas of Shandong and Sichuan provinces. Shandong seems to have produced the straw hats worn by semi-official clerks and attendants in government offices or *yamen*. The more elaborate court hats of officials themselves were made in Sichuan. Lord Hosie, the British Consul-General, visited this area at the turn of the century. His report (see Bibliography) gives us a detailed account of their manufacture:

First a framework of fine split bamboo is made. This is gummed at the top to preserve the shape, and it is then lined inside and outside with silk gauze, the colour of which depends on the taste of the wearer. A cover exactly the same shape of the hat is placed on the top and bound round the edge to the gauze-lined framework. It is this cover which is the work of art. It is a transparent netting woven of bamboo fibre reduced to the fineness of hair. It is so fine that the marvel of it is that it is the work of human fingers. Yet it is so. The industry, which is hereditary, is carried on by certain families in the villages round Cheng-tu, and the hat shops in the city have their respective makers...

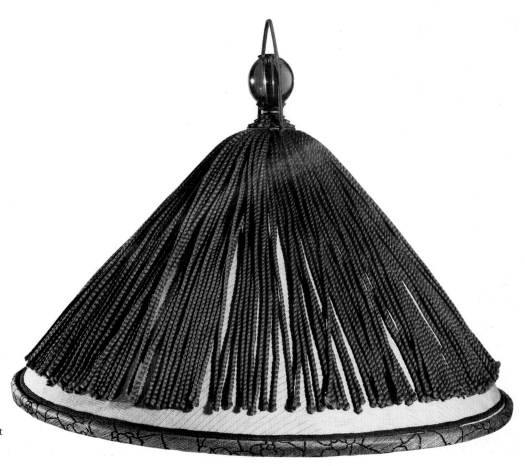

Pl.79 Summer hat
An official summer hat made of bamboo with a taut silk covering.
Linda Wrigglesworth

The cover, which is [naturally] light brown, is never coloured, and the shade of gauze is distinctly visible through the fine bamboo network. Frequently, however, the wearer wishes to show off the colour and fineness of the cover, in which case white gauze is used for the top lining of the framework underneath.

This type of summer hat, with its outer covering of finely woven bamboo fibre, is now extremely rare. Normally the framework of the summer hat was covered with a special type of white gauze, which was woven to give a distinctly striped effect.

Hat Insignia

To make clear the distinction between the various ranks of nobility and official, different-coloured semi-precious stones or glass imitations were mounted on the crown of the hat, denoting the status of the individual. Lord Macartney recorded the various jewels of rank in his journal of 1793, mistakenly believing that they were an innovation of the Qianlong Emperor:

Formerly persons were chiefly known by their robe of ceremony, but as it was not constantly worn in common, the present Emperor invented or founded the distinction of the bead or button, which being fixed on the top of the cap evidently and immediately denotes the title of the wearer.

In fact, the earliest sumptuary laws relating to hat insignia date back to the regulations issued by the Manchu court at Shenyang in 1636. These laws remained largely unchanged until 1727, when the Yongzheng Emperor introduced a secondary form of court hat insignia to be worn on less formal occasions. *Huangchao liqi tushi* codified all previous laws, setting few new precedents regarding hats.

Court Hats

Huangchao liqi tushi further classifies both winter and summer hats into two quite distinct styles: the *chao guan* or court hat, and the *ji guan* or festive hat. The *chao guan*, the most formal headgear in the official wardrobe, was worn with *chao fu* by the nobility and officials with a post in the imperial administration. Graduates with one of the higher degrees in the government examinations wore a similar type of hat.

Both winter and summer *chao guan* were decorated with a tassel of red unspun silk floss. The crown of the winter *chao guan* was completely covered by the floss tassel. The ends of the silk fibres were teased to form a downy mass around the edge of the brim. Summer *chao guan* had a double edging of brocade with the floss tassel extending down as far as the first edge. Summer and winter *chao guan* were surmounted by a tall, elaborate finial. This ornate apex sat on a small disc of brocade with red loops either side of its base. These red silk loops are distinctive features of all Qing official hats and their original purpose may have been to secure the insignia. During the late Qing period, the apex was always bolted through the crown of the hat.

Imperial *chao guan*

The emperor's winter *chao guan* is the first article of court dress illustrated in *Huangchao liqi tushi*. The apex is shown as being composed of three large Eastern pearls arranged in tiers. Each tier is decorated with four golden dragons. The base of this ornate spike is set with four small pearls and each tier further adorned with three pearls. The emperor's jewel of rank, a large pearl of great value, is set in the top of the spike. Eastern pearls are freshwater pearls from the Sungari, Yalu and Amur rivers in Manchuria which, because of their sentimental association with the Manchu homeland, only members of the imperial family were permitted to use on their hats.

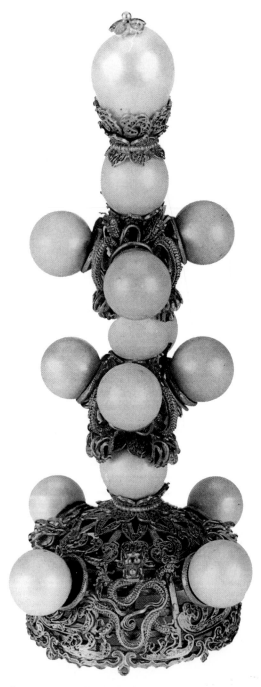

Pl.81 Emperor's hat insignia
The elaborate finial of the emperor's *chao guan* was composed of three tiers of Eastern pearls each clasped by four golden dragons.
National Palace Museum

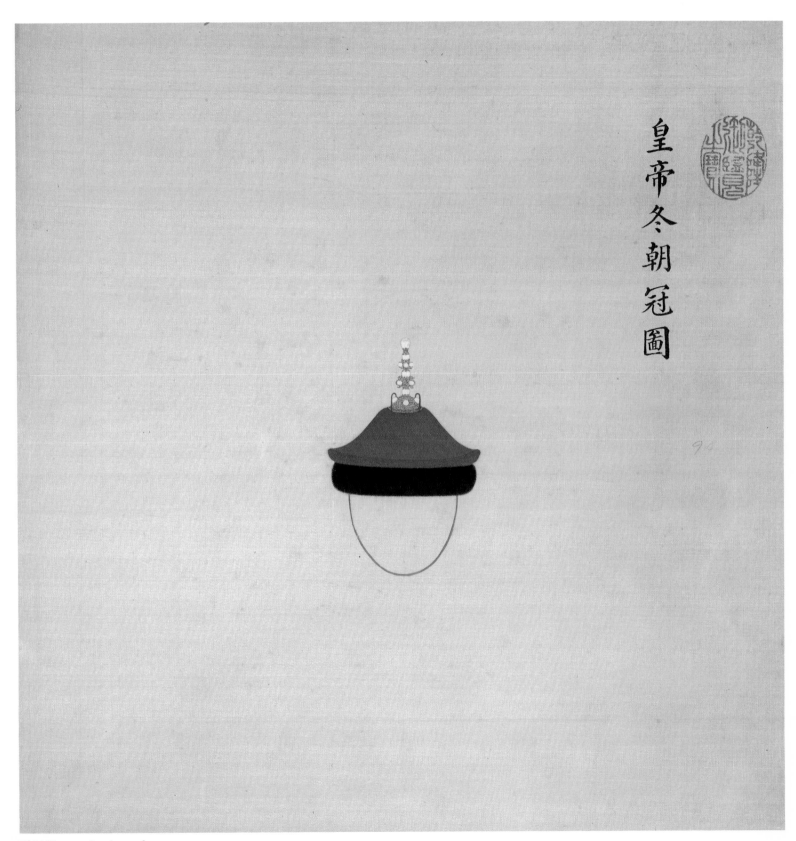

皇帝冬朝冠圖

Pl.80 Emperor's winter *chao guan*
Painting on silk of the emperor's winter *chao guan*.
The oval seal in the top right-hand corner bears the
legend 'Treasure having been examined by
Qianlong'.
V&A

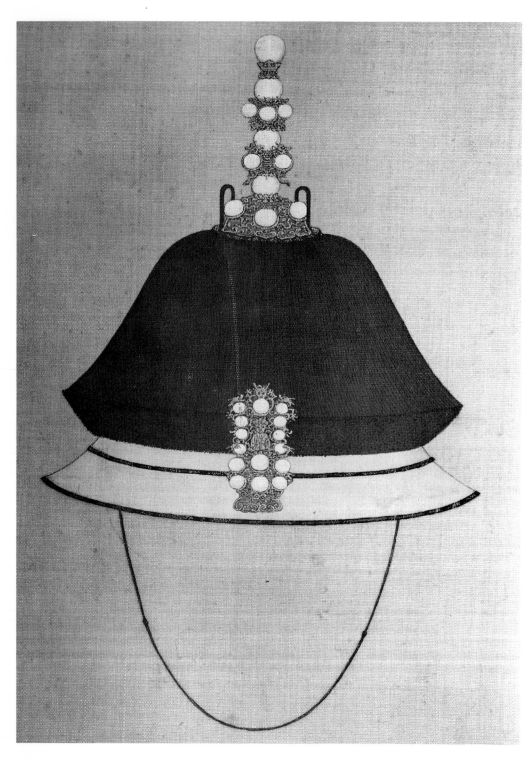

Pl.83 Imperial summer *chao guan*
An ornament from an imperial summer *chao guan* in the form of a tiny golden Buddha.
National Palace Museum

Pl.82 Emperor's summer *chao guan*
Painting on silk showing front view of the emperor's summer *chao guan*.
V&A

The emperor's summer *chao guan* is shown decorated with additional ornaments on the brim. On the front is a tiny golden figure of the Buddha set with 15 Eastern pearls. The ornament at the back is a golden plaque decorated with a dragon and adorned with six pearls. *Huangchao liqi tushi* describes this as the *she lin*, which is possibly a Chinese transliteration of a Sanskrit term for a type of Buddhist reliquary. The apex of the summer hat was identical to that of the winter *chao guan*.

The *huang tai zi* or crown prince was the only other imperial noble permitted to use three tiers of pearls. However, his jewel of rank was another Eastern pearl. The smaller settings were exactly the same as those on the emperor's *chao guan*. He was also allowed to use a

Pl.84 Emperor's summer *chao guan*
Painting on silk showing back view of the emperor's
summer *chao guan* with the ornament on the brim.
V&A

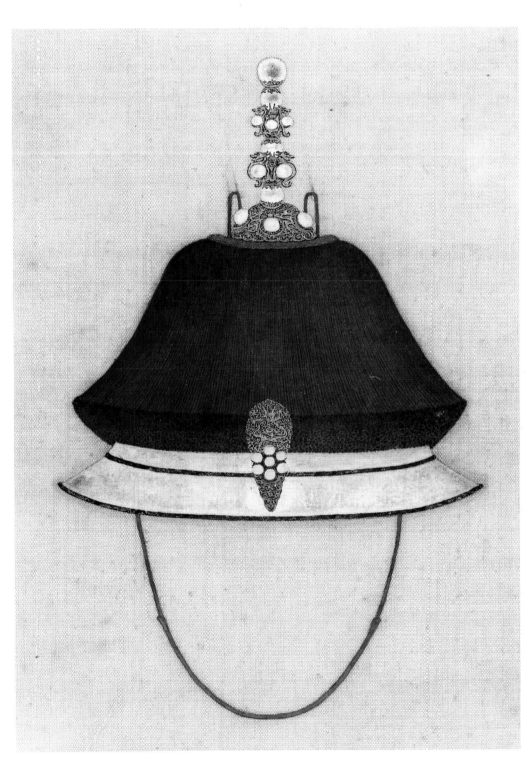

golden Buddha set with 13 Eastern pearls on the front of his summer *chao guan*, as well
as a small reliquary on the back decorated with a golden dragon set with six pearls.

The insignia on the *chao guan* of imperial princes were decorated with fewer numbers of
pearls and golden dragons, and were surmounted by rubies (see Table 4). The emperor's
sons, *huang zi*, and princes of the first order, *jin wang*, were allowed to have the reliquary
on the brim of their summer *chao guan* but positioned at the front. This was set with five
Eastern pearls. At the back of their hats was another golden plaque set with four pearls.
Sons of first-rank princes, *shi zi*, could use the same ornaments. All other princes and
imperial dukes could also use these decorations but with fewer pearl settings (see Table 5).

The use of multiple tiers of large pearls and pearl-studded ornaments on the *chao guan* of imperial princes appears to have been relatively short-lived. Commemorative portraits dating from the early nineteenth century show that only the correct jewel of rank and number of pearl settings were used. The Field Museum in Chicago has one of the few surviving examples of a prince's summer *chao guan*. The spike is decorated with four filigree dragons and set with 10 small freshwater pearls. Although not arranged in strict accordance with *Huangchao liqi tushi*, the number of pearl settings and decorative dragons appear to indicate that the hat belonged either to an emperor's son or to another blood prince. The jewel mounted on the top of the apex is a large, irregularly-shaped piece of mother-of-pearl. The setting shows some signs of damage and the mother-of-pearl may be a later replacement for a missing ruby.

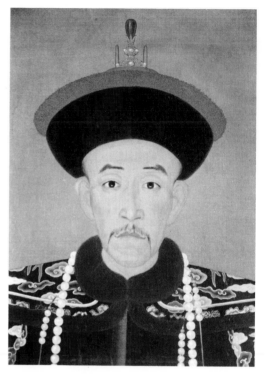

Pl.85 Imperial prince
Detail from a commemorative portrait of an unknown imperial prince.
Metropolitan Museum of Art

Table 4: Insignia on Imperial *chao guan*

Rank	No. of Tiers	No. of Dragons	No. of Eastern Pearls	Jewel of Rank
Emperor	3	12	13	precious pearl
Crown prince	3	12	13	eastern pearl
Emperor's son	2	4	10	ruby
First-rank prince	2	4	10	ruby
Son of a first-rank prince	2	2	9	ruby
Second-rank prince	2	2	8	ruby
Third-rank prince	2	2	7	ruby
Fourth-rank prince	2	2	6	ruby
First-rank duke	2	2	5	ruby
Second-rank duke	2	2	4	ruby

Table 5: Ornaments on Imperial Summer *chao guan*

Rank	Front	Back
Emperor	golden Buddha set with 15 pearls	golden reliquary set with 6 pearls
Crown prince	golden Buddha set with 13 pearls	golden reliquary set with 6 pearls
Emperor's sons, first-rank princes and their sons	golden reliquary set with 5 pearls	golden plaque set with 4 pearls
Second-rank prince	golden reliquary set with 4 pearls	golden plaque set with 3 pearls
Third-rank prince	golden reliquary set with 3 pearls	golden plaque set with 2 pearls
Fourth-rank prince	golden reliquary set with 2 pearls	golden plaque set with 1 pearl
First-rank duke	golden reliquary set with 1 pearl	golden plaque set with 1 green stone
Second-rank duke	golden reliquary	golden reliquary

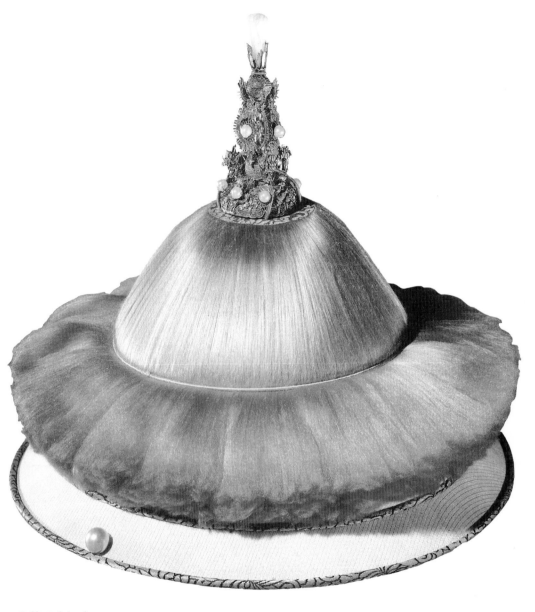

Pl.86 Imperial prince's summer *chao guan*
The large piece of mother-of-pearl set in the top of the hat's insignia may be a replacement for a missing ruby.
Field Museum

Officials' *chao guan*

The insignia on the *chao guan* of officials were much simpler than those of the imperial nobility. They were composed of three sections: a wide base decorated with various symbols in high relief, a spherical section with a small stone setting, and a clasp-like top section containing the jewel of rank. If this was a real jewel the stone was polished to a drop-like shape, but if it was a glass imitation, the jewel was faceted, representing a natural crystal formation. Each section of the apex was connected by a small metal collar in the shape of a florette.

The first laws regarding officials' jewels of rank were laid down by Abahai in 1636 (see Table 6). The early Manchu court at Shenyang divided its civil and military officials into four degrees, each denoted by a different coloured jewel. Officials of the top degree were permitted to use a ruby or another red-coloured stone. Those of the second degree could only use sapphire or a blue-coloured imitation. Officials of the third degree wore rock crystal and the lowest of the four grades could only use a jewel of gilt metal. After the Manchu conquest of China, however, officials were divided into nine ranks and in 1645 new regulations were issued regarding their hat insignia. The same four colours of jewel continued to be used but smaller settings were added to the central section of the insignia to distinguish between principal and subordinate ranks.

The regulations were further revised in 1730 by the Yongzheng Emperor (see Table 6). Until this date all the jewels of rank were transparent. Yongzheng now introduced opaque stones to denote the subordinate rank using each of the four colours of jewel. Only first-rank officials were permitted to continue using a ruby or transparent red jewel. Second-rank officials could now only use coral or an opaque red substitute while officials of the third rank had to use a transparent blue jewel. Similarly, fourth-rank officials had to wear a lapis lazuli or opaque blue jewel. Fifth-rank officials continued to use a crystal jewel but sixth-rank officials now had to use white jade or an opaque white glass substitute. The smaller settings in each case remained unchanged. These revised regulations of 1730 were incorporated into *Huangchao liqi tushi*.

The choice of red, blue, white, and gold-coloured materials for hat insignia seems significant in light of what has already been said regarding the colours that symbolized the *wu xing* or five 'activities' (see The Twelve Symbols). Red can be correlated with fire, blue with wood, white with metal. Gilt jewels may also represent metal. Water seems once again to have been considered too inauspicious to use its colour, black, for insignia. The introduction in 1730 of transparent and opaque materials can also be explained in terms of the *wu xing*. Each activity was believed to have an active or *yang* phase and a passive *yin* aspect. These phases are represented by the sequence of alternately transparent and opaque materials in each colour.

The design of officials' hat insignia closely resembles that of the *rdo-rje* symbol of Lamaist Buddhist iconography. *Rdo-rje*, 'master stone' in Tibetan, symbolized a pure mind, which was likened to a gem capable of cutting through any substance but which itself could not be scratched. The faceted paste jewel in the top of the insignia may represent this flawless stone. The appearance of this symbol and the Buddhist images on imperial court hats should not surprise us since the Manchu, like their cousins the Mongols, were originally Lamaist-Buddhist. Indeed, some ecclesiastical head-dresses of the Lamaist church are also surmounted by the *rdo-rje*.

Table 6: Insignia on Officials' *chao guan*

Rank	1636 Jewel	1645 Jewel	Smaller Setting*	1730-1911 Jewel	Smaller Setting*
First	ruby	ruby	pearl	ruby	pearl
Second	ruby	ruby	red	coral	red
Third	ruby	ruby	blue	sapphire	blue
Fourth	sapphire	sapphire	blue	lapis lazuli	blue
Fifth	crystal	crystal	blue	crystal	blue
Sixth	crystal	crystal	—	white jade	crystal
Seventh	gold	chased gold	blue	plain gold	crystal
Eighth	gold	chased gold	—	chased gold	—
Ninth	—	chased silver	—	chased silver	—

*Smaller settings were always transparent stones or pieces of glass of the appropriate colour.

Pl.88 Official's insignia
The insignia from a first-rank official's *chao guan*.
Spink & Son Ltd

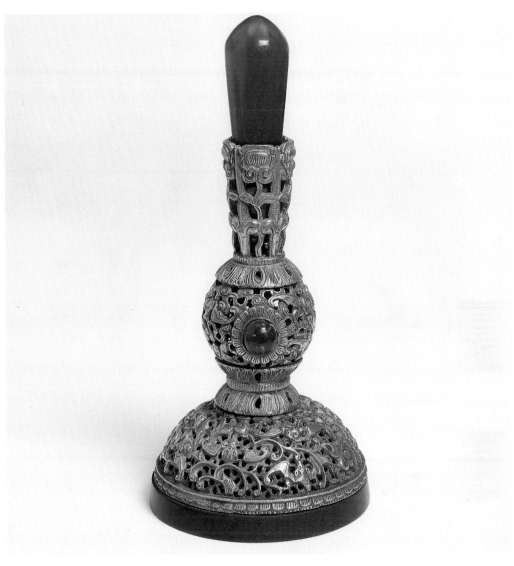

Pl.87 First-rank official's winter *chao guan*
The apex is set with a large ruby and a small pearl.
This hat was presented to General Gordon by the
grateful Tongzhi Emperor for leading imperial
troops against the Taiping Rebellion.
Royal Engineers Museum

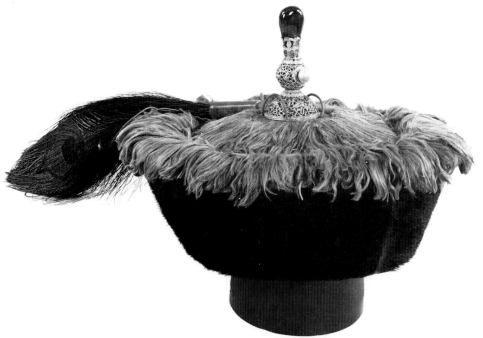

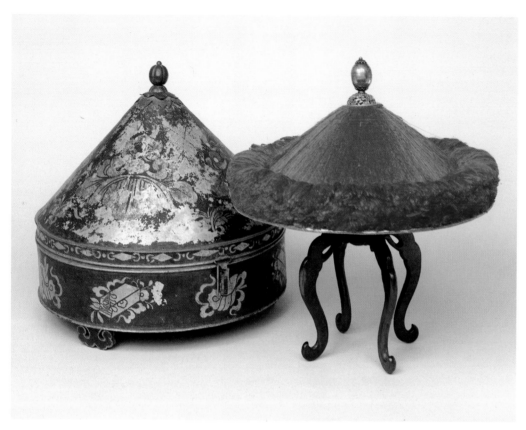

Pl.90 Official's summer hat
An early example of an official's less formal summer hat with the insignia of a ninth-rank official.
Linda Wrigglesworth

Ji guan

At the beginning of the Qing period, the *chao guan* was worn on semi-formal occasions without its usual ornate spike. The Yongzheng Emperor appears to have felt that this was unsatisfactory. In 1727 he introduced a new type of hat insignia which could be worn in place of the ornate spike with less formal court attire, and also with ordinary dress when dealing with official business. The new insignia was a large round bead of material of the appropriate colour mounted on a gilt base. These jewels of rank, so-called 'mandarin hat buttons', survive in large numbers and are still popular with today's collectors.

The laws of 1727 stipulated that the emperor himself should wear a knot of red silk cord mounted on the top of his semi-formal hats. However, the rest of the imperial hierarchy had to use the small round jewel. The imperial nobility was permitted to wear a transparent red hat jewel. Officials of the first rank had to wear a red coral jewel unless they had been given the right to use the 'ruby hat button'. Officials of the second and third ranks also used a coral jewel but with a small design engraved on the surface. Fourth- and fifth-rank officials were permitted a plain lapis lazuli jewel while those of the sixth rank could use crystal. The three lowest ranks wore plain gilt jewels. When the regulations concerning the insignia on officials' *chao guan* were changed in 1730, insignia on semi-formal hats were similarly revised.

We do not know for certain whether the smaller type of insignia was mounted on the *chao guan* in place of its usual elaborate finial for semi-formal wear. One unique summer hat, in a private collection, has a red silk floss tassel like the *chao guan* but is surmounted by a silver hat button appropriate to a ninth-rank official. By the early Qianlong period semi-formal insignia was being worn on a new type of hat which had a tassel made of twisted red silk cords and a single red cord which looped from front to back over the jewel. The Qianlong Emperor can be seen wearing this type of hat in Castiglione's *Inauguration Portraits* handscroll, which we have dated to 1736. The revised regulations of 1730 were incorporated into *Huangchao liqi tushi* where the semi-formal type of hat is referred to as *ji guan* or festive hat (see Table 7).

Table 7: Insignia on Officials' *ji guan*

Rank	Glass Imitation Jewels
First	opaque red (plain)
Second	opaque red (engraved)
Third	transparent blue
Fourth	opaque blue
Fifth	transparent white
Sixth	opaque white
Seventh	gilt (plain)
Eighth	gilt (engraved)
Ninth	silver

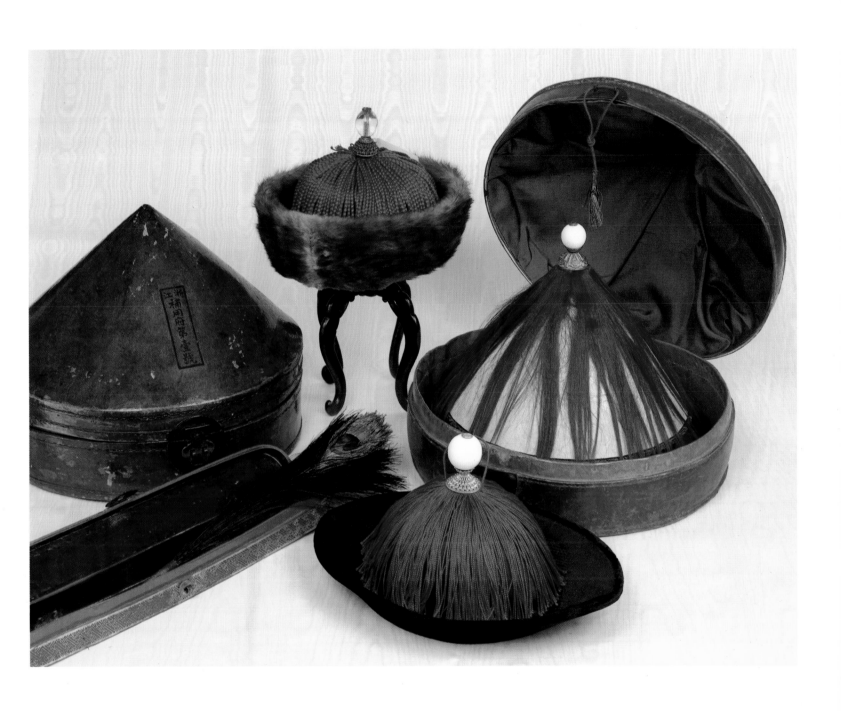

Pl.89 *Ji guan*
This collection of *ji guan* shows the variety of
millinery worn by officials: back, winter hat of a
fifth-rank official faced with mink; right, summer hat
of a sixth-rank official decorated with a horsehair
tassel; front, winter hat of a sixth-rank official faced
with velvet.
Private collection

Huangchao liqi tushi permits the emperor and crown prince to wear a single large pearl as insignia on their *ji guan*. Each of these fabulous baroque pearls was given an official title, such as the 'Azure Dragon'. Another famous hat pearl was called the 'Glorious Good Omen'. It was said to have originally been brought from Ceylon in the fifteenth century by Admiral Zheng He. In 1625 it was stolen from the palace by a eunuch called Wei Chongxian. The pearl remained in private hands until 1781 when it was sent as a gift to Qianlong on his seventieth birthday only to be appropriated by the Emperor's profligate Prime Minister, He Shen. The Jiaqing Emperor confiscated the pearl from He Shen's estate after he fell into disgrace in 1799. Later it was mounted on an imperial hat. Jiaqing prophesied that the loss of the Glorious Good Omen would spell ruin for the Qing dynasty. In August 1911 the pearl is rumoured to have been stolen by a eunuch called Shen Loting. The Qing dynasty survived its loss a bare three months.

Graduates' Court Hats

Successful candidates in the government examinations were not permitted to wear *chao fu* or use a jewel of rank until they had been given an official appointment. On special ceremonial occasions, such as the official banquets given in their honour at graduation, they wore a type of official costume called *gong fu* or public dress (see Men's Court Robes). The hat worn with this costume is simply described in *Huangchao liqi tushi* as *gong fu guan* or public dress hat. Like the *chao guan*, its tassel was made of red silk floss and it was decorated with a tall gilt spike. Scholars with the highest degrees, *jin shi* and *ju ren*, had a tiny golden bird in the top section. Graduates with the lower degree, *sheng yuan*, wore similiar insignia but silvered.

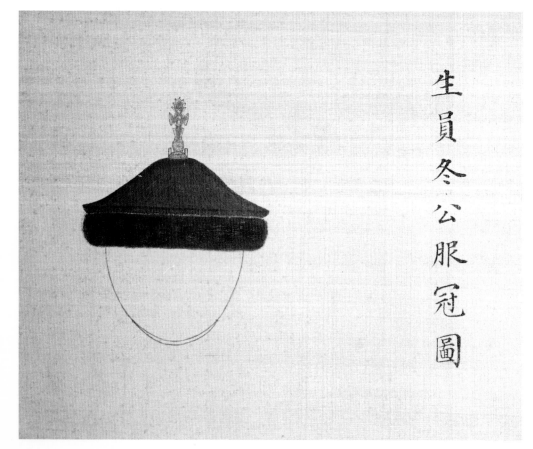

Pl.91 Graduate's court hat
Painting on silk of the *gong fu guan* of a graduate with the *sheng yuan* degree in the government examinations.
V&A

Other Official Hats

The minor official functionaries at the imperial court wore special ceremonial hats on great state occasions. Court musicians and the Gentlemen of the Imperial Equipage Department, who carried the imperial insignia, wore hats with finials decorated with bright yellow feathers. During the winter the brims of their hats were sometimes faced with leopard skin. The civil posturers, who performed the slow, rhythmic dancing at the principal annual sacrifices offered by the emperor, wore hats decorated with gilt insignia in the form of a flaming pearl. The military posturers, who performed the martial dances, used insignia in the form of a trident.

Hat Decorations

Hat insignia established an order of precedence at court, defining the position of the nobles and officials in the imperial hierachy. In addition, individuals could be awarded special privileges which distinguished them from other members of the same group. The most exalted officials might be allowed to use winter hats faced with sable, a fur specifically forbidden to their rank. Others were given the right to wear a *ling zhi* or plume on their official hats. The *ling zhi* was attached to the back of the hat by a tube made of jade or a glass imitation. The decoration was secured by means of a metal fitting which was fixed beneath the hat insignia's mount and which stopped the *ling zhi* from moving about.

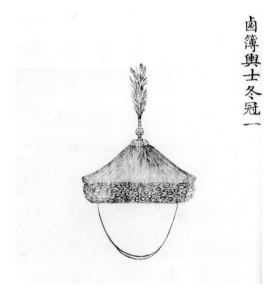

鹵簿輿士冬冠一

Pl.92 Insignia bearer's winter hat
Illustration of an insignia bearer's winter hat trimmed with leopard skin.
SOAS

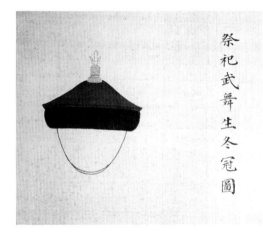

祭祀武舞生冬冠圖

Pl.93 Military posturer's winter hat
Painting on silk of a military posturer's winter hat.
V&A

Pl.97 Hat boxes
The official hat was treated with the greatest respect. When not in use the hat was kept in its own case. The few surviving hat boxes are mostly of high quality, a reflection of the care with the which the hat was treated.
Royal Engineers Museum

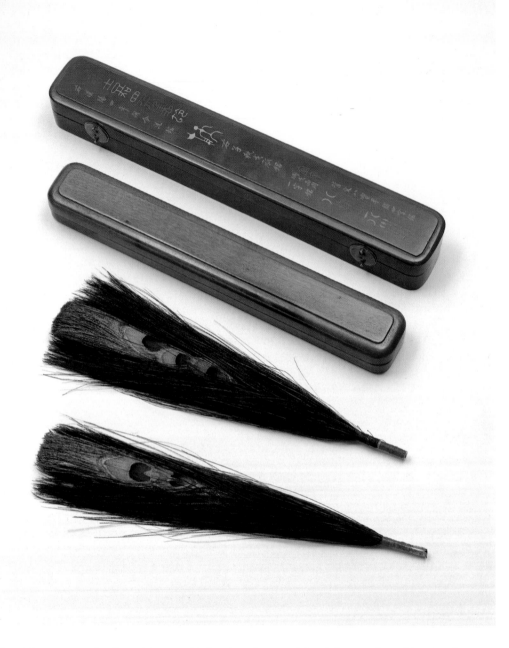

Pl.94 Peacock feather hat decorations
The peacock feather *ling zhi* was a distinction
awarded by the imperial throne for a special service.
Imperial princes wore the triple-eyed plume, *san yan
hua ling*, while lesser nobles used the double-eyed
plume, *shuang yan hua ling*.
Private collection

The right to wear the *ling zhi* was a distinction that could only be conferred by the throne.
In theory it was bestowed in recognition of some meritorious service. In practice many
officials obtained their *ling zhi* by placing suitable gifts in the hands of a high-ranking
person. The Chinese made no distinction between those who had 'purchased' their
feathers and those who had obtained them legitimately.

Huangchao liqi tushi describes several classes of *ling zhi* that could be awarded by the
throne. The *san yan hua ling*, the triple-eyed peacock feather, was the highest and was
restricted to the first three ranks of imperial prince. The *shuang yan hua ling*, the
double-eyed peacock feather, was awarded to lower-ranking Manchu nobles. The *dan
yan hua ling*, single-eyed peacock feather, was conferred on Chinese nobles and officials
down to the sixth rank. Each of these *ling zhi* consisted of a thick wad of peacock feathers
tightly bound together inside an outer sheath of black glossy filaments made of blue
pheasant feathers or sometimes horsehair. The peacock feathers were wired together in
layers so that only the prescribed number of 'eyes' were visible. Each *ling zhi* was
approximately 10 inches long.

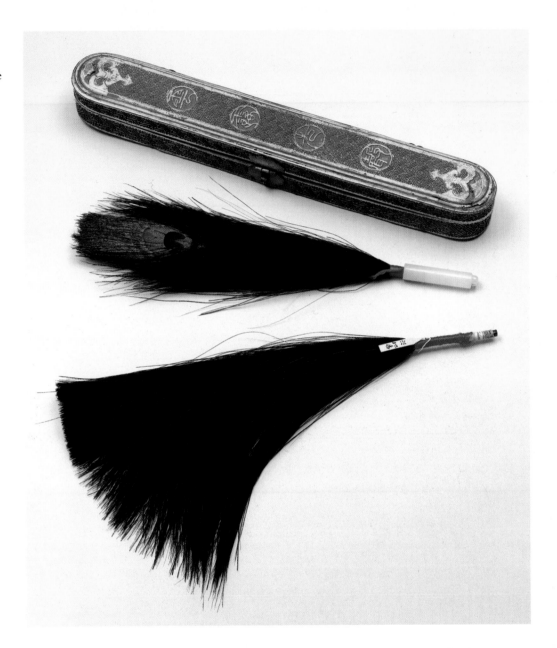

Officials of the seventh rank and below were not eligible for the peacock feather.
However, they could be awarded the *lan ling*, the blue feather, for their services. This
ling zhi was similar to the peacock feather except that it had no peacock feather 'eyes'.
The *lan ling* was also worn by the rank and file of the Imperial Guard as part of their
uniform. Their *ling zhi* were much longer, almost 12 inches. Eunuchs could also be
awarded the *lan ling*. Although eunuchs were strictly forbidden to wear peacock feather
ling zhi, the rule was broken by Li Lianying, Chief Eunuch of the household of Empress
Dowager Cixi.

Another special hat decoration was the *diao wei*, or 'sable tail'. This decoration was the
badge of soldiers on active military service. The *diao wei* was only worn on less formal
official hats and consisted of a piece of card, shaped like a bat, with two strips of fur,
backed with red paper and stiffened with wire. These strips of fur were neither sable tails
nor necessarily even sable. The paper bat was secured beneath the base of the hat insignia
so that the 'sable tails' extended in a V-shape from the back of the hat. If the soldier were
an officer who had been awarded the plume, this was worn between the two strips of fur.
The *diao wei* was originally worn on hunting expeditions in the imperial game reserve at
Jehol.

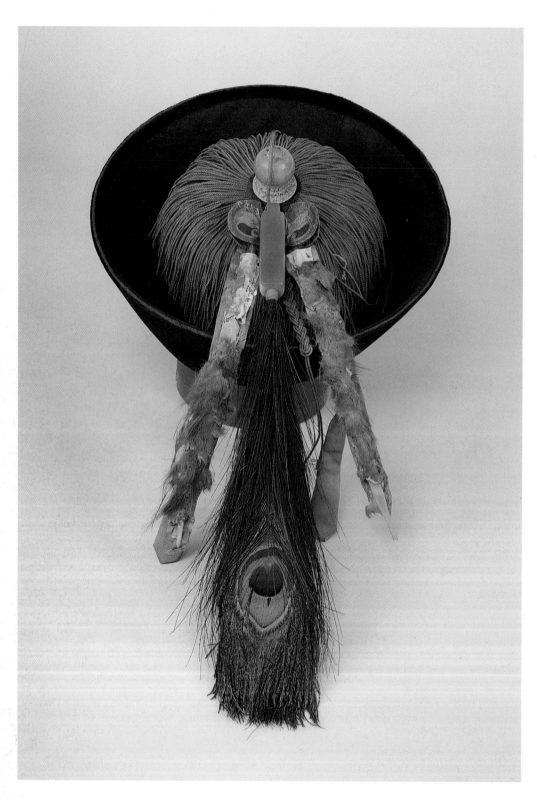

Pl.96 *Diao wei*
This winter *qi guan* from General Gordon's
collection of Qing costume has the *diao wei* attached
to the back.
Royal Engineers Museum

OFFICIAL COATS

Official Coats

Surcoats

The first group of garments illustrated in *Huangchao liqi tushi* are front-opening coats with vents at the front, rear and sides, and wide, straight sleeves. Although of a very simple construction, these garments were important articles in the official wardrobe often being worn as surcoats over court robes. This group included a short riding jacket, a fur coat, and a plain, dark-coloured coat which carried distinctive badges of rank, known popularly as 'mandarin squares'.

Riding jackets

The *ma gua*, the horse jacket, was a waist-length, front-opening riding coat worn by Manchu horsemen. The *ma gua* was worn with informal dress by officials when transacting ordinary business even within the palace itself. It was normally made of material of a dark-blue colour. However, generals and captains of all Manchu, Mongol and Chinese banners were also permitted to wear a *ma gua* in the colour appropriate to their regiment when in personal attendance upon the emperor. The use of *ma gua* in regimental colours may, therefore, have originally served a practical function, as a means of identifying the commanders of the various divisions of the Manchu army.

The right to wear a *huang ma gua*, a yellow riding jacket, was one of the most coveted honours that could be bestowed on any Qing official. Only the highest-ranking ministers and officers of the imperial bodyguard were permitted to wear a yellow *ma gua* as a privilege of rank. The distinction of the yellow jacket effectively made the recipient an honorary captain of the imperial banner and a member of the emperor's bodyguard.

Two Europeans are known to have been honoured with this privilege: M. Prosper Giquel, for assisting with the establishment of the arsenal at Fuzhou, and General Charles Gordon, for his part in the suppression of the Taiping Rebellion. According to a note in Gordon's handwriting: 'When the Manchu dynasty conquered China, the leader of the invaders feared assassination, so he clothed 40 of his bodyguard in yellow like himself. This precaution by time became unnecessary, and the Emperor then turned the yellow jacket into a decoration for military service. There are accordingly 40 mandarins allowed to wear the yellow jacket; no one else but the Emperor and the 40 can wear yellow.'

Fur coats

The *duan zhao* was a three-quarter-length surcoat completely faced with fur. The character *duan* describes archaic ceremonial dress; *zhao* means cloak or overcoat. In China, fur was normally only used as a lining or, in the case of the most expensive pelts, as a trimming. For this reason, the *duan zhao* was commonly called the 'inside-out coat'. Only the nobility, the top three ranks of official and imperial guardsmen were permitted to wear this garment. The type of fur and the colour of lining and the pair of pointed silk bands, which hung from each side of the coat, were determined by rank (see Table 8).

The emperor had two fur coats, one made of sable to be worn in the late autumn and early spring, and a second coat of black fox worn during the coldest months of the year. The crown prince was permitted to use black fox while all other imperial princes had coats made of blue fox. Sable was restricted to the lower echelons of the nobility. During the nineteenth century the sable *duan zhao* was also decorated across the chest and knees with small tufts of white fur from the neck of the sable. Unless they had been given the right to use sable, officials had to wear mink coats.

Officers in the imperial guard wore fur coats made of lynx inlaid with mink. The lower sleeves and hem of the coat were faced with mink with a band of mink around the waist. The collar and front closure were also edged with mink. The arrangement of these furs resembles the construction of the robe worn as part of *chao fu* (see Men's Court Robes). Other imperial guardsmen wore coats made from leopard skin.

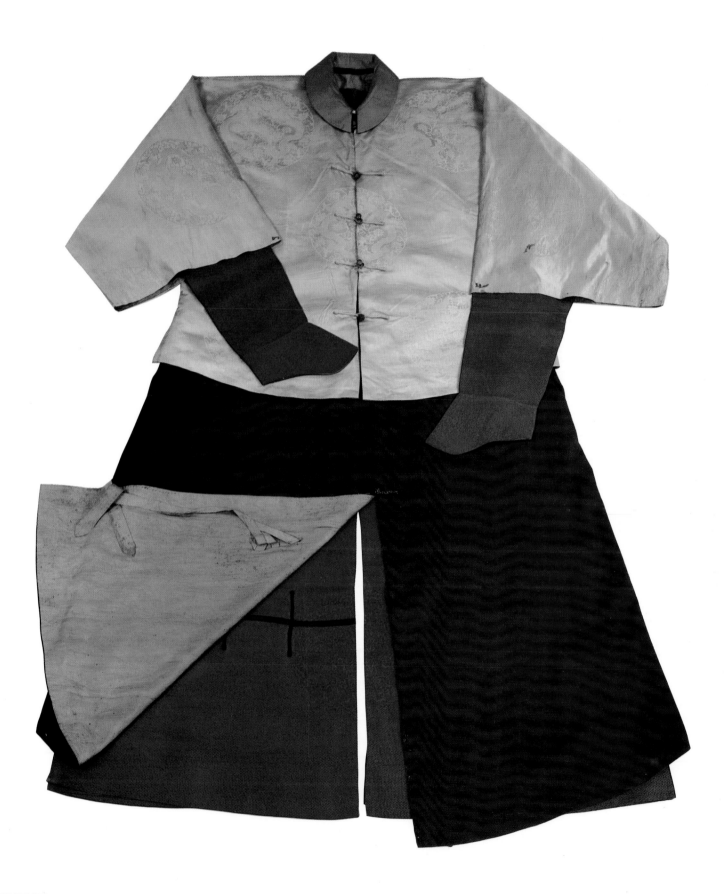

Pl.98 *Huang ma gua*
This example of a *huang ma gua* was presented to
Charles Gordon for his part in putting down the
Taiping Rebellion.
Royal Engineers Museum

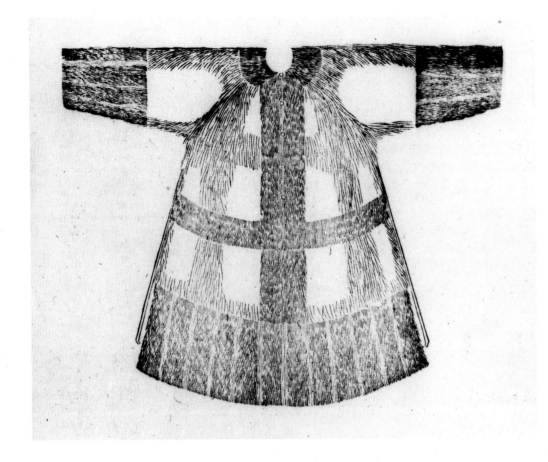

Pl.100 Imperial guard's *duan zhao*
Illustration of the *duan zhao* of a first-class imperial guardsman.
SOAS

Although the fur surcoat could be worn with all formal court attire as well as semi-formal official dress, its use was limited. The fur surcoat did not carry any distinctive insignia of rank and was therefore inappropriate for most ceremonial occasions. Officials entitled to wear the fur coat did so for the formal visits to their colleagues during the first three days of the New Year celebrations. This may even have extended to the Grand Audience ceremony held on New Year's Day in the palace. In *Twilight in the Forbidden City*, Sir Reginald Johnston describes another Grand Audience held by the deposed Xuantong Emperor on the occasion of his birthday in 1919 at which 'those who had been granted the right to wear the sable court cloak, with the sable-fronted hat that went with it, naturally did so'. Some palace scroll paintings also show important nobles and officials wearing fur coats for ceremonies at which the emperor was not present. This appears to indicate that the fur coat could be used, during the winter months, when the wearer was the most senior person present.

Table 8: *Duan zhao*

Rank	Fur	Lining & Silk Bands
Emperor	sable/black fox	yellow
Crown prince	black fox	apricot-yellow
Emperor's sons	blue fox	golden-yellow
Imperial princes of the first four ranks	blue fox	pale blue
Other nobles	sable	pale blue
First- to third- rank officials	mink	pale blue
First-class imperial guards	lynx and mink	pale blue
Other imperial guardsmen	leopard	red

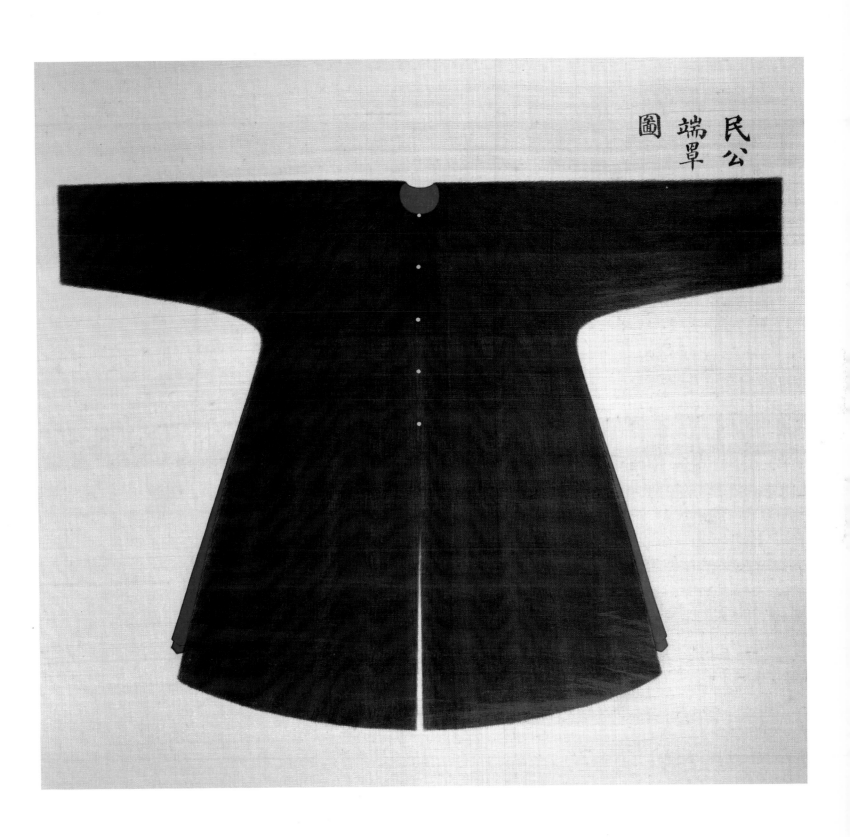

民公
端罩
圖

Pl.99 Imperial duke's *duan zhao*
Painting on silk of the sable *duan zhao* of an imperial
duke. The artist has attempted to show an insert of
darker fur at the top of the coat's front closure.
British Library

Gun fu and *pu fu*

The Qing was the first dynasty to use hat ornaments as insignia. But as the complex bureaucracy needed to effectively administer the territories under its control developed, hat insignia were no longer sufficient as a means of distinguishing between the different types and grades of official. In 1652, a decree was issued requiring all civilian and military officials to wear badges to signify their position in the imperial hierarchy. During the Ming period, badges applied directly onto court robes, displaying birds and fabulous animals, were important indications of rank. Qing insignia badges were smaller than their Ming prototypes. These badges, or *pu zi*, were displayed on plain, dark-coloured three-quarter-length surcoats.

Huangchao liqi tushi describes the surcoat displaying the emperor's insignia badges as *gun fu* or royal robes while the surcoats of imperial princes, nobles and officials are called *pu fu* or coat with a patch. These types of surcoat had already become an integral part of court dress by the late Kangxi period. It was not until the reign of the Qianlong Emperor that all members of the imperial hierarchy were required to wear the surcoat over their most formal court robes.

Imperial insignia

The surcoats of the upper ranks of the imperial nobility were decorated with dragon roundels. The circle was a symbol of Heaven and the dragon the emblem of imperial power. The number of roundels, the style in which the dragons were portrayed, and the number of claws on the dragons were all important indications of the wearer's rank.

The emperor's *gun fu* had four roundels displaying front-facing *long*. The four badges were arranged symmetrically around the neck opening of the coat with one on the front and back, and one on each shoulder. The roundels on the shoulders also had two of the Twelve Symbols on them. Above the dragon's head on the left shoulder was the Sun, a red disc containing a three-legged cockerel. The right shoulder showed the Moon, a white disc containing the Moon Hare pounding the elixir of life under a cassia tree. The front and back roundels were supposed to have the seal form of the character *shou* or longevity above the dragons' heads. However, imperial *gun fu* dating from the second half of the nineteenth century have the three-star Constellation and Rock on the chest and back. The clouds on the background of the roundel were executed in the 'five colours'.

All the emperor's sons were permitted to wear *pu fu* with four roundels displaying front-facing *long*. Imperial princes of the first order, *jin wang*, were only allowed front-facing *long* on the chest and back but, in theory, the dragons on the shoulders were shown in profile. *Xing long*, literally 'walking dragons', were inferior to the front-facing type. Princes of the second degree, *jun wang*, were not allowed to use any front-facing dragons at all; their four badges displayed profile *long*.

Third-rank princes were permitted just two roundels displaying front-facing *mang*, the four-clawed species of dragon. *Bei zi*, fourth-rank princes, could only use two *mang* in profile. Imperial dukes and non-imperial nobles had to wear square dragon badges. The square was a symbol of Earth. The dragons were supposed to be four-clawed but, in practice, most nobles seem to have adopted the extra claw (see Table 9).

Civil officials' insignia

Civil officials wore *pu fu* decorated on the chest and back with square badges displaying different types of bird (see Table 10). The birds used as rank insignia were based on real, rather than imaginary, species. They all tend to be represented on Qing insignia squares in a stereotypical manner – standing on a small rock, wings outspread as if alighting. But each type of bird is usually depicted with certain characteristic features that allow us to identify them.

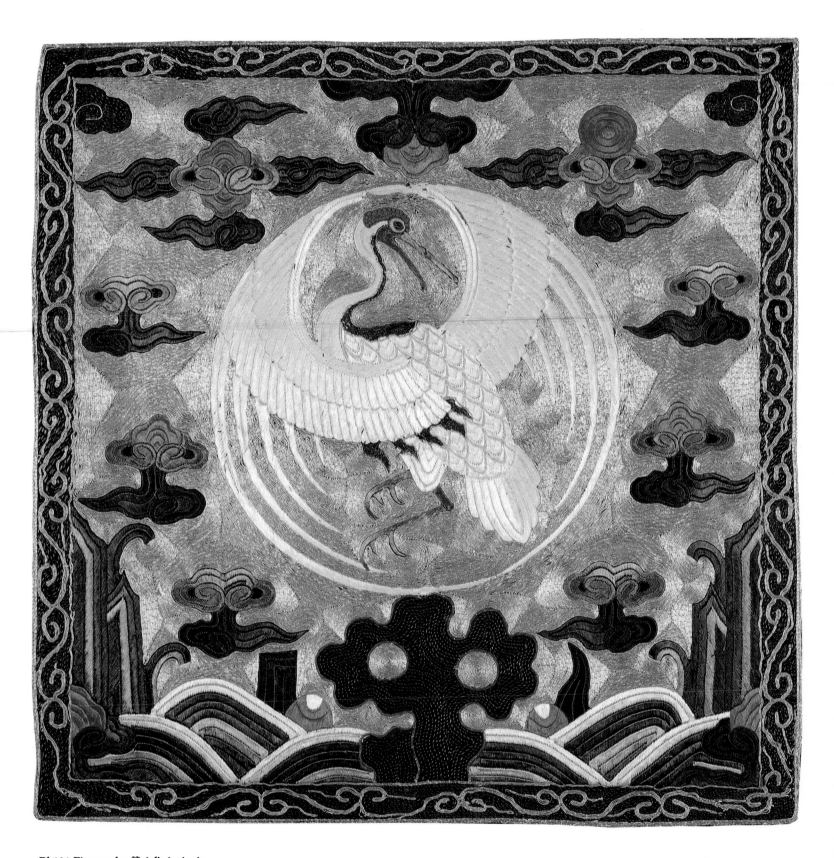

Pl.101 First-rank official's insignia
Early Qing squares had stunning designs executed in
brilliant colours and couched gold thread. This rare
example probably dates from the Kangxi period and
depicts the white crane of a first-rank civil official.
Linda Wrigglesworth

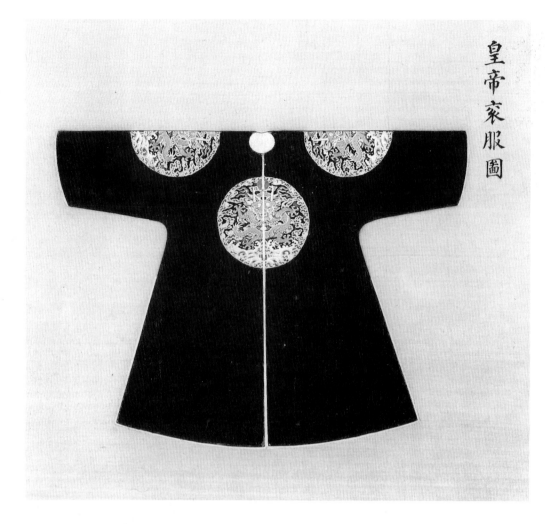

皇帝袞服圖

Pl.102 Emperor's *gun fu*
Painting on silk of the summer *gun fu* of the emperor.
V&A

Civil officials of the first rank wore badges displaying the Manchurian crane, depicted on insignia squares as an elegant white bird with a red cap, long slender neck and short tail feathers. Second-rank civil officials' rank badges were decorated with the golden pheasant which is shown as having variegated plumage and two distinctive straight tail feathers. Civil officials of the third rank used badges showing the peacock, which is easily distinguishable from other birds by the 'eyes' on the tail feathers. Fourth-rank civil officials wore badges of rank decorated with the wild goose which is usually shown as having a slender neck and ochre plumage with black speckles. Fifth-rank civil officials' rank badges displayed the silver pheasant, which is depicted on insignia squares as having white plumage, a dark blue crest and long serrated tail feathers. Civil officials of the sixth rank wore badges decorated with the egret. This bird is shown as a small white bird with short tail feathers and a dark blue crest. Seventh-rank civil officials wore badges displaying the mandarin duck, one of the most aesthetically pleasing animals shown on rank insignia. It is usually depicted as having a variegated plumage with a prominent crest and short tail feathers. Civil officials of the eighth rank wore insignia squares decorated with a quail, shown as a small, squat, ochre-coloured bird with a very short tail. Ninth-rank civil officials wore badges displaying the paradise flycatcher, which is depicted as a white bird with a slender neck and two long tail feathers with black spots at the ends.

The bird was a symbol of literary elegance and, therefore, an appropriate creature to designate civil officials who had gained their position through examinations based on the classics of the Confucian canon. However, many of the species of bird used as rank insignia were themselves popular symbols of longevity and good fortune.

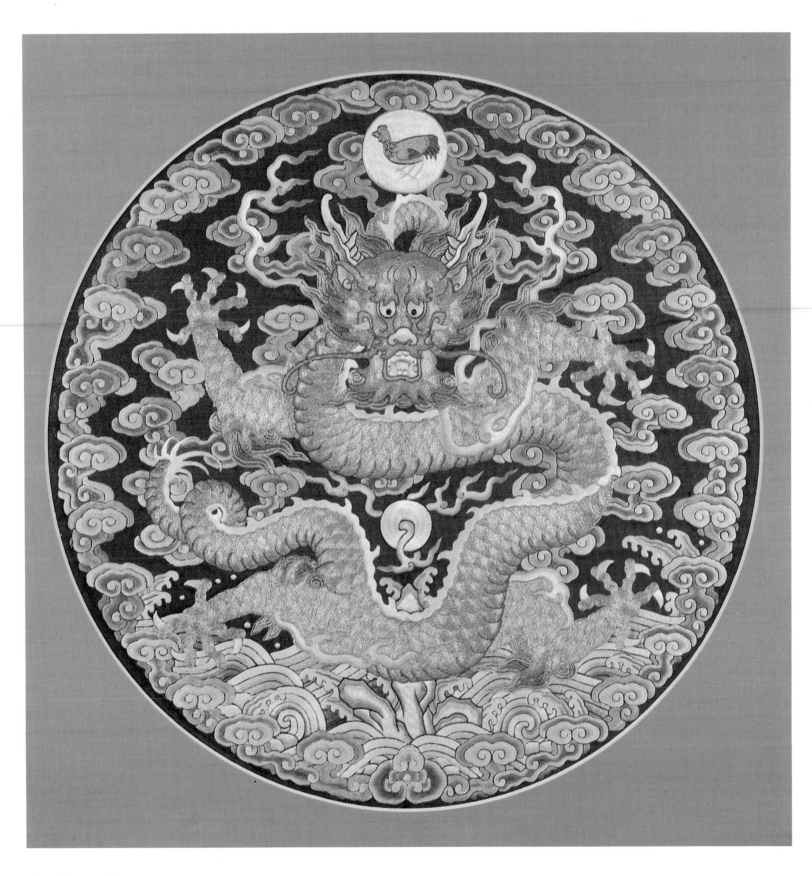

Pl.103 Emperor's insignia
Dragon roundel from the *gun fu* of an emperor
showing the Sun above the dragon's head.
Spink & Son Ltd

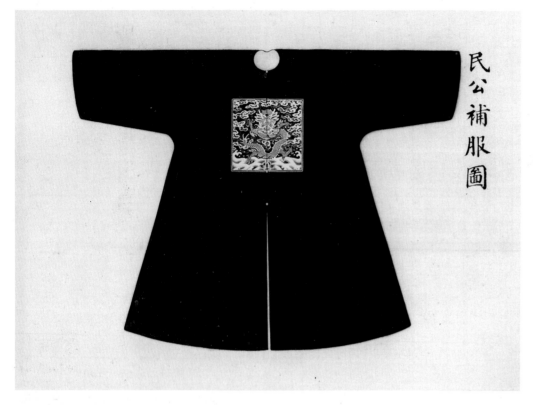

民公補服圖

Pl.104 Imperial duke's *pu fu*
Painting on silk of an imperial duke's *pu fu* displaying a four-clawed dragon square.
British Library

The crane was considered to be a very auspicious bird, whose name in Chinese is *xian he*. *Xian* means an immortal being, while a pun on the character *he* (crane) associates the bird with happiness. According to legend the white crane could live at least 2,000 years. The peacock is an obvious choice as a symbol of rank, its tail feathers even being used to decorate the hats of meritorious officials. The wild goose and mandarin duck were popular symbols that represented loyalty, a quality held in high esteem by autocratic emperors, and were usually associated with marriage because they were thought to mate for life.

Table 9: Imperial Nobles' Rank Insignia

Rank	Insignia
Emperor	4 roundels showing front-facing *long*; Sun on right shoulder, Moon on left shoulder; *shou* symbols on front and back roundels
Emperor's sons	4 roundels showing front-facing *long*
First-rank princes	4 roundels showing front-facing *long* on the chest and back with profile dragons on shoulders
Second-rank princes	4 roundels showing profile *long*
Third-rank princes	2 roundels showing front-facing *mang*
Fourth-rank princes	2 roundels showing profile *mang*
Imperial dukes	2 square badges showing front-facing *mang*
Other non-imperial nobles	as above

Table 10: Civil Officials' Rank Insignia

Rank	Bird
First	Manchurian crane
Second	golden pheasant
Third	peacock
Fourth	wild goose
Fifth	silver pheasant
Sixth	egret
Seventh	mandarin duck
Eighth	quail
Ninth	paradise flycatcher

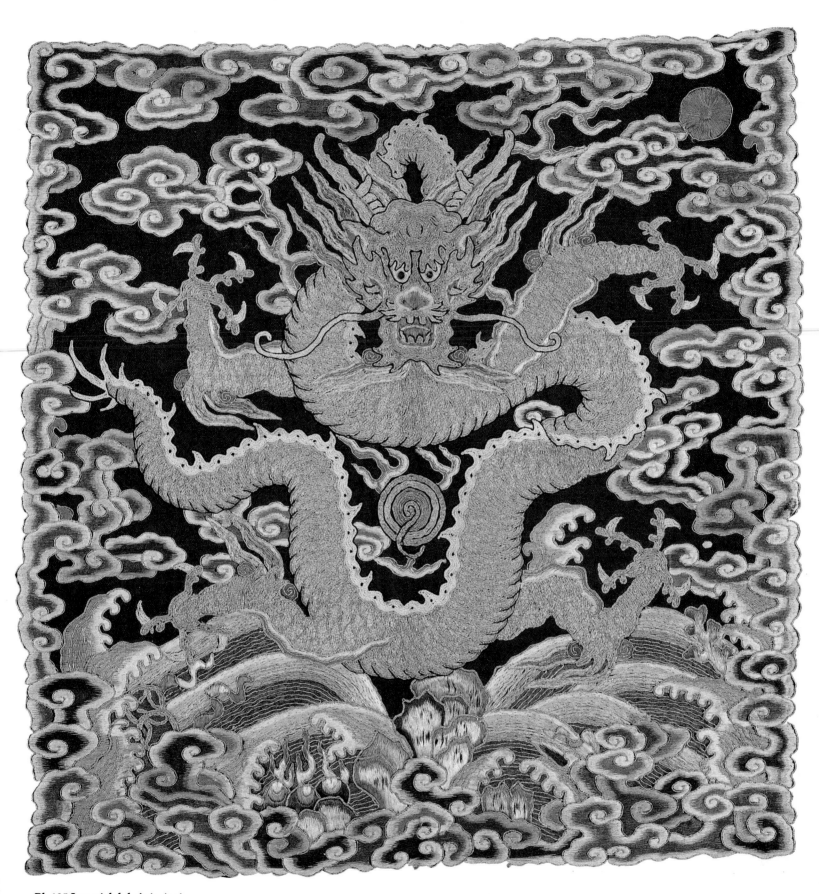

Pl. 105 Imperial duke's insignia
The square insignia badge of an imperial duke
showing a *mang* on a ground of five-coloured clouds.
Private collection

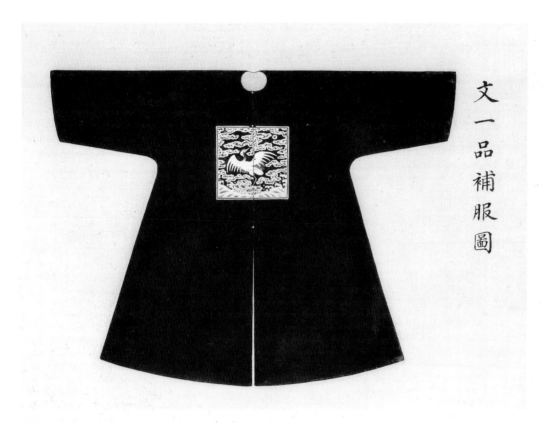

文一品補服圖

Censors' insignia

Huangchao liqi tushi made provision for special insignia badges to be worn by *yan yuan*, 'speech officials' or censors. During the Qing period, censors were usually drawn from the top ranks of official, and held concurrently such posts as viceroy and provincial governor. These censors had to wear the badges corresponding to their substantive civil or military ranks. The secretaries and clerks at the offices of the Censorate throughout the empire were supposed to wear square rank badges decorated with a fabulous animal called a *xie zhai*. This legendary creature is depicted as having a dragon's head with a single horn, a white body with a crested spine and a bushy tail.

Military insignia

Civil officials' rank badges survive in greater numbers than military insignia squares. A number of theories have been proposed to explain this disparity. The most probable explanation lies in the fact that there were many more civil than military posts. Military officials had square badges applied to the front and back of their *pu fu* displaying animals that symbolized courage and ferocity (see Table 11). The lowest ranks of the imperial nobility were also permitted to use military rank badges as their official insignia.

First-rank military officials were distinguished by badges displaying the *qi lin*. This fabulous creature is depicted in *Huangchao liqi tushi* with a dragon's head, a scaly body, graceful stag's legs and a bushy tail. Some rare insignia squares show the *qi lin* with short legs and paws. Imperial nobles of the ninth order of descent could also wear this badge. The second military rank wore badges showing the *shi zi*, a lion-like creature with a curly mane and bushy tail. Tenth-degree imperial nobles also wore this badge. Officials of the third and fourth military ranks wore badges displaying, respectively, a leopard and tiger. The leopard, of course, is shown with spots and the tiger with stripes. Imperial nobles of the eleventh and twelfth orders of descent also used these badges. Fifth-rank military officials used insignia badges displaying a bear. This animal closely resembles the lion of the second rank. It is usually depicted as a white or blue animal with curly hair on its back but without the lion's characteristic mane. Military officials of the sixth rank wore badges showing a *biao*, which is depicted on Qing insignia squares as a sleek panther-like animal

Table 11: Military Officials' Rank Insignia

Rank	Animal
First	*qi lin*
Second	*shi zi* (lion)
Third	leopard
Fourth	tiger
Fifth	bear
Sixth	*biao* (panther)
Seventh	rhinoceros
Eighth	rhinoceros
Ninth	sea-horse

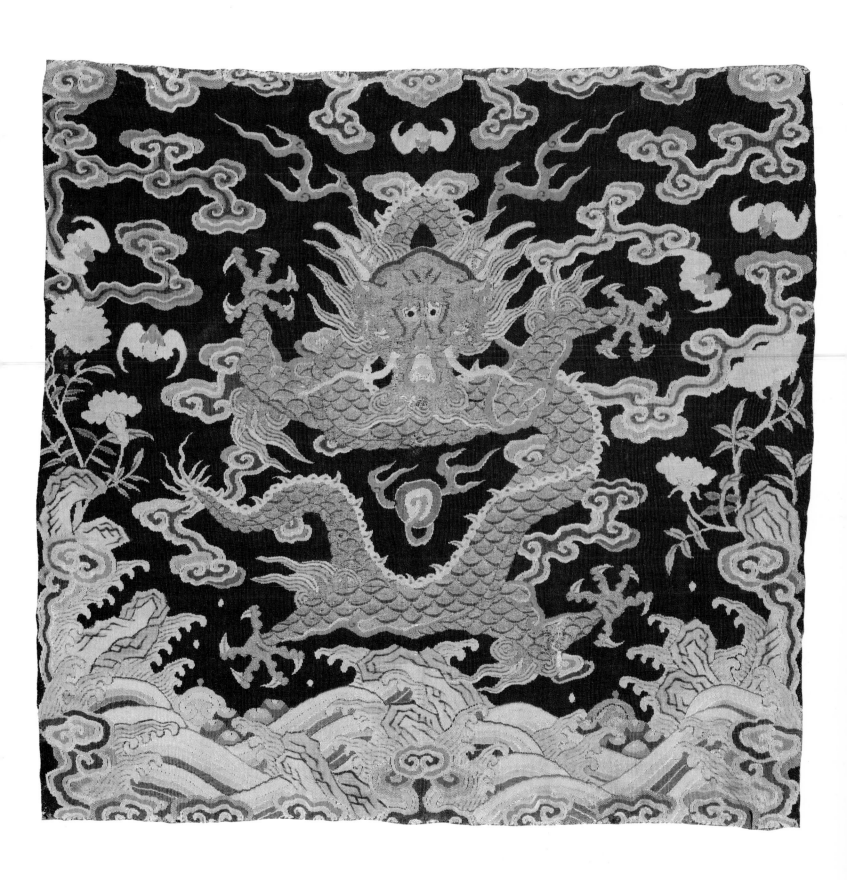

Pl.106 Imperial duke's insignia
This example of an imperial duke's insignia badge
displays a *long*.
Linda Wrigglesworth

文二品補服圖

Pl.108 Second-rank civil official's *pu fu*
Painting on silk of a second-rank civil official's *pu fu*
with insignia square showing the golden pheasant.
V&A

文三品補服圖

Pl.110 Third-rank civil official's *pu fu*
Painting on silk of a third-rank civil official's *pu fu*
with insignia badge showing the peacock.
V&A

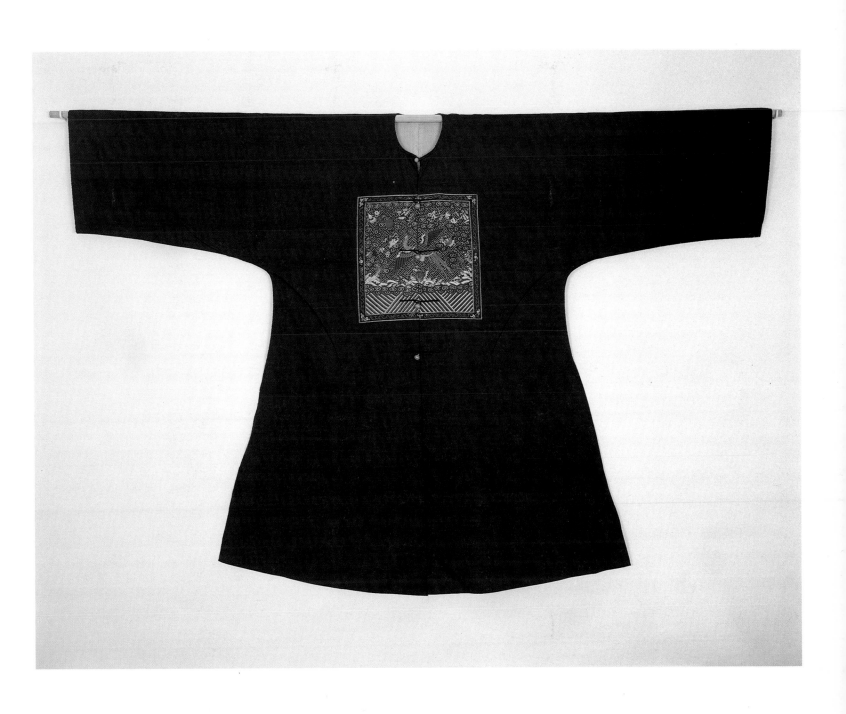

Pl.109 Second-rank civil official's *pu fu*
Officials' insignia badges were usually applied to
their surcoats. On this example the squares have
been tapestry-woven as part of the fabric of the coat.
Linda Wrigglesworth

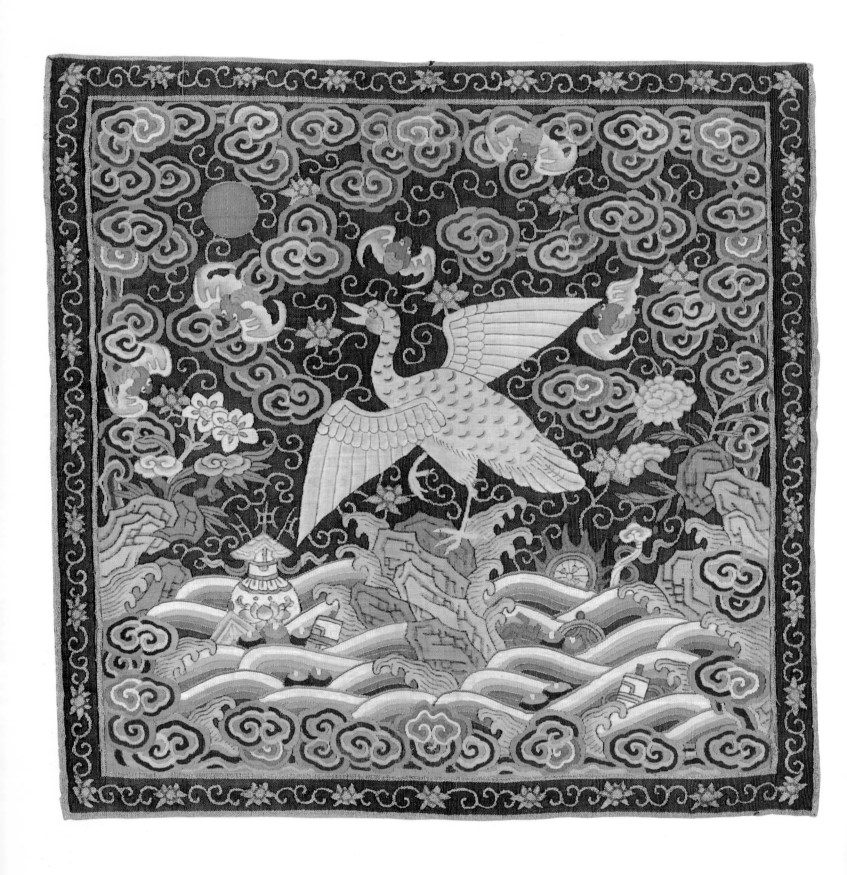

Pl.111 Fourth-rank civil official's insignia
Fourth-rank civil official's insignia badge displaying
the wild goose.
Linda Wrigglesworth

Pl.112 Fifth-rank civil official's *pu fu*
Painting on silk of a fifth-rank civil official's *pu fu*
with insignia badge showing the silver pheasant.
British Library

文五品補服圖

Pl.113 Sixth-rank civil official's insignia
Sixth-rank civil official's insignia badge displaying
the egret.
Linda Wrigglesworth

131

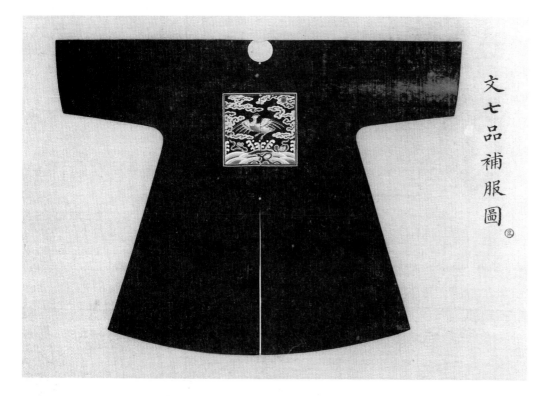

文七品補服圖

Pl.114 Seventh-rank civil official's *pu fu*
Painting on silk of a seventh-rank civil official's *pu fu*
with insignia square displaying the mandarin duck.
V&A

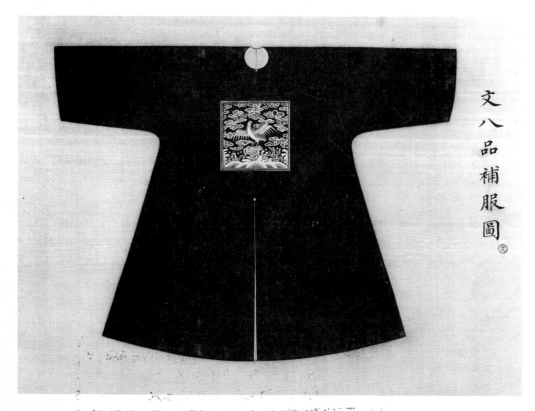

文八品補服圖

Pl.115 Eighth-rank civil official's *pu fu*
Painting on silk of an eighth-rank civil official's *pu fu*
with insignia badge showing the quail.
V&A

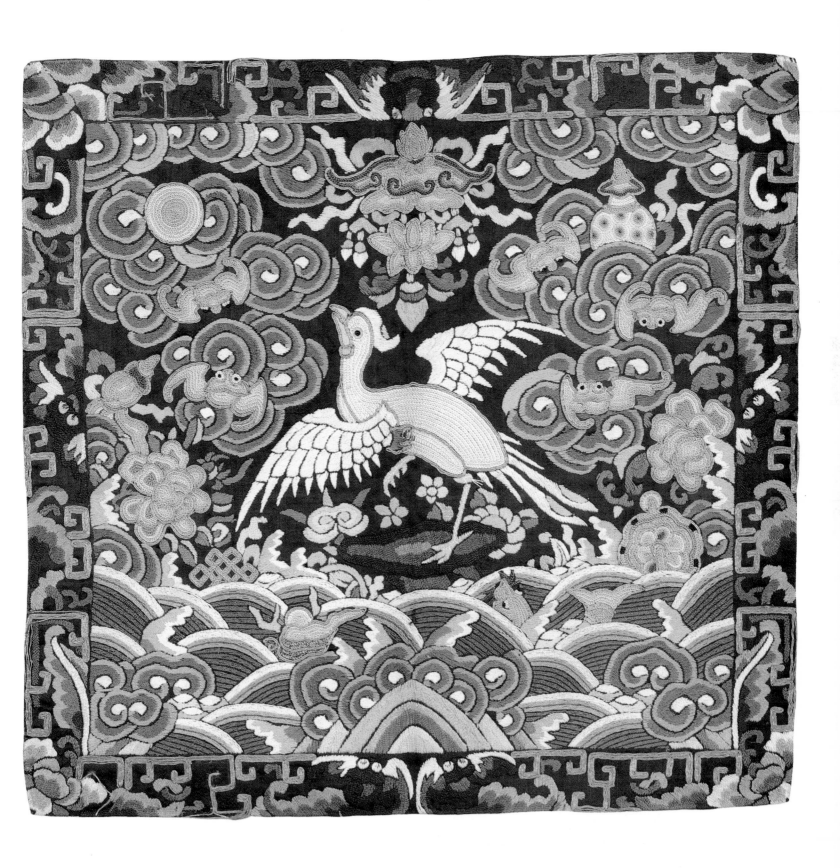

Pl.116 Ninth-rank civil official's insignia
Ninth-rank civil official's insignia badge displaying
the paradise flycatcher.
Linda Wrigglesworth

都御史補服圖

Pl.117 Censor's *pu fu*
Painting on silk of the *pu fu* of a censor with a badge showing the *xie zhai*.
V&A

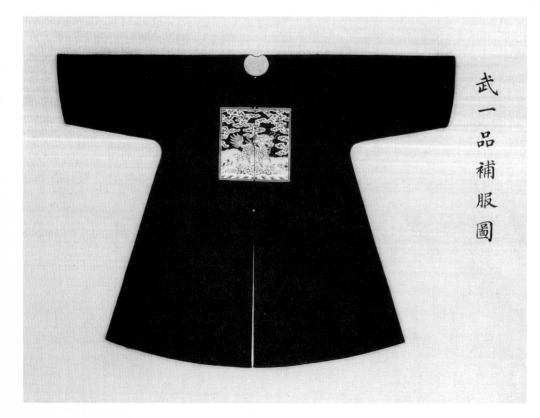

武一品補服圖

Pl.118 First-rank military official's *pu fu*
Painting on silk of a first-rank military official's *pu fu* with square badge showing the *qi lin*.
V&A

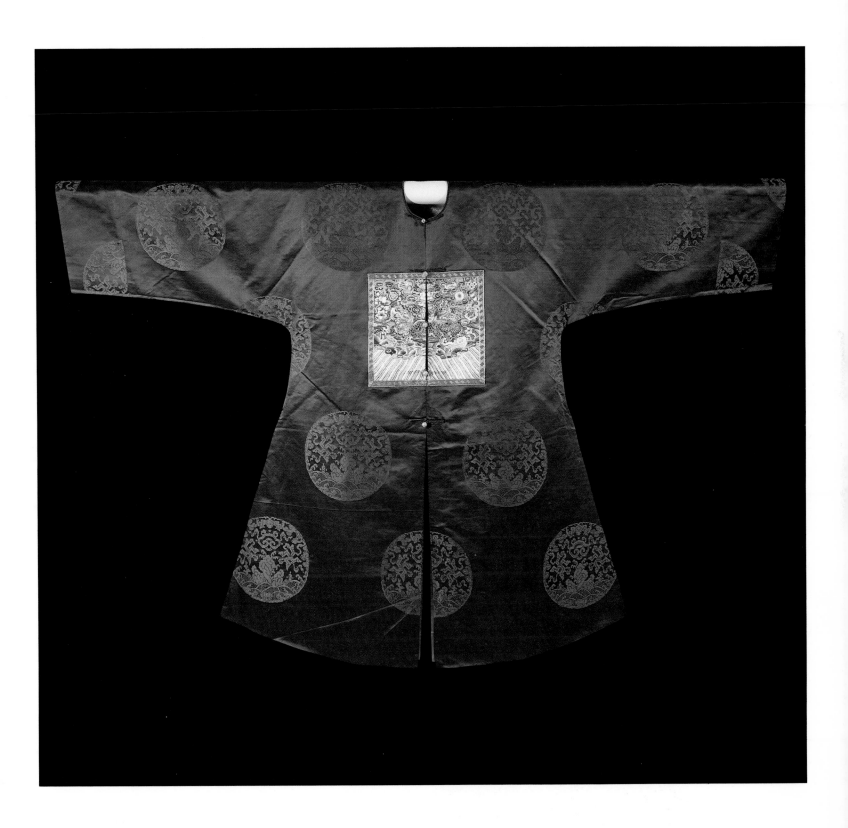

Pl.119 First-rank military official's *pu fu*
Some rare examples of military officials' rank badges
show the *qi lin* with short legs and paws rather than
the long graceful legs of a stag. This surcoat belonged
to Charles Gordon, who was given the first military
rank.
Royal Engineers Museum

with no distinctive markings. The seventh and eighth military ranks both wore badges decorated with an animal described as a *xi niu* or rhinoceros. *Huangchao liqi tushi* depicts this animal as a sheep or ram with a single horn. Members of the ninth military rank were supposed to wear badges decorated with *hai ma*, literally 'sea-horse'. This term has in the past been translated as sea-lion or seal. The illustrations in the 1766 block-printed edition of *Huangchao liqi tushi* and the folio paintings show the *hai ma* as a horse galloping over waves.

The various creatures displayed on the badges of the different ranks of noble and official largely follow the order established during the Ming period. Although they are depicted in a highly stylized fashion many of the beasts used by military officials were also based on real animals, such as the leopard and tiger. Some, such as the rhinoceros of the seventh and eighth military ranks, had long been extinct in China but had acquired an almost legendary status. Other animals used as rank insignia, such as the dragon, were purely mythological. But, whether imaginary or real, the creatures used as rank insignia were all important symbols in popular folklore. Nor does the order of precedence appear to have been arbitrary.

Purely mythological beasts were considered to be the most auspicious. The annals of Chinese history are full of references to the appearance of such supernatural creatures at the births and deaths of great men. Naturally, the dragon was the most important of these. The presence of claws was an important feature that distinguished the dragon from lesser creatures. It was largely this difference that made the dragon superior to another popular auspicious creature, the *qi lin*. As we have seen, the *qi lin* was used as rank insignia by imperial clansmen of the ninth order of descent (i.e. below the third and lowest grade of imperial duke), as well as by military officials of the first rank. Although having a dragon's head and scaly body, the *qi lin* suffers in comparison to the dragon in that it has cloven hooves rather than claws.

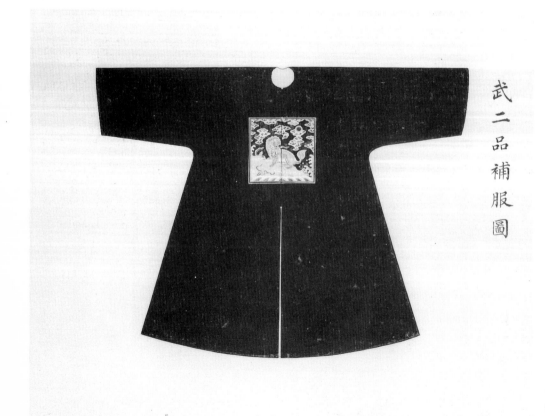

武二品補服圖

Pl.120 Second-rank military official's *pu fu*
Painting on silk of a second-rank military official's *pu fu* with insignia badge displaying the *shi zi*, the lion.
V&A

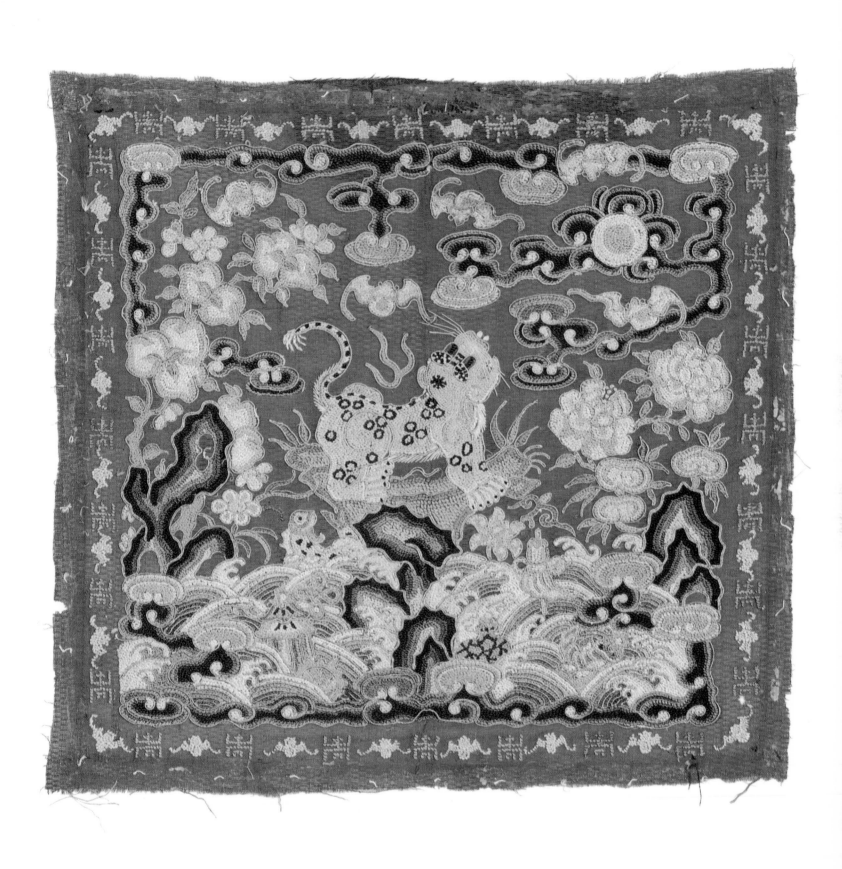

Pl.121 Third-rank military official's insignia
Third-rank military official's insignia badge
displaying the leopard.
Linda Wrigglesworth

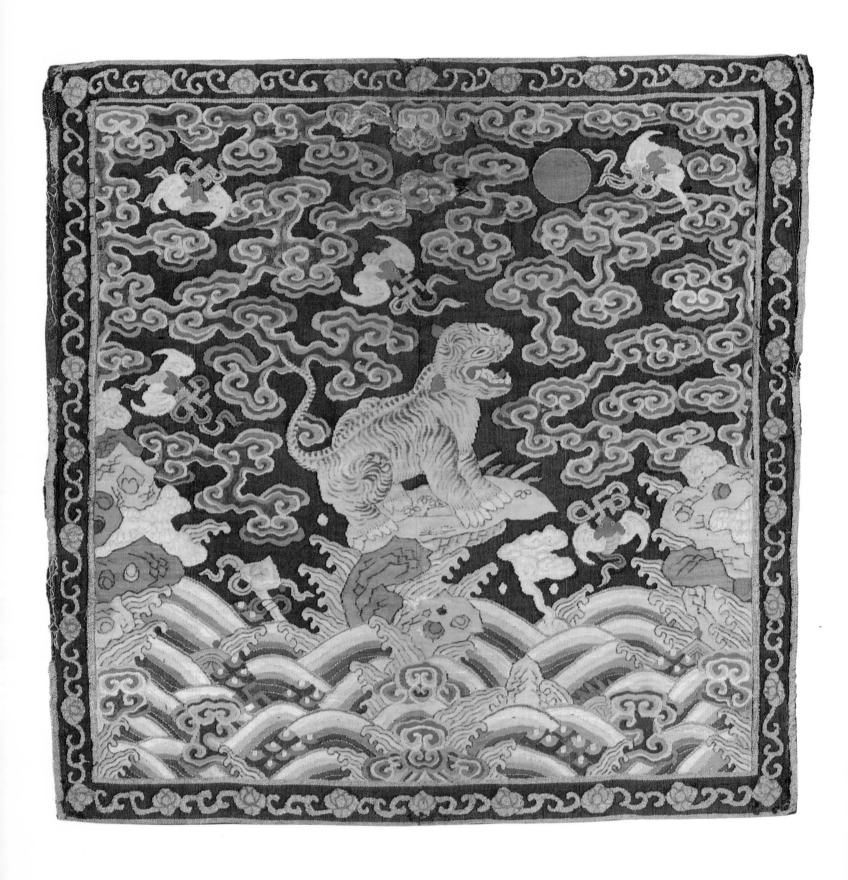

Pl.122 Fourth-rank military official's insignia
Fourth-rank military official's insignia badge
displaying the tiger.
Linda Wrigglesworth

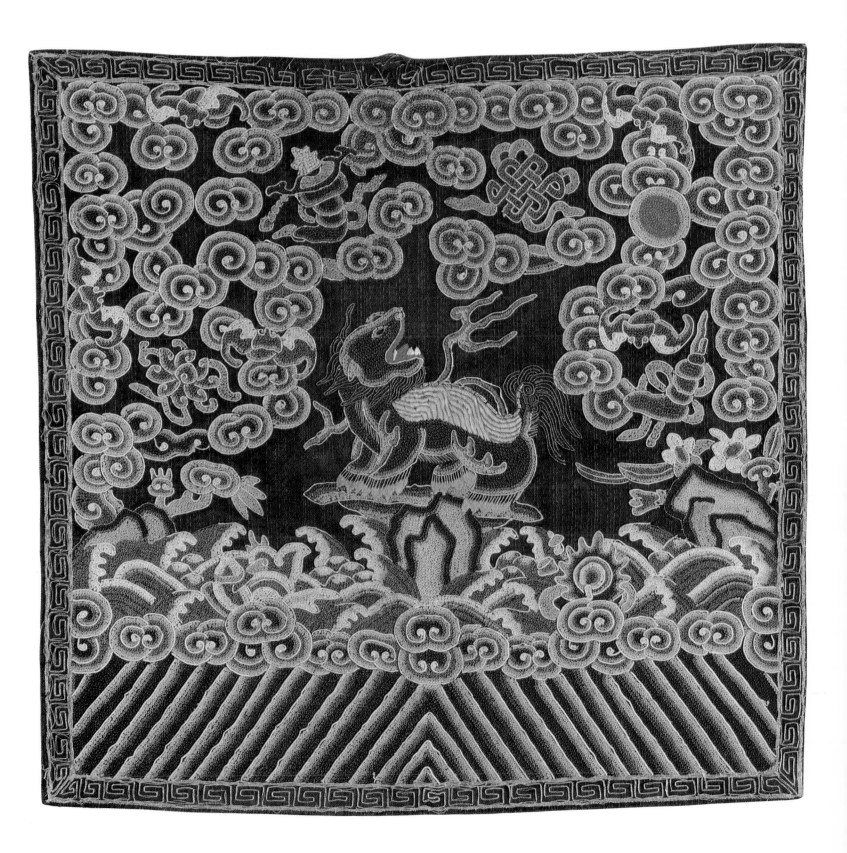

Pl.123 Fifth-rank military official's insignia
The insignia badges of fifth-rank military officials
were decorated with a bear. This animal is similar to
the lion of the second rank but lacks its characteristic
mane.
Linda Wrigglesworth

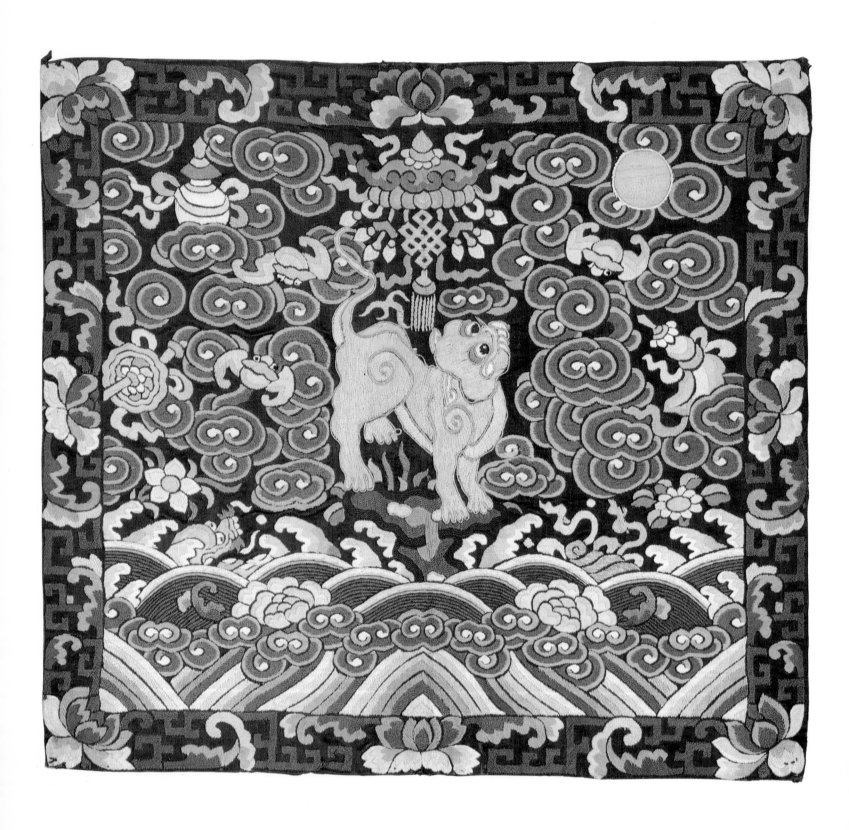

Pl.124 Sixth-rank military official's insignia
Sixth-rank military official's insignia badge showing
the *biao*, a panther-like creature.
Linda Wrigglesworth

Pl.125 Detail of seventh- and eighth-rank military officials' *pu fu*
Painting on silk of the *pu fu* of seventh- and eighth-rank military officials showing the *xi niu* or rhinoceros, as a brown sheep-like animal with a single horn.
V&A

Pl.126 Detail of a ninth-rank military official's *pu fu*
Painting on silk of the *pu fu* of a ninth-rank military official showing the *hai ma*, the sea-horse, as it gallops across waves.
V&A

The *xie zhai* is the only other purely mythological creature in the Chinese bestiary as represented by Qing insignia squares. In legend, the *xie zhai* was able to recognize the unjust and gore them with its single horn and it was probably this quality that made it an appropriate symbol for a censor. Like the *qi lin*, the *xie zhai* had a dragon's head, but it lacked scales on its body and had paws. The *xie zhai* is only distinguishable from another mythological creature, the *bai ze*, by having one rather than two horns. Like the *xie zhai*, the double-horned *bai ze* was a creature of great wisdom and had been used as rank insignia by low-ranking nobles during the Ming period. The *qi lin* took the place of the *bai ze* during the Qing period.

A folio illustration of a censor's *pu fu* from the manuscript edition of *Huangchao liqi tushi* clearly shows the creature on the insignia badge as having two horns, like a *bai ze*. The text, however, refers to the single-horned *xie zhai*. Examples of surviving insignia badges depict a dragon-headed animal with a single horn, a white body with a crested spine, and a bushy tail. They were most probably badges worn by clerks in the Censorate. There is, however, a possibility that this creature is also the *xi niu* or rhinoceros, worn by military officials of the seventh and eighth ranks. No examples matching the illustrations of the rhinoceros in *Huangchao liqi tushi* have come to light during our research. Even assuming that military officials had less occasion on which to use rank badges, it seems odd that the insignia of two ranks should be entirely absent in western collections. Yet censors' insignia badges, while not common, are not unknown.

Imperial nobles of the three lowest orders of descent were protected from becoming commoners and wore insignia badges decorated with the lion, the leopard and the tiger. These badges were also used by military officials of the second, third and fourth ranks. While all three animals are obviously based on real species, they are represented on Qing insignia as fantastic creatures with tongues of flame appearing from their bodies. The *shi zi* or lion does not appear to have ever been a native of China but had long been associated with Buddhism.

Position of Bird and Animal Insignia

Huangchao liqi tushi shows all the birds and animals depicted on rank badges facing towards a solar disc in the top right-hand corner of the square. The birds, alighting on a small rocky outcrop, spread their wings and turn as if to face the sun. All the military animals are shown looking directly towards the red disc. However, during the nineteenth century a different design begins to appear: the bird is sometimes shown facing towards a sun disc in the left-hand corner. Most military badges dating from this period depict the animals facing right.

The *pu fu* with its insignia badges was worn over formal court robes at many important court ceremonies. Civil officials usually occupied the place of honour on the eastern side of the emperor while their military counterparts took the western side. In these positions the left-handed birds and right-handed animals would both have faced towards the emperor.

During the Qing period, the wives of officials were permitted to wear the same insignia badges as their husbands. Although the wives of Chinese officials were not invited to court functions, in private, on important social occasions such as marriages, they wore a sleeveless vest called a *xia pei* which was loosely based on the stoles worn by ladies of the Ming court (see Women's Court Dress). On the front and back of these garments were insignia badges. When both husband and wife appeared together, the man took the place of honour on the left with his wife on the right. The woman wore her badges so that the bird or animal faced towards that of her husband, in the same way as the civil birds and military beasts did at court.

MEN'S COURT ROBES

Men's Court Robes

Early Court Robes

The early Manchu leaders obtained their first court robes either directly from the Ming court itself or from raids on Chinese settlements. The traditional Chinese cut of these garments was re-tailored to suit Manchu tastes (see The Imperial Wardrobe). In this way several important features of the patterns of Ming robes were carried over to Qing court dress. Although dependent on supplies of fabric from China, which made it difficult to impose control over patterns, Abahai nevertheless decreed that nobody below the highest rank of Manchu prince could wear yellow robes or have their robes decorated with *long*.

Court robes do not seem to have been widely available during the reign of the first Qing Emperor, Shunzhi. Commemorative portraits of nobles and officials dating from this period often carry inscriptions that indicate that their splendid court robes were gifts from the throne. In this way the court would have been able to keep a tight rein on the use of restricted colours and patterns. The first laws relating specifically to the designs of court robes begin to appear during the reign of the Kangxi Emperor, when the Qing dynasty had secured access to the silk producing areas of China. The greater availability of fabrics brought with it the opportunity for misuse.

Chao fu

Chao fu was perhaps the most conservative costume in the official wardrobe and only relatively minor changes were made to its design during the Qing period. During the late Kangxi or, more probably, Yongzheng periods series of small dragon medallions were added to the pattern of the *chao pao*. The Palace Museum in Peking has a series of commemorative portraits that shows the Kangxi, Yongzheng and Qianlong Emperors wearing *chao pao* decorated with these dragon medallions. The Twelve Symbols must have been added to the design of imperial robes sometime between 1736 and 1759. The final forms of *chao fu* were established during Qianlong's reign and incorporated into *Huangchao liqi tushi*.

The *chao pao* was tailored in two sections consisting of a hip-length bodice with tapered, composite sleeves and horsehoof cuffs, attached to a fully pleated skirt. This two-part construction was probably a feature inherited from Ming court dress. On the right side, at the seam between the lower and upper sections of the robe, there was a small square flap called a *ren*. The *ren* is not a pocket and apparently served no purpose. In her book *Chinese Dress*, Verity Wilson states that the *ren* may originally have been a scabbard slide.

The *pi ling* was a wide, stiffened collar that emphasized the shoulders. The illustrations in *Huangchao liqi tushi* show the *chao pao* and collar together, confirming that the *pi ling* was an integral part of *chao fu*. When the dark-coloured *pu fu* was worn with *chao fu*, the *pi ling* was worn over the surcoat.

Officials in regular attendance at the palace needed several sets of court robes to meet the demands of court ritual. However, for most officials the occasions on which they were required to wear *chao fu* were extremely rare. To save themselves the enormous expense of providing complete suits of *chao fu*, some officials wore a pleated skirt decorated with a band of dragons and often a series of medallions, although strictly speaking they were not permitted to use this decorative feature. Concealed beneath the dark-coloured surcoat with its distinctive insignia badges, this skirt was a substitute for a full robe. Most of these skirts date from the late nineteenth century and range enormously in quality. The crudest examples could simply have been burial garments.

Pl.127 Imperial nobleman's winter *chao fu*
Commemorative portrait of an early Qing nobleman
wearing winter *chao fu*. The pattern of his *chao pao*
appears to derive from court robes of the Ming
period.
British Museum

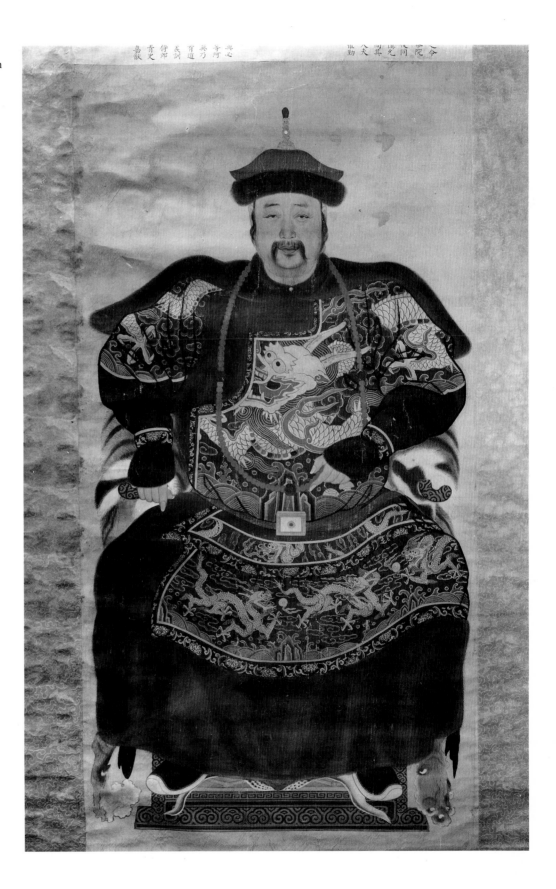

Winter *chao fu*

The emperor had two quite distinct styles of winter *chao fu*. The first was heavily decked with furs. The line of the robe's right-hand closure as well as the lower portion of the skirt, the cuffs, *ren*, and the *pi ling* were all completely faced with fur. The robe was also apparently lined with fur. For ordinary ceremonial occasions, between the first of the eleventh moon and the New Year, the emperor wore a yellow-coloured *chao pao*. However, for the winter solstice sacrifice at the Altar of Heaven he wore this style of winter *chao pao* in blue.

The upper body of the robe was decorated with four front-facing *long*, the Twelve Symbols, and other cosmological motifs in a characteristic four-lobed pattern that extended over the chest, back and shoulders. The upper part of the skirt was decorated with a band of dragons: one front-facing, and two profile *long* on both the front and back of the skirt.

This first style of winter *chao fu* was perhaps the most important costume in the official wardrobe. Its use was restricted to the imperial nobility and civil officials of the first three ranks, but only military officials of the first two ranks and imperial guardsmen of the first class could wear this type of *chao fu* (see Table 12).

One of the reasons for the restriction on this style was its lavish use of precious furs such as sable. The majority of sable pelts used for court robes came from a region north of the Amur river in Manchuria. By the middle of the eighteenth century the court had become dependent on Russian traders for sables. This factor may have led to the restrictions on the use of sable.

Table 12: First Style of Winter *chao fu*

Rank	Colour	Pattern
Emperor	yellow/blue*	front-facing *long* on chest, back and shoulders; 1 front-facing and 2 profile *long* on front and back of skirt; Twelve Symbols all confined to the upper part of the robe
Crown prince	apricot-yellow	as above but without the Twelve Symbols
Emperor's sons	golden-yellow	4 front-facing *long* on upper body; 4 profile *long* on front and back of skirt
First- & second-rank princes	brown or blue**	as above
Third- & fourth-rank princes	brown or blue**	4 front-facing *mang* on upper body; 4 profile *mang* on front and back of skirt
Other nobles; officials of the first, second & third civil ranks; officials of the first & second military ranks; first-class imperial guardsmen	blue-black	4 profile *mang* on upper body; 2 *mang* on front and back of skirt

* The emperor wore blue robes at the Altar of Heaven.
** These nobles were permitted to wear any colour except orange or yellow, unless expressly given the right to do so.

Pl.128 Court skirt
This design of an official's court skirt is based on the
skirt section of the *chao pao*.
Linda Wrigglesworth

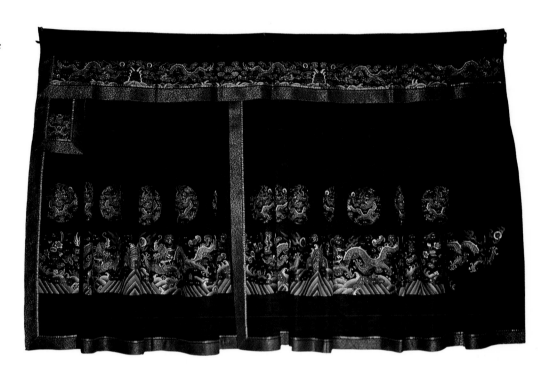

Pl.129 Emperor's winter *chao fu*
Painting on silk of the emperor's first style of winter
chao fu.
V&A

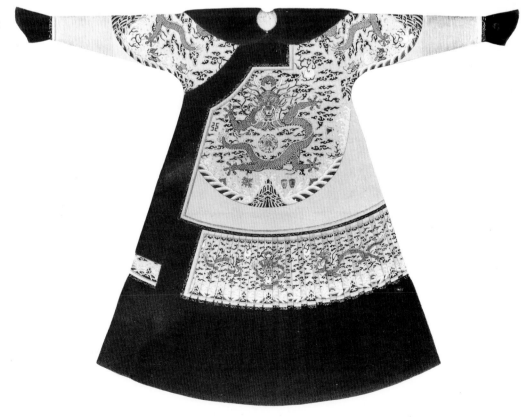

The *huang tai zi*, crown prince, was permitted to wear exactly the same type of *chao fu* as the emperor but without any of the Twelve Symbols and the ground colour of the robe had to be *xing huang*, apricot-yellow. In modern Chinese usage *xing huang* describes the colour orange. Although the meaning of the term may have changed since the eighteenth century, we can be almost certain that *xing huang* was an orange-yellow colour. Unfortunately, none of the folios from the manuscript based on *Huangchao liqi tushi*, which provides us with new information regarding other colours, shows an example of apricot-yellow.

The emperor's other sons, *huang zi*, had to wear robes of *jin huang* or golden-yellow, and instead of three dragons across the front and back of the skirt they had to have four profile dragons. Imperial princes wore robes decorated with exactly the same pattern but could only use *jin huang* if the right to do so had been specifically extended to them. However, the surviving folios from the manuscript based on *Huangchao liqi tushi* indicate that they were allowed a choice of either brown or blue.

The British Library's collection of folios from this manuscript include illustrations of the two styles of *chao fu* worn by imperial princes during winter. The first shows the *chao pao* as having a rich brown ground colour while the second is depicted in blue. The descriptive text accompanying these illustrations does not specify the colour of the robes but simply repeats the injunction against using *jin huang*.

Only the top two ranks of prince were permitted to display *long* on their court robes. Other nobles were, strictly speaking, only allowed the *mang*, although in practice this restriction appears to have been largely ignored. There were several attempts to enforce this regulation, but all proved unsuccessful.

The first style of winter *chao fu* of those ranks of official and imperial guardsmen who were permitted to wear it differed in two respects from the dress of their superiors.

Pl.132 Imperial duke's winter *chao fu*
Illustration of an imperial duke's first style of winter *chao fu*.
SOAS

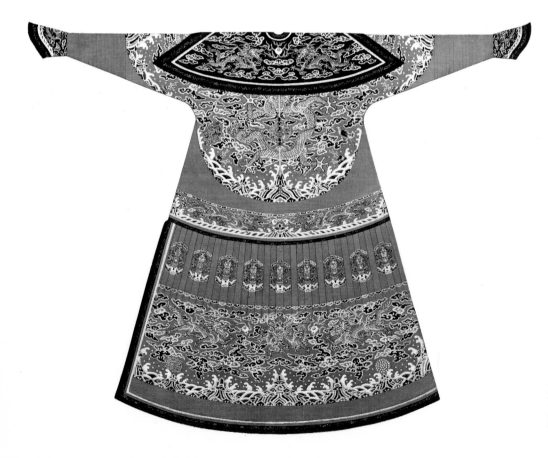

Pl.133 Emperor's winter *chao fu*
Painting on silk of the emperor's second style of winter *chao fu*.
V&A

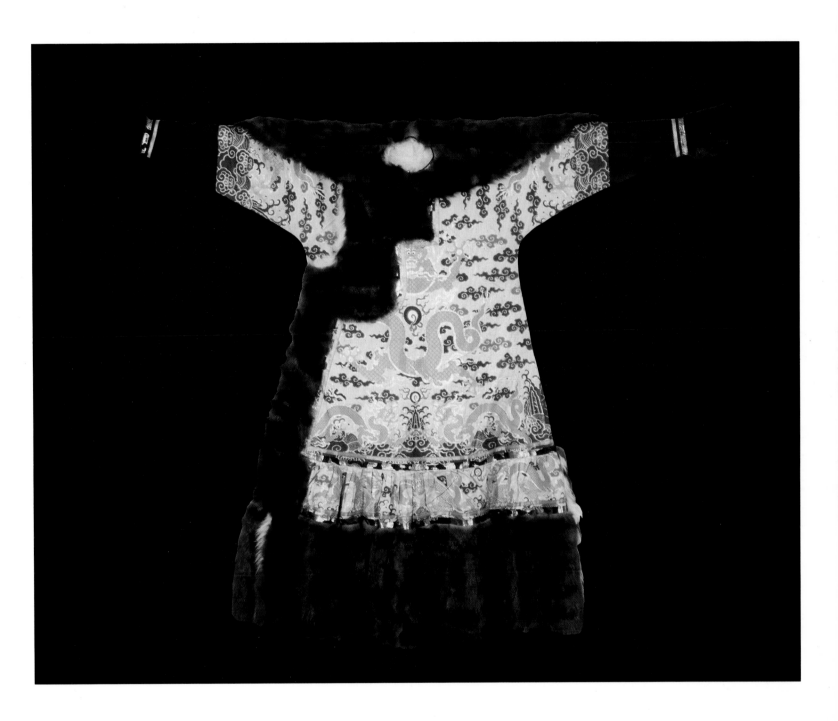

Pl.130 Emperor's winter *chao fu*
The lavish use of furs on the first style of winter *chao fu* points to it having been one of the earliest garments in the official wardrobe. These imperial *chao fu* were probably made for the Kangxi Emperor. Palace Museum

Instead of front-facing dragons on the chest, back and shoulders of the *chao pao* they were only allowed *mang*, in profile, and on the skirt they could only use two profile dragons. The robe also had to be blue-black in colour. The same ranks of official were allowed front-facing dragons on the upper body of their second style of winter *chao pao* as well as on their summer robes.

Although of the same basic two-part construction, the second style of winter *chao fu* was simply trimmed with fur. The pattern of the *chao pao* worn as part of this type of costume was very similar to that of the first winter *chao fu*. The upper body of the robe is decorated with a four-lobed yoke which extends over the chest, back and shoulders. The band of dragons around the skirt is dropped to just above the hem. In addition, another strip of dragons decorate the waist, just above the seam between the bodice and the skirt. The cuffs and *pi ling* are made of dark-coloured silk and are also decorated with dragon patterns.

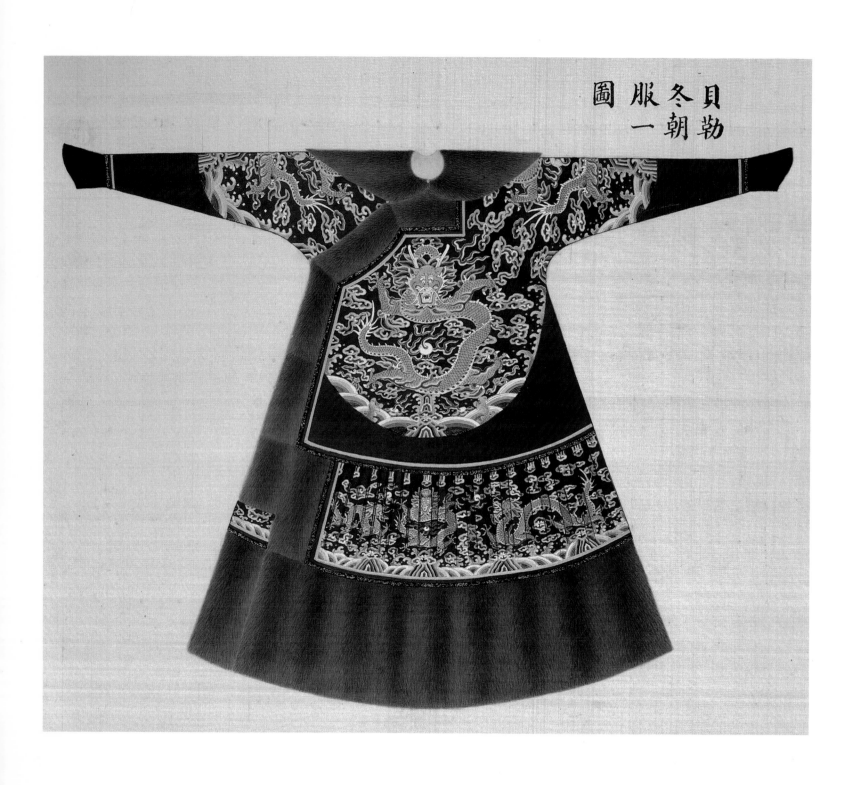

圖服冬貝
一朝勒

Pl.131 Imperial prince's winter *chao fu*
Painting on silk of an imperial prince's first style of
winter *chao fu*. The corresponding illustration of a
prince's second style of winter *chao fu* shows the
ground colour of the robe to be blue. The
accompanying text does not specify which colour
should be used but simply repeats the injunction
against the wearing of golden-yellow.
British Library

Pl.134 Imperial prince
The badges of rank and the ruby mounted on the hat indicate that the sitter in this commemorative portrait was a prince of the highest degree. His robe is shown as orange-yellow in colour. He may, therefore, have been a son of an emperor or an imperial noble who had been given the right to use golden-yellow.
Metropolitan Museum of Art

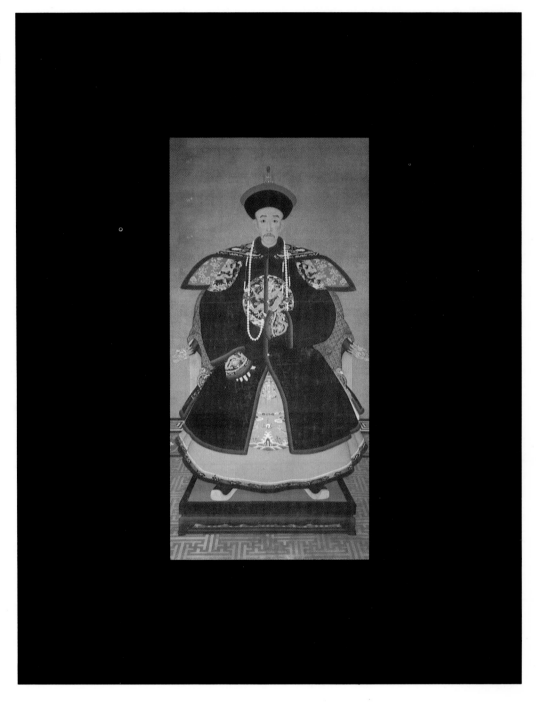

All ranks of noble and the top four ranks of civil and military official were permitted to wear the second style of winter *chao fu*. Again, there were variations in the number and disposition of the dragons according to rank (see Table 13). The emperor's robes are distinguished from all others by the presence of the Twelve Symbols; the upper part of his skirt was also decorated with small dragon medallions, nine across the front and nine at the back. The crown prince was permitted to use seven medallions on the front and back skirts. No other rank was permitted to use these medallions. During the nineteenth century many nobles and even officials appear to have adopted various numbers of medallions.

The *huang zi* were, again, permitted to wear golden-yellow robes, while other ranks of imperial prince could only use this colour if they had been specifically given the right to do so. No examples of a golden-yellow *chao pao* have come to light during our research. However, the fine collection of Qing commemorative portraits in the Metropolitan Museum of Art in New York includes a painting of an unknown imperial prince which shows him wearing an orange-coloured robe as part of his *chao fu*. The insignia badges on his surcoat and the ruby set in the top of his formal court hat indicate that he was a prince of the highest degree, *jin wang*. This suggests that he was the son of an emperor or had been given the right to use *jin huang* as an honour.

Summer *chao fu*

Huangchao liqi tushi makes a distinction between the second type of winter *chao fu* and the single style of summer *chao fu*. In fact the two styles of dress were identical both in construction and decoration. The only difference was that the summer *chao pao* was edged with brocade and could be made of gauze. *Chao fu* is one of the rarest types of Qing court dress in collections today although summer *chao fu* survives in much larger numbers than either of the winter styles. This is because officials who had occasion to wear *chao fu* during their lifetime were normally buried in the costume. During the Qing period it was also customary for officials to be buried wearing winter costume rather than summer dress.

Table 13: Second Style of Winter and Summer *chao fu*

Rank	Colour	Pattern
Emperor	yellow/other colours	front-facing *long* on chest, back and shoulders; upper part of skirt decorated with 9 dragon medallions on front and back of the skirt; lower part of skirt decorated on front and back with 1 front-facing and 2 profile *long*; Twelve Symbols
Crown prince	apricot-yellow	as above but without Twelve Symbols and only 7 dragon medallions on front and back of skirt
Emperor's sons	golden-yellow	4 front-facing *long* on upper body; lower part of skirt decorated on front and back with 4 profile *long*
First- & second-rank princes	brown or blue	as above
Third- & fourth-rank princes; other nobles	brown or blue	4 front-facing *mang* on upper body; lower part of skirt decorated on front and back with 4 profile *mang*
Officials of the first four ranks; first-class imperial guardsmen	blue-black	as above

Pl.135 Imperial duke's summer *chao fu*
Painting on silk of an imperial duke's summer *chao fu*.
British Library

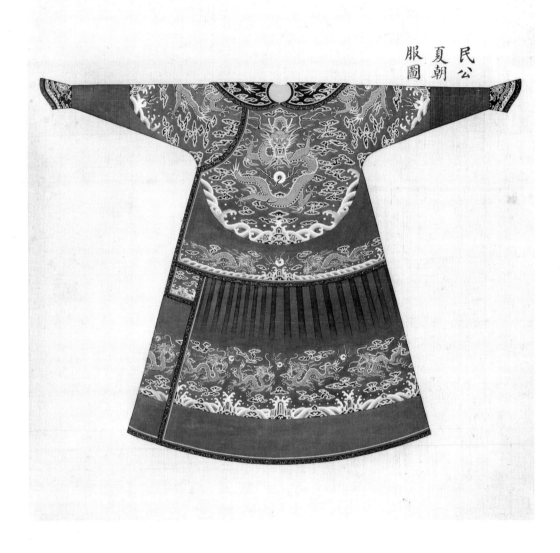

民
公
夏
朝
服
圖

Other *chao fu*

Low-ranking officials and imperial guardsmen were also permitted to wear *chao fu*. Although the construction of their garments was similar to those of higher-ranking individuals, the patterns on the *chao pao* were radically different. Imperial guardsmen of the second and third class wore *chao fu* that resembled the first style of winter *chao fu*, the type heavily decked with furs. The lower part of the skirt, the cuffs and *pi ling* were all faced with dark-coloured crimped satin. They wore these robes during the summer and the winter months. The body of the *chao pao* was damasked all over with cloud patterns and, on the chest and back, were square badges displaying profile *mang*. Imperial guards of the second class also had a strip of dragons on the lower part of the body, above the seam between the bodice and skirt.

All officials of the fifth, sixth and seventh ranks were also only permitted to wear one type of *chao fu*. Their *chao pao* had the same construction as the second winter and summer styles of robe worn by their superiors. However, the robe's ground was plain except for the cloud pattern damask and the profile dragon badges on the chest and back. These square badges were not insignia squares. The officials would have worn *pu fu* displaying the appropriate bird or animal to their rank. Officials of the two lowest ranks wore severely plain *chao pao* which did not have the profile dragon squares and were only decorated with the cloud damask (see Table 14).

Pl.136 Imperial guardsman's *chao fu*
Illustration of the *chao fu* of a second-class imperial guardsman.
SOAS

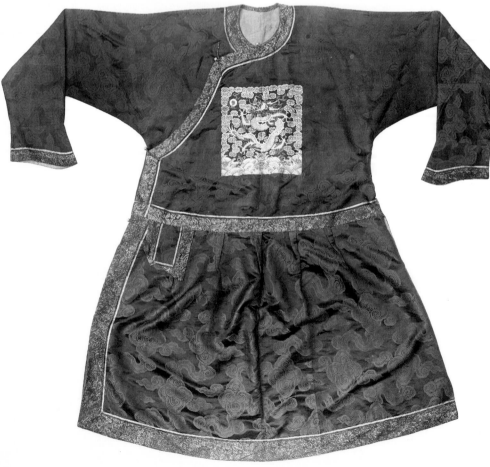

Pl.137 *Chao pao*
Example of a state robe appropriate for use by an official of the fifth, sixth or seventh rank as part of his *chao fu*.
Metropolitan Museum of Art

Table 14: Other *chao fu*

Rank	Pattern
Second-class imperial guards	construction same as first style winter *chao fu*: lower part of skirt, cuffs and *pi ling* completely faced with dark-coloured, crimped satin; body of robe damasked with cloud pattern; square badges on chest and back displaying profile *mang*; strip of dragons above seam between bodice and skirt sections
Third-class imperial guards	same as above but without strip of dragons at waist level
Officials of the fifth, sixth & seventh ranks	construction same as summer *chao fu*: robe damasked all over with cloud pattern; square badges on chest and back displaying profile *mang*; edged with brocade
Officials of the eighth & ninth ranks	construction same as above; body of robe damasked all over with cloud pattern

Chao dai

The *chao pao* was held tightly around the waist by the *chao dai*, or court belt. The colour of the belt varied according to rank. The emperor wore a yellow belt or, at imperial sacrifices, other colours. The crown prince wore apricot-yellow, while all other members of the imperial clan were permitted to wear golden-yellow court belts. Manchu belonging to the collateral branches of the royal Gioro clan wore red belts. Other nobles and all officials could use only blue or blue-black girdles.

The *chao dai* was decorated with four belt plaques. Ornamented plaques were an important part of a Ming courtier's insignia and the Manchu court adopted them in 1636. The plaques varied according to rank. The emperor had two types. The first was round and was set with either red, blue or turquoise stones, five large Eastern and some 20 small pearls. The second type was square and had different settings depending on the ceremony at which they were to be worn. At the sacrifice to Heaven, lapis lazuli was used, at the Altar of Earth, yellow jade, at the sacrifice to the Sun the plaques were set with coral, and at the Altar of the Moon, green or white jade was used.

The crown prince also wore round belt plaques but these were set with lapis lazuli and had five pearls only. The emperor's other sons had four square belt plaques set with a cat's-eye surrounded by four pearls. All other imperial princes were permitted to use the same type. Officials of the first rank also had square belt plaques but these were inlaid with a piece of white jade in the centre of which was set a single red stone. Lower-ranking officials wore plainer belt plaques (see Table 15).

Suspended from both the left and right sides of the belt were two small purses. On the belts worn for the state sacrifices these were plain, while the purses used for other important court ceremonies were embroidered. The purse-strings matched the colour of the cloth belt itself. Also suspended from the belt were a small knife and two ceremonial kerchiefs. The latter were bands of white and blue silk with pointed ends which were twisted together at the top and passed through a metal collar or clasp.

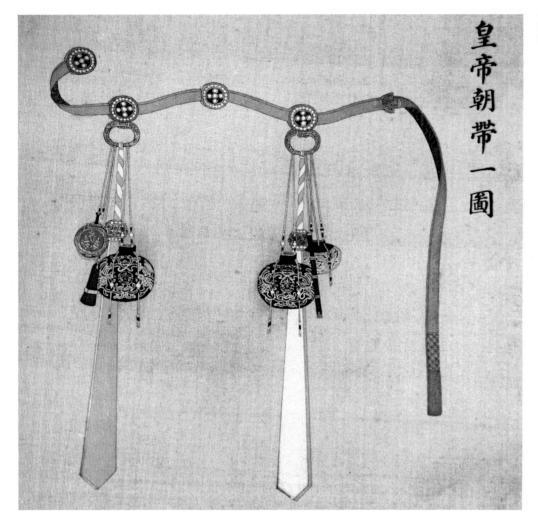

Pl.138 Emperor's *chao dai*
Painting on silk of an emperor's *chao dai*.
V&A

Table 15: *Chao dai*

Rank	Colour of Belt	Belt Plaques
Emperor	yellow	4 round gold plaques set with coral/turquoise and 25 pearls
	yellow, red or blue	4 square gold plaques set with jade/coral/lapis lazuli
Crown prince	apricot-yellow	4 round gold plaques set with lapis lazuli and 5 pearls
Imperial princes	golden-yellow	4 square gold plaques set with a cat's-eye and 4 pearls
Other nobles	red	as above
First-rank officials	blue-black	4 square gold plaques inlaid with white jade and set with a red stone
Second-rank officials	blue-black	4 round chased gold plaques set with a red stone
Third-rank officials	blue-black	4 round chased gold plaques
Fourth-rank officials	blue-black	4 round chased gold plaques inlaid with a silver boss
Fifth-rank officials	blue-black	4 round gold plaques inlaid with a silver boss
Sixth-rank officials	blue-black	4 round gold plaques inlaid with tortoise-shell
Seventh-rank officials	blue-black	4 round silver plaques
Eighth-rank officials	blue-black	4 round silver plaques inlaid with transparent ram's horn
Ninth-rank officials	blue-black	4 round silver plaques inlaid with black horn

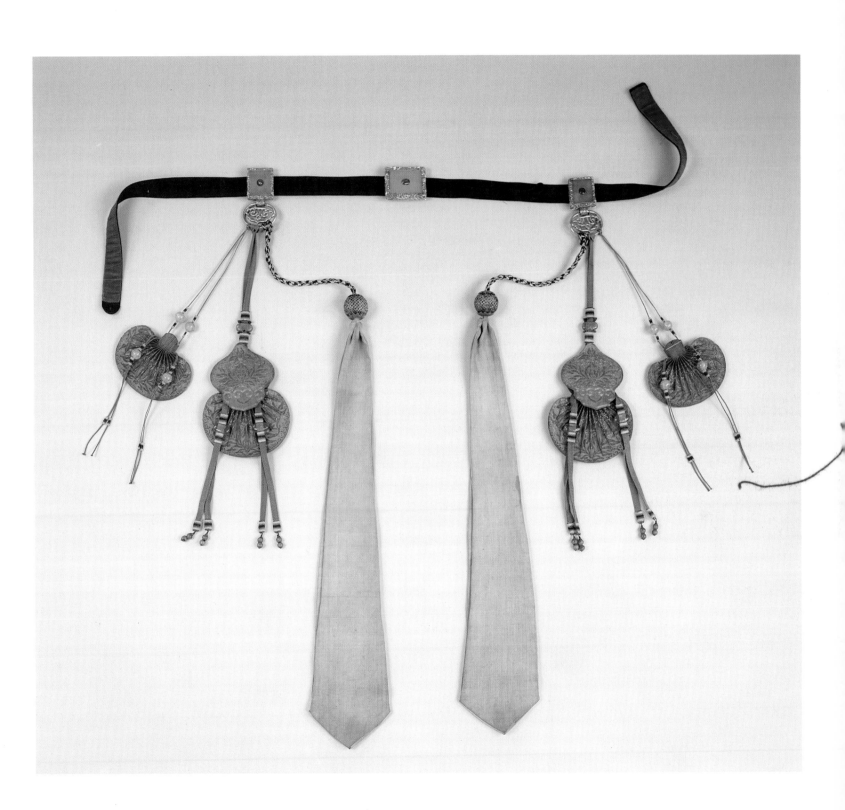

Pl.139 First-rank official's *chao dai*
The pendant purses and ceremonial kerchiefs with
their pointed ends can be clearly seen on this
example of a first-rank official's *chao dai*. The belt
plaques are gilt bronze inlaid with white jade and set
with a small red stone. This belt was presented to
General Gordon by the Tongzhi Emperor.
Royal Engineers Museum

157

Chao zhu

The *chao zhu* or court necklace was an important part of Qing ceremonial dress. Its design appears to have been based on the Buddhist rosary and it was probably introduced into the official wardrobe by the first Qing Emperor, Shunzhi, who was a devout Buddhist. The main string was composed of 108 small beads equally divided into groups of 27 by four larger beads called 'Buddha heads'. Attached to one of these larger beads was a long tape, decorated about half-way down by a plaque and finished with a pendant. Also attached to the main string were three smaller strings of 10 beads, each divided into two sets of five beads. When the *chao zhu* was worn, two of these subsidiary strings hung from the left shoulder and the other from the right shoulder. The long tape hung down the back from the nape of the neck and probably acted as a counterweight.

The use of *chao zhu* was restricted to imperial nobles and officials down to the fifth rank. The materials each rank of person could use for their *chao zhu* were, of course, strictly prescribed. The emperor's principal *chao zhu* was made of 108 Eastern pearls. The four larger beads were made of coral with two tiny lapis lazuli beads either side. The three subsidiary strings were made of green jade and the plaque at the back set with a cat's-eye. All the pendants were made from coral. The *chao zhu* worn by the emperor at the state sacrifices were made of different coloured materials appropriate to each occasion, while the strings and tape used were yellow.

The crown prince was allowed to use any semi-precious stones, with the exception of Eastern pearls, on his *chao zhu*, which were strung on apricot-yellow thread. The emperor's other sons and imperial princes of the first two degrees were supposed to use amber with golden-yellow strings, while other nobles and officials were permitted to use any stone other than pearls strung with blue-black thread. In practice many *chao zhu* were made of glass imitations of jade and amber.

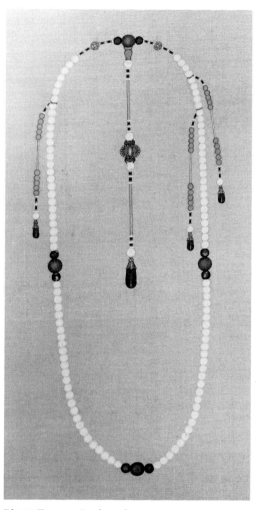

Pl.140 Emperor's *chao zhu*
Painting on silk of an emperor's *chao zhu*.
V&A

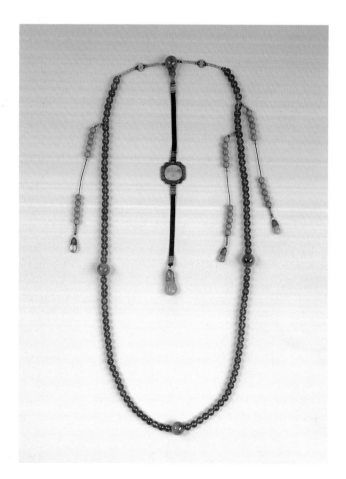

Pl.141 *Chao zhu*
Officials were permitted to use *chao zhu* of any semi-precious stone except the restricted ones. This example, presented to General Gordon by the Tongzhi Emperor, is made of amber, jade and coral beads with rose quartz and peridot pendants.
Royal Engineers Museum

Pl.145 Detail of dragon robe
The hidden ninth dragon can be seen here on the underflap of this dragon robe. The dragon has been embroidered on both sides of the gauze.
Private collection

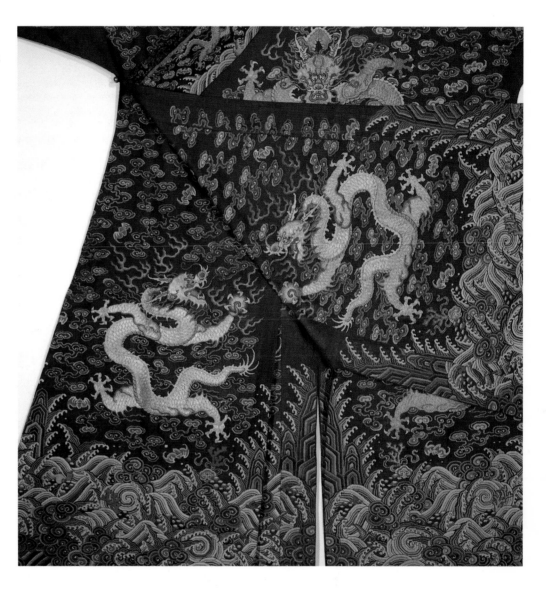

Ji fu

The less formal style of Qing court dress known as *ji fu* consisted of a full-length robe decorated with dragon patterns and was worn tightly belted. The *ji fu dai*, the festive dress belt, was similar to the *chao dai* except that its decorative belt plaques were not as strictly regulated and the ceremonial kerchiefs were straight and had squared rather than pointed ends. *Ji fu* was usually worn with the *ji guan* or festive hat, the court necklace and the surcoat for ordinary court ceremonies. For imperial birthday celebrations and on semi-formal occasions, the surcoat could be dispensed with and the splendour of the robe revealed.

The robe worn as part of *ji fu* was called a dragon robe because of the principal motif emblazoned on it. Of all Qing court robes in western collections, the dragon robe has survived in the greatest numbers and for this reason there has been much scholarly work devoted to its development through the Qing period. Colloquially, Chinese called the dragon robe the 'great robe' and during the nineteenth century it appears to have grown in importance at the expense of *chao pao*. There is some evidence to suggest that the dragon robe was even worn with the *chao guan* and *pi ling* on very formal occasions.

The tailoring of the dragon robe was much simpler than that of the *chao pao*. It was a full-length, side-fastening garment with tapered, composite sleeves and horsehoof cuffs.

159

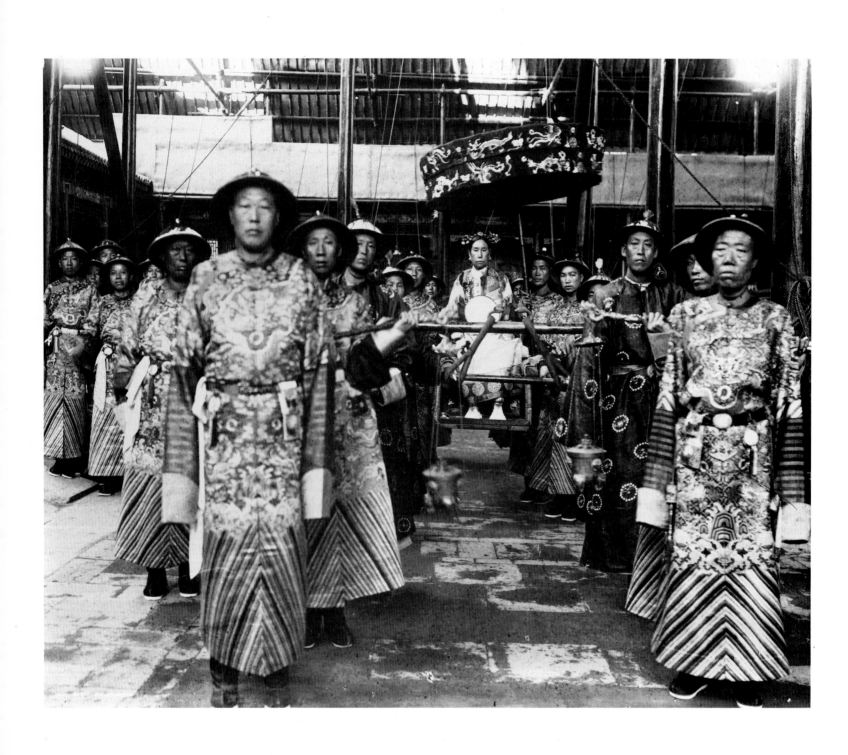

Pl.142 Empress Dowager Cixi
The splendour of the dragon robe was usually concealed beneath the dark-coloured *pu fu* on ceremonial occasions. However, during the celebrations at the New Year and on imperial birthdays the *pu fu* was dispensed with and the dragon robe revealed. It is said that the Empress Dowager Cixi (centre) ordered her eunuchs to remove their surcoats for this photograph.
Freer Gallery of Art

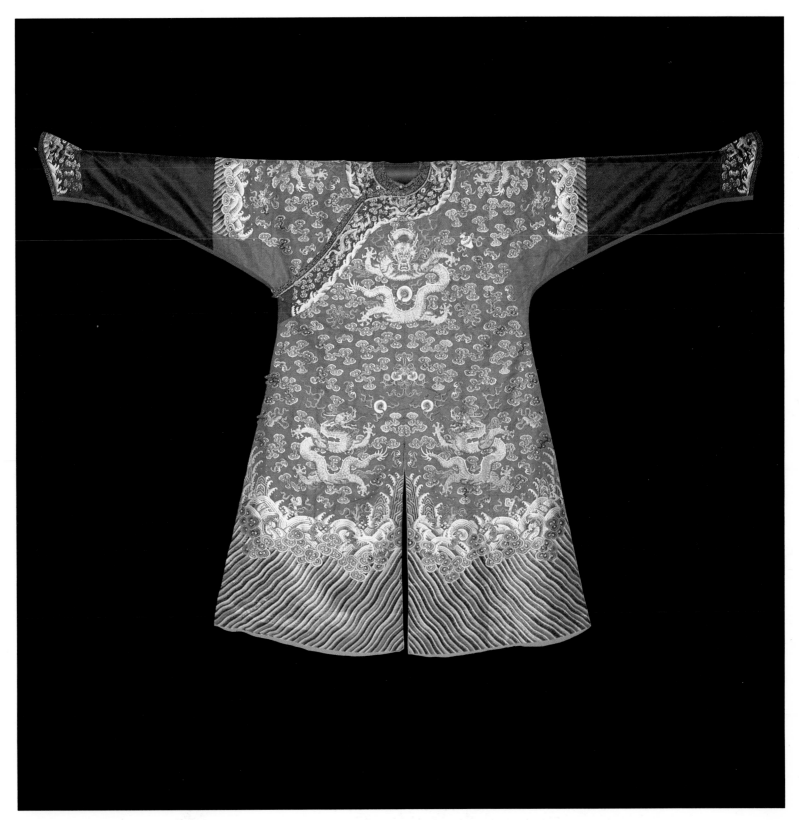

Pl.143 Imperial nobleman's dragon robe
The manuscript based on *Huangchao liqi tushi*
appears to have given members of the imperial
family the choice of either blue or brown court
robes. Brown was considered to be an off-shade of
yellow.
Linda Wrigglesworth

Unlike the *chao pao*, the dragon robe had an additional facing, decorated with dragons, around the collar which extended down under the right arm following the line of the closure. All male dragon robes were vented at the front and back, while dragon robes worn by Manchu men appear to have have had side vents as well. The construction of the dragon robe owes less to Ming styles of court dress than the more formal *chao pao* and was probably based on a traditional Manchu garment.

Imperial dragon robes

The emperor's dragon robes or *long pao* were bright yellow unless he was preparing for one of the principal annual sacrifices. The body of the robe was decorated with nine *long*, the Twelve Symbols, clouds, and other cosmological symbols. The dragons were placed symmetrically on the robe: front-facing dragons on the chest, back and shoulders and two profile dragons on the front and back of the lower part of the robe. Another profile dragon was hidden on the inner flap of the coat. The clouds were in five colours and the hem of the dragon robe was decorated with waves and diagonal stripes called *li shui* or standing water. Rising out the waves, at the front, back and sides of the robe, were triple-peaked rocks.

The *long pao* of the *huang tai zi* were identical to those of the emperor, except that he was not permitted to use any of the Twelve Symbols and his robes had to be *xing huang* in colour. The emperor's other sons were allowed to have *mang* dragons on their robes which had a *jin huang* ground. Imperial princes and other nobles were not permitted to use this colour unless they had been given the right to do so.

Many large collections of Qing court robes include examples of men's orange-coloured dragon robes some of which bear 2, 4, 8 or even all 12 of the symbols. Most of these robes appear to date from the second half of the nineteenth century. As previously noted, *xing huang* was most likely an orange-yellow colour and these orange-coloured robes are, therefore, often described as having been made for the crown prince. However, there are a number of historical reasons why it would seem highly unlikely that all of these robes belonged to Qing emperors before their accession.

Firstly, the identity of the *huang tai zi* was kept secret until the reigning emperor lay dying and almost all the nineteenth century emperors ascended the throne within one month of being proclaimed crown prince (see Table 1) leaving them little opportunity to wear *xing huang* colour robes. Secondly, the Tongzhi, Guangxu (r. 1875–1908) and Xuantong (r. 1908–11) Emperors all succeeded each other as infants whereas all the surviving orange-coloured dragon robes dating from these periods were made for adults. Those robes made for men are more likely, therefore, to have once belonged to imperial princes with the right to use *jin huang*, a shade which the manuscript based on *Huangchao liqi tushi* indicates was an orange colour (see Treasures of the Yuanmingyuan).

Table 16: Dragon Robes

Rank	Colour	No. of Dragons
Emperor	yellow/others	9 *long**
Crown prince	apricot-yellow	9 *long*
Emperor's sons	golden-yellow	9 *mang*
Imperial princes	blue or brown	9 *mang*
Other nobles	blue or brown	9 *mang*
Officials of the first, second & third ranks	blue	9 *mang*
Officials of the fourth, fifth & sixth ranks	blue	8 *mang*
Other officials	blue	5 *mang*

* The emperor's *long pao* were also decorated with the Twelve Symbols.

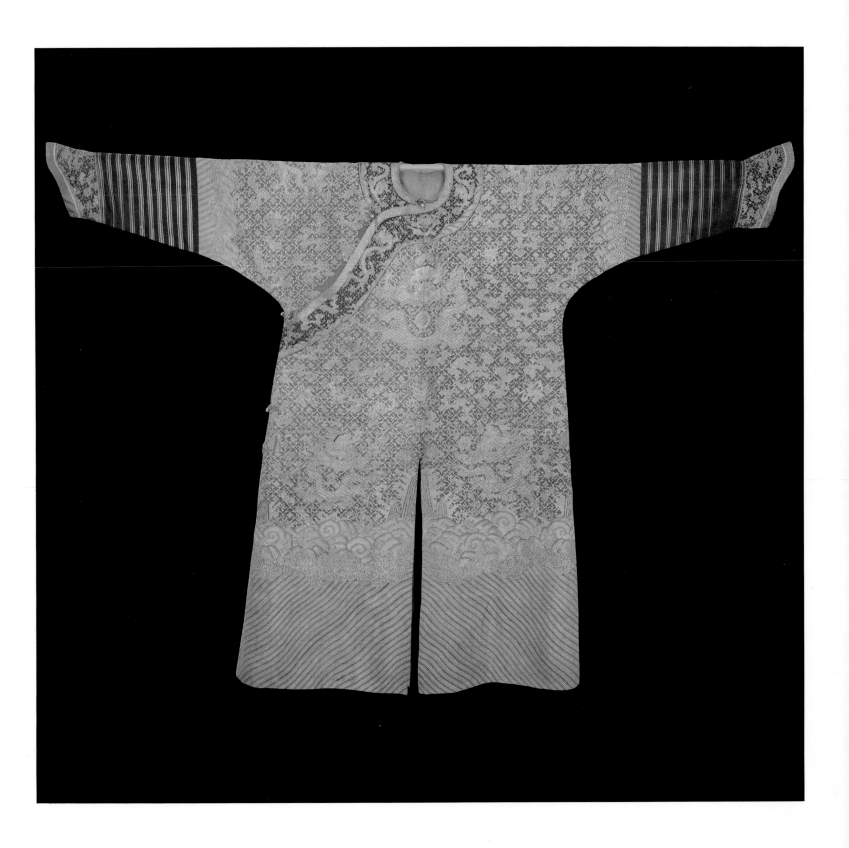

Pl.144 Official's dragon robe
Many officials appear to have adopted five-clawed
dragons for their less formal court robes although
they were supposed to decorate their court dress
with *mang*.
Linda Wrigglesworth

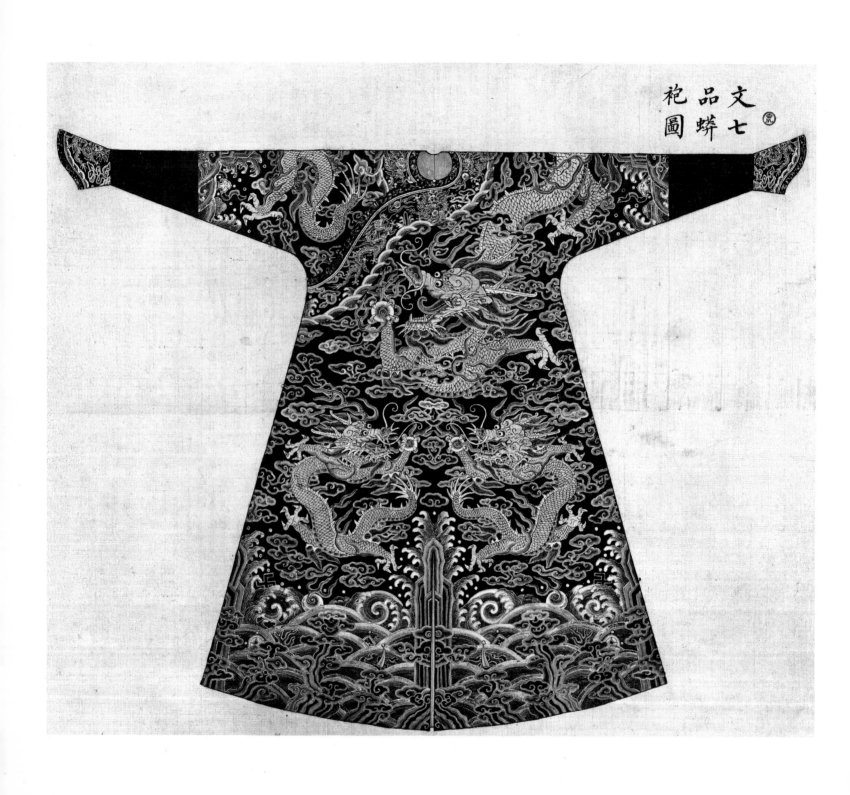

文品文
袍蟒七
圖

Pl.146 Seventh-rank official's dragon robe
Painting on silk of a seventh-rank official's *mang pao*.
V&A

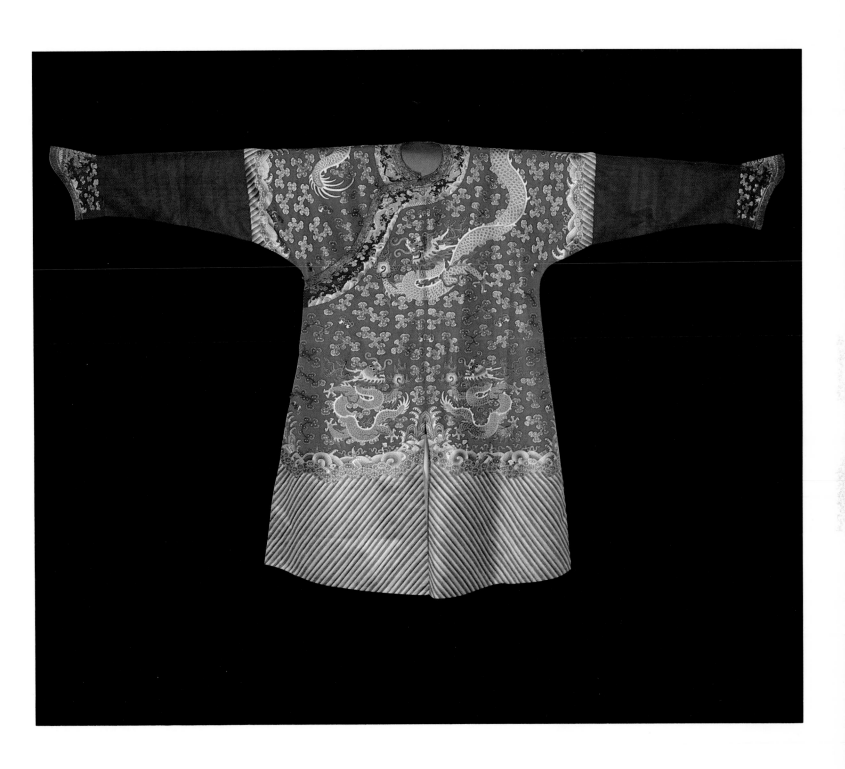

Pl.147 Seventh-rank official's dragon robe
Example of a *mang pao* decorated with only five
four-clawed dragons.
Private collection

祭祀武舞生袍圖

Pl.149 Military posturer's ceremonial robe
Painting on silk of a military posturer's ceremonial robe.
V&A

Pl.148 Detail of a seventh-rank official's dragon robe
The single dragon, coiling across the shoulders of a low-ranking official's *mang pao*, is probably derived from the patterns of court robe inherited by the Manchu from the Ming dynasty.
Private collection

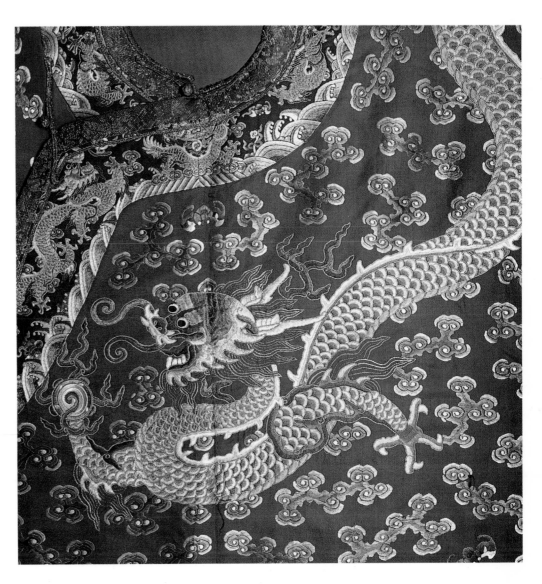

Pl.150 Insignia bearer's ceremonial robe
Illustration of an insignia bearer's ceremonial robe.
SOAS

Officials' dragon robes

Officials of the three highest ranks wore similar robes to their Manchu peers but were restricted to using blue. The dragon robes of officials of the fourth, fifth and sixth ranks lacked the dragon concealed on the inner flap. Examples of dragon robes with *mang* are uncommon. It appears that the majority of nobles and officials alike simply assumed the right to the fifth claw.

Officials of the seventh, eighth and ninth ranks were not even permitted to wear eight dragons on their less formal court robes. Their dragon robes were decorated with only five *mang*. A large, sinuous *mang* in profile extended over the upper body of the robe from the chest over the left shoulder with its tail on the right shoulder. On the front and back of the lower part of the robe were pairs of profile *mang*. The robe was decorated with clouds and waves in the same manner as other styles of dragon robe. This type of dragon robe is extraordinarily rare. One example dates from the late nineteenth century and probably owes its existence to the fact that it was manufactured for use in the palace itself. A seal impression identifies the robe as the property of the Board of State Music, a department of the Board of Ritual. Such a robe would have been worn by a sub-director of the Board, who would have the seventh rank.

Gong fu

Below those at the pinnacle of the imperial hierachy – the emperor and his family, nobility and officials – was a host of unclassed public servants attached to the imperial household or to the government departments that supervised state ceremonial occasions. The court musicians, the posturers who performed the ritual dances at the great annual sacrifices, the insignia bearers and other gentlemen-at-arms all had particular ceremonial costumes laid down in *Huangchao liqi tushi*. We have estimated that there were close on 1,000 of these functionaries at any of the major imperial ceremonies. The ceremonial garments of these people must, therefore, have existed in enormous numbers. But, because of the eclectic tastes of those who brought back from China most of the robes in western collections, these types of ceremonial garment are now rarer than the most formal court costumes of the emperor himself. Some we know only through the illustrations in *Huangchao liqi tushi*.

We have classified all these various ceremonial garments under the heading *gong fu* or public dress, a term that was also applied to the formal dress of graduates in the government examinations. All garments in this category were of full-length, side-fastening coats with tapered sleeves and horsehoof cuffs. An instrumentalist in the court orchestra wore a red coat decorated on the chest and back with square badges displaying a yellow oriole. The ritual posturers who performed the civil dances also wore coats with square badges on them. Their badges displayed a large mallow flower. The colour of their robe depended on the ceremony at which they were performing: at the Altar of Heaven they wore blue; at the Altar of Earth, black (not yellow); at the Altar of the Sun, red; and at the Altar of the Moon, pale blue. The military posturers also wore coats of the same colour but these were patterned all over with small mallow flowers couched in gold thread. The insignia bearers who accompanied the emperor to the sacrifices also had to wear coats of the same colour, which were patterned all over with the character for longevity.

Successful candidates in the highest government examinations were presented in audience to the emperor. On these occasions they wore a blue ceremonial robe with a wide black border around the hem, the vents and the line of the coat's closure. This type of robe was worn with a *pi ling* or detachable cape, also of the colour blue bordered with black (see Table 17).

Table 17: *Gong fu*

Rank	Colour	Design
Instrumentalist	red	square badges with yellow oriole
Civil posturer	red, blue, black and pale blue	square badges with large mallow flower
Military posturer	as above	patterned all over with small mallow flowers
Insignia bearer at imperial sacrifices	as above	patterned all over with longevity characters
Graduate in state examinations	blue	plain blue ground bordered with black

WOMEN'S COURT DRESS

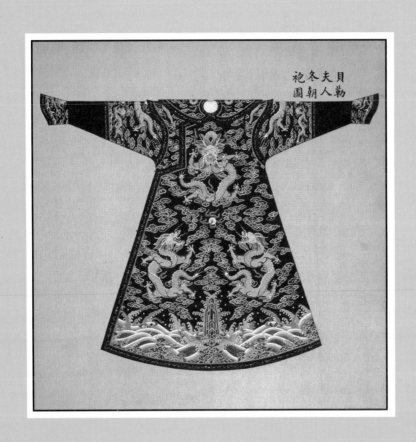

Women's Court Dress

Chao fu

Examples of women's court dress are now rarer than those of male costume. One reason for this may be that women had fewer ceremonial duties than their male counterparts. Another reason is that Chinese women were largely excluded from the imperial court and, in private, the wives of Chinese officials often wore elaborate formal costumes which evoked the styles of Ming court dress.

Huangchao liqi tushi made provision for the court dress of the wives of every rank in the imperial hierarchy. Women's court costume was dealt with in a separate section that followed male dress. When a woman married she was effectively adopted by her husband's family and took the rank of her spouse. The emperor had many consorts in addition to his empress or *huang hou*, who, if she survived his death, became known as *huang tai hou* or empress dowager. *Huangchao liqi tushi* illustrates the court costumes of these noblewomen first, followed by those of the secondary imperial consorts.

Women's court costume was more elaborate than that of their husbands. Their most formal head-dress consisted of a *chao guan*, so heavily jewelled that it began to resemble a crown. This head-dress was worn with a golden diadem. Tradition also required all Manchu women to wear three sets of pearl earrings. Women's *chao fu* comprised three separate garments: a *chao pao* worn unbelted with the *pi ling* cape, a *chao gua* and a pleated underskirt. High-ranking noblewomen also wore torque-like jewelled collars around the neck and no fewer than three court necklaces. A ceremonial kerchief also hung from the breast.

Chao guan and *jin yu*

The winter *chao guan* of the empresses and the secondary imperial consorts were even more elaborate than those of the emperor. The apex was composed of large Eastern pearls and golden phoenixes arranged in tiers. The empresses were permitted three tiers of Eastern pearls alternating with three golden phoenixes each of which was decorated with 17 smaller pearls. Their jewel of rank was another large pearl.

The crown of the hat was covered with a tassel made of red silk floss and decorated with seven golden phoenixes each set with a single cat's-eye stone and nine small pearls. On the crown at the back was a golden pheasant adorned with a cat's-eye and 16 small pearls. From its tail hung three strings of pearls with a golden clasp inlaid with lapis lazuli about half-way down. The brim of the empresses' *chao guan* was faced with black fox. Attached to the brim at the back of the hat was a small flap, also faced with black fox, which protected the nape of the neck.

The *chao guan* of the emperor's other wives differed only in detail. Imperial consorts of the highest degree, *huang gui fei*, could wear almost identical head-dresses except that their hats were faced with sable and the phoenixes on the crown were not decorated with cat's-eyes. Lower-ranking imperial consorts used fewer phoenixes and the *chao guan* of princesses were decorated with golden pheasants. Other Manchu noblewomen were required to use hat insignia similar to those of their husbands but the floss tassel was further decorated with brooch-like plaques inlaid with kingfisher feather and set with semi-precious stones.

Commemorative portraits from the early Qing period show that the wives of nobles and officials wore the same conical summer hats as their spouses. By the mid-Kangxi period, women's summer *chao guan* were exactly the same style as their winter head-dresses. Instead of being faced with fur, the upturned brim of women's summer hats were covered with gloss silk satin and the flap that protected the nape of the neck was faced with brocade.

The *chao guan* rested on a diadem called a *jin yu*. This segmented golden circlet was inlaid with semi-precious stones such as lapis lazuli and set with pearls.

Pl.151 Empress Xiaoxian
Commemorative portrait by Castiglione depicting
Empress Xiaoxian in *chao fu*.
Palace Museum

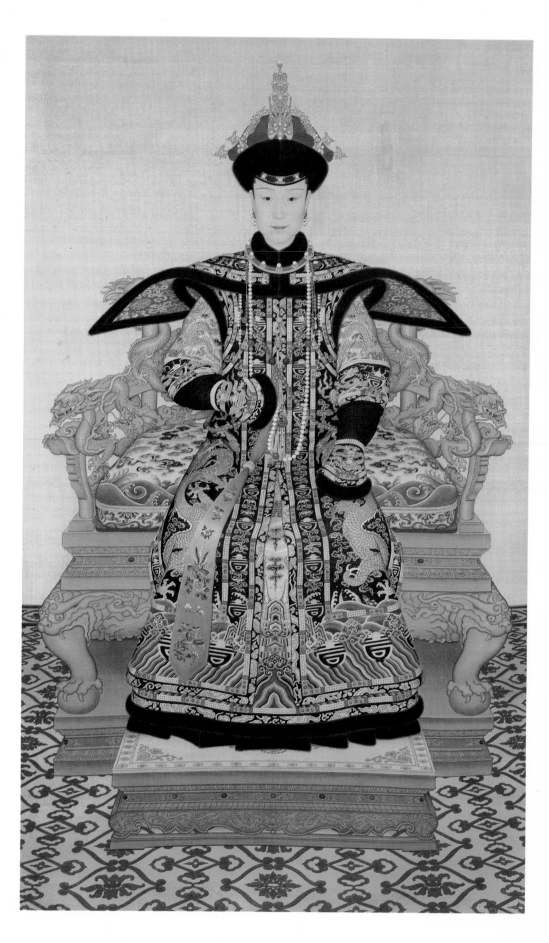

171

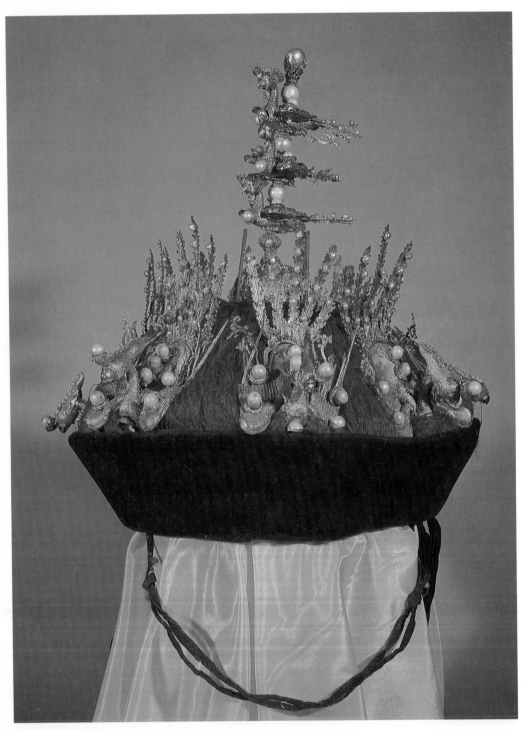

Pl.152 First-rank imperial consort's winter *chao guan*
The most formal court hats of imperial noblewomen were so heavily adorned that they began to resemble crowns.
National Palace Museum

Pl.153 Winter *chao guan*
Painting on silk of the winter *chao guan* of the wife of
an imperial duke.
Private collection

輔國公女鄉君冬朝冠圖

Winter *chao pao*

Huangchao liqi tushi assigns the empresses no fewer than three types of winter *chao pao*.
The first was a full-length, side-fastening garment with composite, tapered sleeves. It was
lined throughout with white fur and trimmed with sable. Women's *chao pao* did not have
integral sleeves. The upper sleeve was joined to the body of the robe at the shoulders. The
seam was disguised with brocade facings and epaulette-like projections above the
shoulders. The sleeves were extended with lengths of dark-coloured material and finished
with the characteristic horsehoof cuffs. Additional bands, decorated with dragons, were
inserted between the upper and lower parts of the sleeve.

The body of the robe was decorated with dragons, clouds, water motifs, and other
auspicious symbols in a similar way to the male dragon robe. Front-facing dragons were
placed on the chest, back and on the upper sleeves below the epaulettes. Pairs of profile
dragons were shown on the lower part of the robe at the front and back. Four
triple-peaked rocks were placed symmetrically around the hem of the robe, at the front,

back and sides, rising out of waves and other water motifs. However, the diagonal stripes that raised the water line above the hem to create the *li shui* or 'standing water' effect, are absent on women's *chao pao*.

This first type of winter *chao pao* could also be worn by the emperor's secondary consorts and the wife of the crown prince. Only the empresses and *huang gui fei* were permitted to wear yellow. Imperial consorts of the second and third degrees could use *jin huang* or golden-yellow, but lower-ranking consorts were only permitted the greenish-yellow *xiang se* or incense colour. The crown princess wore *xing huang* or apricot-yellow.

The construction of the second type of winter *chao pao* differed radically from the first. Like the male *chao pao* it was tailored in two sections: a hip-length bodice attached to a pleated skirt. The sleeves were composite with the upper sleeve being attached to the bodice at the shoulders. Again, the seams were disguised by the epaulettes, and additional bands of dragons were also inserted between the upper and lower sleeves. The skirt section was fully gathered with box pleats.

This type of robe appears to have been much older than the first type of women's winter *chao pao*. The body of the robe is decorated with a four-lobed yoke pattern extending over the chest, back and shoulders. The lower part of the skirt was decorated with the a band of dragons, and just above the seam between the bodice and skirt sections was an additional band of dragons. As with male *chao pao*, these decorative features were inherited from Ming court robes and altered to fit Manchu styles.

Early eighteenth-century portraits of officials' wives show them wearing this type of court robe. However, *Huangchao liqi tushi* restricts its use to the empresses, imperial consorts and the wife of the crown prince. In each case the colour of the robe was the same as the first type.

The third type of empresses' winter *chao pao* was almost identical to the first except that it was simply trimmed with black fox and had a central vent at the rear. This type could, however, be worn by all ranks of noblewomen and the wives of officials. In the case of the emperor's and crown prince's consorts, the colour of the robe was the same as for the first two types. In addition, the consorts of the emperor's other sons and also his daughters wore *xiang se*. The wives of imperial nobles and officials were supposed to wear the same colour and also number of dragon's claws as their husbands (see Table 18).

Table 18: Women's *chao pao*

Rank	Colour	Dragons
Empress dowager, empress & *huang gui fei*	yellow	front-facing *long* on chest, back and shoulders; 2 profile *long* on lower part of robe at front and back
Second- & third- degree imperial imperial consorts	golden-yellow	as above
Other imperial consorts	incense colour	as above
Consort of the crown prince	apricot-yellow	as above
Consorts of first- & second-rank princes	brown	as above
Wives of other nobles	blue-black	as above but with *mang*
Wives of officials of the first, second & third ranks	blue-black	as above
Wives of officials of the fourth, fifth, sixth & seventh ranks	blue-black	2 confronting *mang* on front and back

174

Pl.154 First-rank imperial consort's winter *chao pao*
Painting on silk of a first-rank imperial consort's third style of winter *chao pao*.
V&A

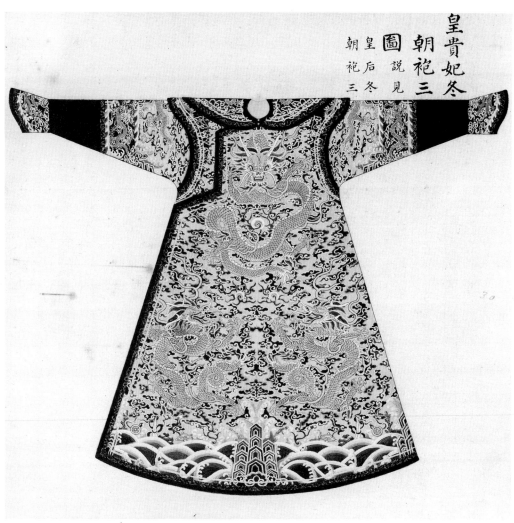

皇貴妃冬
朝袍三
圖說見
皇后冬
朝袍
三

Pl.158 Court skirt
Painting on silk of the underskirt of an imperial daughter-in-law.
British Library

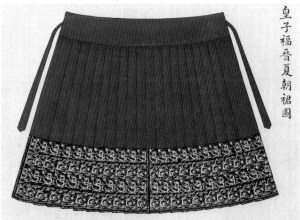

皇子福晉夏朝裙圖

Summer *chao pao*

The empress dowager, empress and *huang gui fei* had two types of summer *chao pao*. The first type, like the second type of winter robe, was tailored in two sections: a hip-length bodice attached to pleated skirts. This type of robe was, again, restricted to use by imperial consorts and the crown princess. Their second type of summer *chao pao* was identical in construction to the third type of winter robe. All ranks of noblewomen and the wives of officials could wear this type of summer *chao pao*. In all cases, the summer *chao pao* could be made of gauze or satin, in which case it was lined with a thin material. All the exposed edges of the robe were finished with a brocade border.

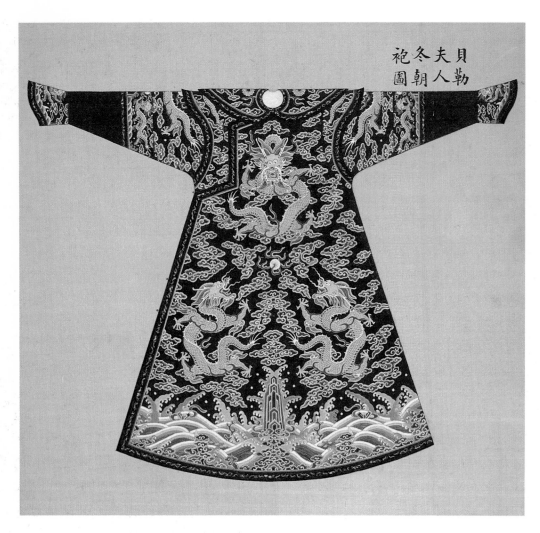

袍冬夫貝
圖朝人勒

Pl.155 Imperial noblewoman's *chao pao*
Painting on silk of the summer *chao pao* of the wife
of an imperial duke.
Private collection

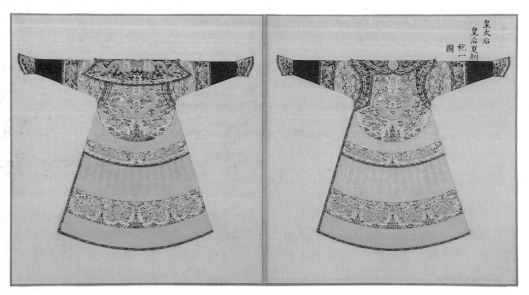

皇太后
皇后夏朝
袍一
圖

Pl.156 Empress' summer *chao pao*
Painting on silk showing front and back views of the
first style of summer *chao pao* of an empress or
empress dowager.
Sotheby's

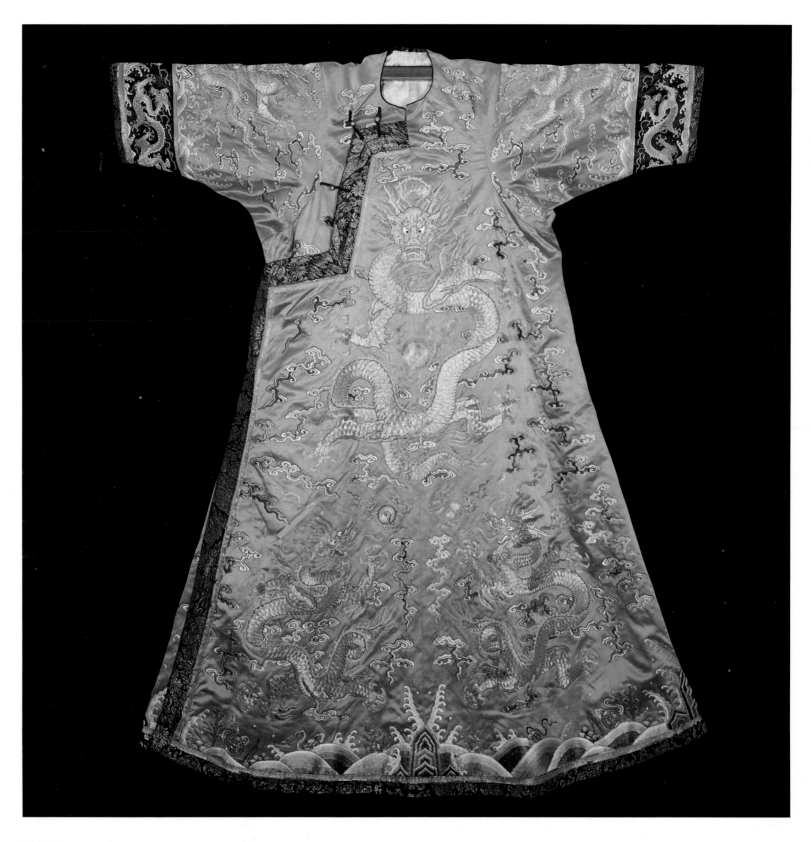

Pl.157 Summer *chao pao*
Although now much altered, this is one of the
earliest examples of a women's orange-coloured
chao pao. It may have been made for an imperial
consort.
Private collection

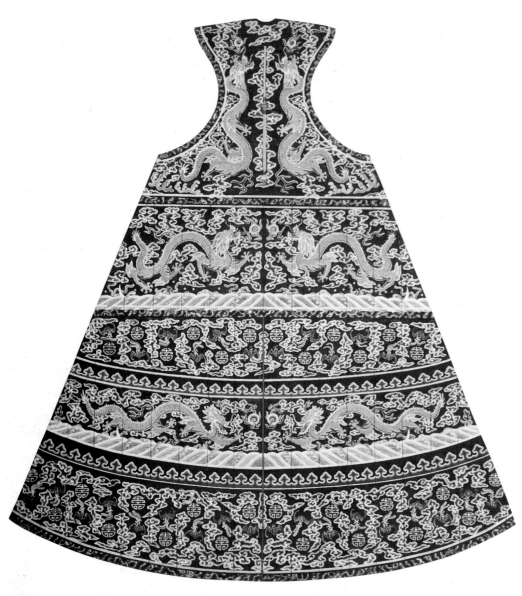

Pl.159 Imperial consort's *chao gua*
Painting on silk of an imperial consort's first style of
chao gua.
V&A

Chao gua and *zai shui*

The *chao pao* was worn beneath a front-opening, sleeveless garment called a *chao gua* or
court vest. The empress dowager, empress and *huang gui fei* had three distinct types. The
first type was tailored in three sections: the upper body, a section from the waist to the
knee, and from the knee to the hem. This type of *chao gua* was dark blue in colour and
was decorated with five horizontal bands of dragons, clouds and other auspicious
symbols.

The second type was constructed in a similar way as the second style of winter *chao pao*:
a hip-length, sleeveless bodice attached to a pleated skirt. The ground colour of this
chao gua was also dark blue. A four-lobed yoke design extended over the chest and back
with a strip of dragons above the seam between the bodice and the skirt section. The
lower part of the skirt was decorated with the band of dragons. This type of *chao gua* also
had a vent at the rear. No examples of this type of court vest have come to light during
our research.

The first two types of *chao gua* were restricted to use by the empresses, imperial consorts
and the crown princess. However, the third type, a simple, full-length, dark-blue garment
patterned with dragons and other motifs, could be worn by all ranks of women. The
number and disposition of the dragons indicated rank in each case (see Table 19).

Pl.160 *Chao gua*
This court vest resembles the first type of *chao gua* and is constructed in three sections. The four panels of decoration show vertical or ascending dragons: 2 on the upper part, 10 in the middle and 12 and 16 in two rows on the bottom section. There is no precedent for this style of *chao gua* in *Huangchao liqi tushi* and it may therefore predate 1759.
Palace Museum

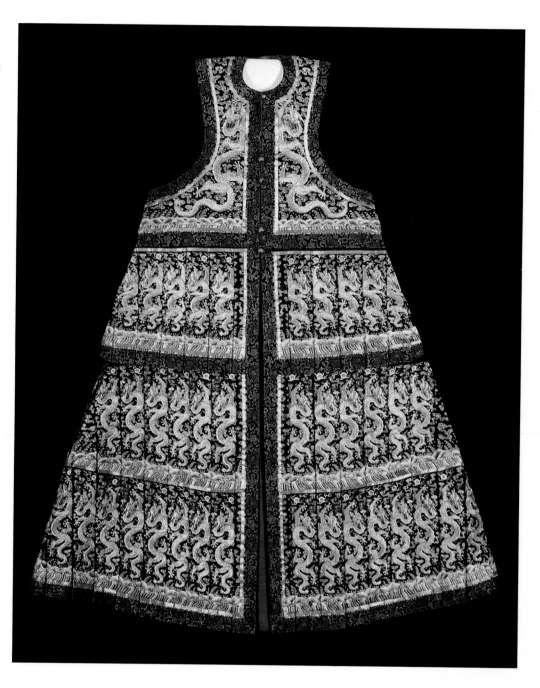

Suspended from the third button of the *chao gua* was a type of ceremonial kerchief made of embroidered silk called a *zai shui*. The colour and motifs on the kerchief indicated rank. Half-way down was a gold clasp set with semi-precious stones.

Table 19: *Chao gua*

Rank	Pattern
Empress dowager, empress & *huang gui fei*	2 ascending profile *long* on front and back
Second- & third- degree imperial consorts	as above
Wives of first- & second-rank princes	4 profile *long* on front and back
Wives of other nobles & officials	2 ascending profile *mang* on the front and ba

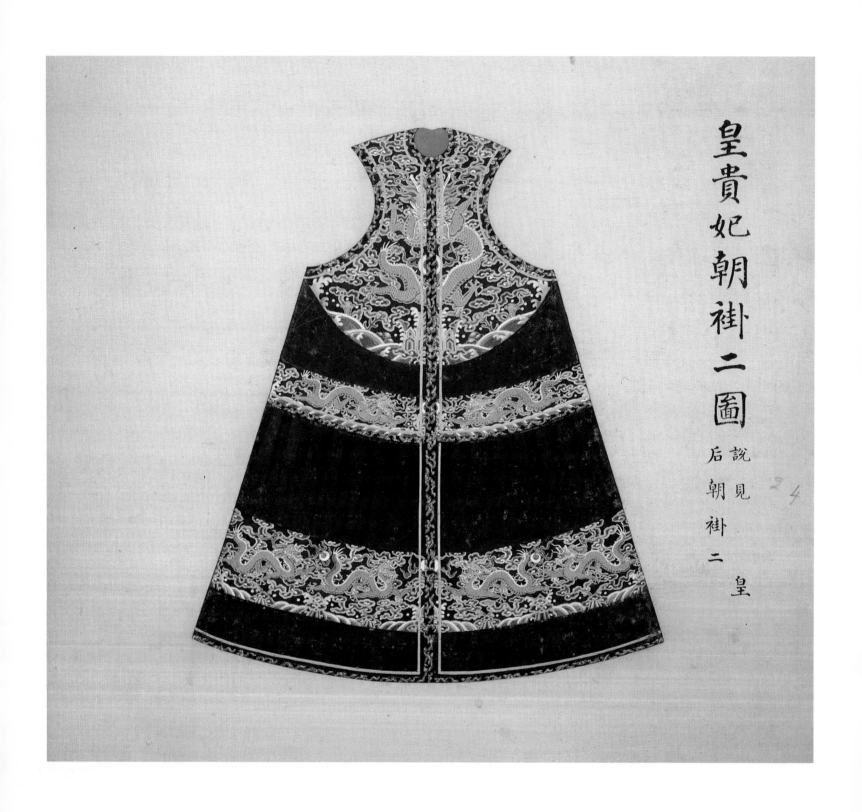

皇貴妃朝褂二圖 說見 皇
后朝褂二

Pl.161 Imperial consort's *chao gua*
Painting on silk of an imperial consort's second style
of *chao gua*. The pattern of this type of *chao gua*
strongly resembles the male *chao pao*.
V&A

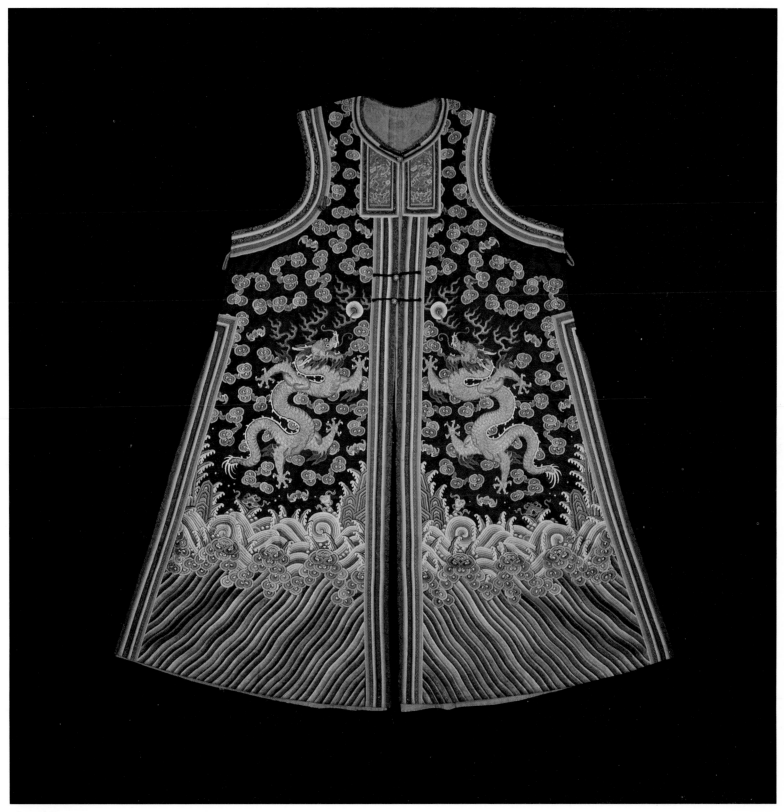

Pl.163 *Chao gua*
The design of this *chao gua* suggests that it was worn by an imperial consort. However, the garment has coloured bindings where it should have brocade, indicating that it was probably made up from unused yardage.
Linda Wrigglesworth

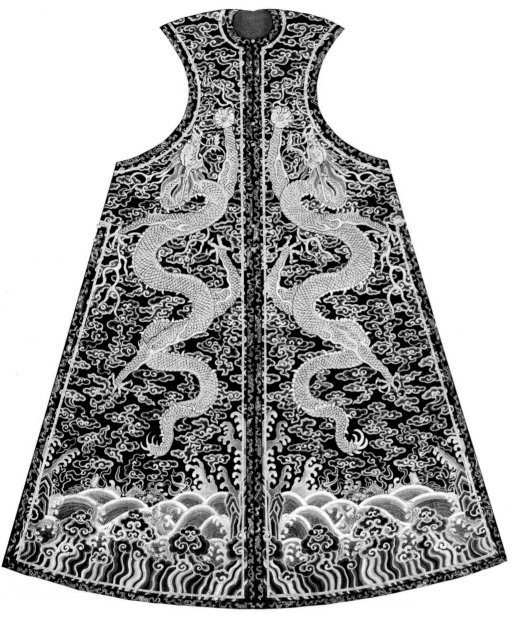

Pl.162 Imperial consort's *chao gua*
Painting on silk of an imperial consort's third style of *chao gua*.
V&A

Pl.164 *Zai shui*
Painting on silk of the *zai shui* or ceremonial kerchief of an imperial daughter-in-law.
British Library

Chao zhu and *ling yue*

Women wore three separate *chao zhu* or court necklaces with their *chao fu*. The principal string was hung around the neck. Another necklace worn over the left shoulder crossed under the right arm. The third string was worn over the right shoulder, crossing under the left arm. The materials each rank could use were strictly regulated. Only an empress or empress dowager could use pearls for her principal court necklace. The two other chains were made from coral. The first three degrees of secondary imperial consort wore a principal chain made of honey amber and also two other necklaces of coral. The lowest grades of imperial consort, together with the wives of imperial princes, wore one chain of honey amber and two of coral. Other noblewomen and the wives of officials could use any semi-precious stone except the restricted ones (see Table 20).

Pl.165 *Chao zhu*
Painting on silk of the three *chao zhu* of an imperial
daughter-in-law.
British Library

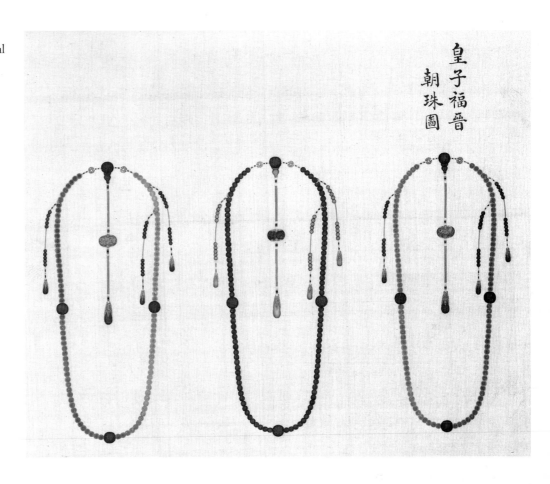

皇子福晉朝珠圖

Imperial noblewomen wore a torque-like collar called a *ling yue* with their most formal
court dress. This was made of gold or gilt metal and inlaid with coral and set with a
number of pearls. The empresses' collar was set with nine pearls and had two yellow
ribbons that hung from the back of the neck. Lower-ranking consorts could use only six
pearls and their ribbons were golden-yellow. Other noblewomen were also permitted to
wear the *ling yue* but the colour of the ribbons varied according to rank.

Table 20: Women's *chao zhu*

Rank	Principal Chain	Other Chains	Colour of Strings
Empress dowager, empress	pearls	coral	yellow
Huang gui fei	honey amber	coral	yellow
Second- & third-degree imperial consorts	honey amber	coral	golden-yellow
Other imperial consorts	coral	honey amber	golden-yellow
Consort of the crown prince	coral	honey amber	apricot-yellow
Consorts of first- & second-rank princes	coral	honey amber	golden-yellow
Consorts of third- & fourth-rank princes	coral	honey amber	blue-black
Wives of other nobles & officials down to the fourth rank	any stone*	same as principal chain	blue-black

* Except the restricted ones.

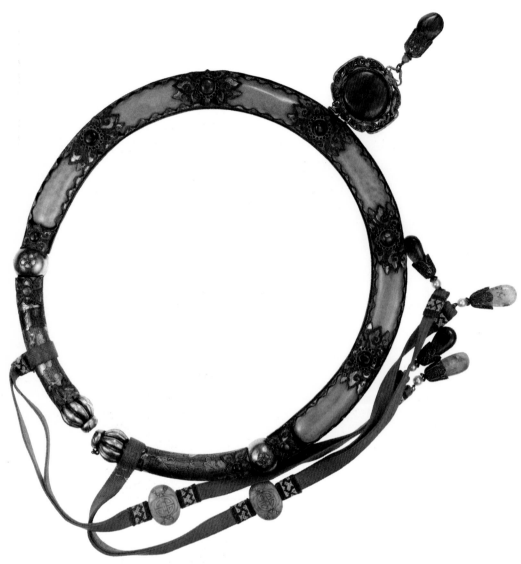

Pl.166 *Ling yue*
This example of a noblewoman's *ling yue* has a brooch-like pendant similar to those found on *chao zhu*. This ornament is not shown on illustrations of the *ling yue* in *Huangchao liqi tushi*.
Royal Ontario Museum

Chinese Women's Ceremonial Dress

As native Chinese women were largely excluded from the court, their traditional bridal costume generally took the place of *chao fu* in their wardrobes. A Chinese woman's bridal trousseau consisted of a *mang ao*, a dragon jacket, similar in style to a *shen yi*, a type of burial robe. It was a short, side-fastening coat with wide, bell-shaped sleeves. The *mang ao* was usually red and decorated with dragons and other cosmological motifs common to court dress. Although this garment did not come within the scope of Qing sumptuary laws, the wives of high-ranking Chinese officials seem to have worn *mang ao* decorated with up to 10 dragons while the wives of low-ranking mandarins wore jackets with fewer dragons, probably in deference to their superiors.

The *mang ao* was worn over a pleated skirt called a *mang chu*, a dragon skirt, which had decorative panels at the front and rear. The ensemble was completed by the *xia pei* or stole, a three-quarter-length tabard with a front closure and open sides, secured under the arms with cloth ties. This garment had a tasselled fringe around the hem and was decorated with dragons, clouds and water motifs. In many cases all the different types of bird used as rank insignia by civil officials are shown flying among the clouds. If the wearer were the wife of an official, the appropriate badges of rank were often applied to the front and rear of the *xia pei*. Like the *mang ao*, the *xia pei* was not a court garment and the badges of rank have been borrowed from the Qing official wardrobe.

Pl.168 *Xia pei*
The wives of Chinese officials applied the badges of
their husband's rank to the front and back of their
xia pei.
Linda Wrigglesworth

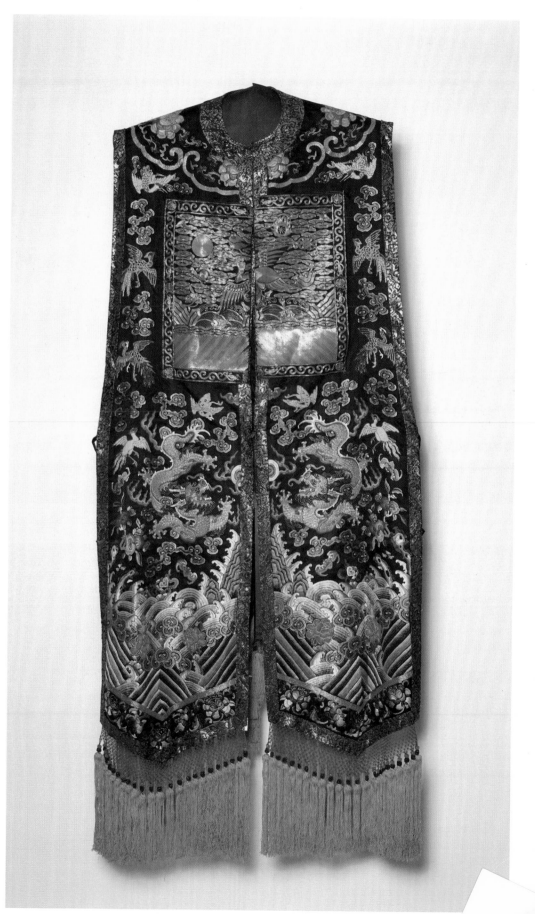

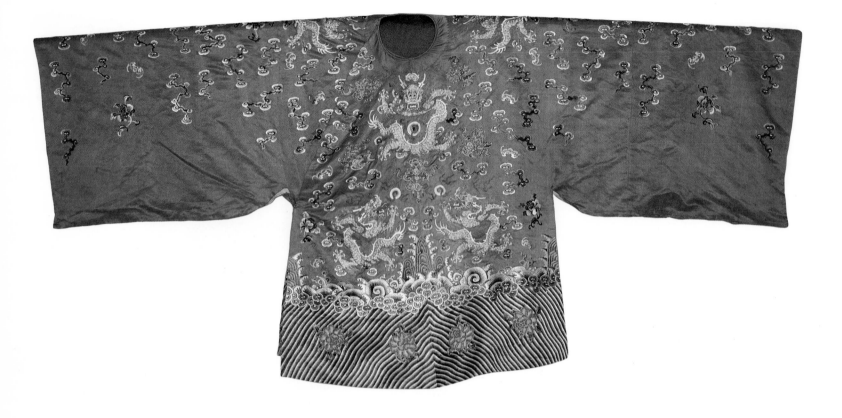

Manchu women's court dress was always worn unbelted. However, Chinese women wore an inflexible, hoop-like belt with their ceremonial costume. The *jiao dai*, the horn belt, was in fact made of bamboo and had a covering of red silk. It was decorated with ornamental plaques set with semi-precious stones or glass imitations.

The costume was completed by the *feng guan* or phoenix hat, a very elaborate head-dress made of gilt copper wire and heavily inlaid with kingfisher feather and glass imitation jewels. The *feng guan*, as its name suggests, was often decorated with filigree phoenixes. De Groot, in *The Religious System of China* (see Bibliography), also mentions four leaves standing conspicuously above the other decorative features bearing the characters *Feng tian gao ming*. This phrase translates as 'I have received an official appointment from Heaven'. The *feng guan* was usually worn with a red headband decorated with tiny silver figures of the Eight Immortals of popular Daoism.

Long gua

Immediately following the most formal costumes of the imperial consorts and the wives of imperial nobles, *Huangchao liqi tushi* illustrates their *long gua* or dragon coats, a type of full-length, front-opening surcoat decorated with dragon roundels and other motifs.

The empress dowager and empress had two types of *long gua*. The first was decorated with eight roundels displaying front-facing *long* on the chest, back and shoulders with profile dragons at the front and back on the lower part of the coat. In addition the hem and the lower sleeves were decorated with water and wave motifs. During the nineteenth century, Qing empresses adopted some of the Twelve Symbols on their *long gua*: the Sun on the left shoulder, the Moon on the right shoulder and the Constellation and Rock symbols on the chest and back. The second type of *long gua* was similar except that it lacked the wave motifs around the bottom of the hem and sleeves.

Pl.167 *Mang ao*
The tailoring of this short jacket, which was worn as part of a Chinese woman's bridal attire, evokes traditional Chinese styles of dress that predate the Qing period.
Linda Wrigglesworth

Imperial consorts of the first three degrees were allowed to use the first type of *long gua*.
Lower-ranking imperial consorts could wear only the second *long gua*, the type without
the wave border. The lower roundels on their coats were also decorated with highly
stylized, two-toed *gui long* dragons.

The crown princess was permitted to use the first type of *long gua*. The consorts of all
other imperial princes were supposed to wear full-length *pu fu* displaying the same
insignia badges as their husbands. In practice many of these imperial princesses wore the
more impressive type of *long gua* with the wave border. Their only apparent concession
to sumptuary laws was that the upper roundels usually followed the regulations laid down
for their consort's insignia (see Official Coats). The wives of lower-ranking imperial
nobles and officials were supposed to wear surcoats with eight roundels decorated with
floral motifs enclosing a *shou* or longevity symbol.

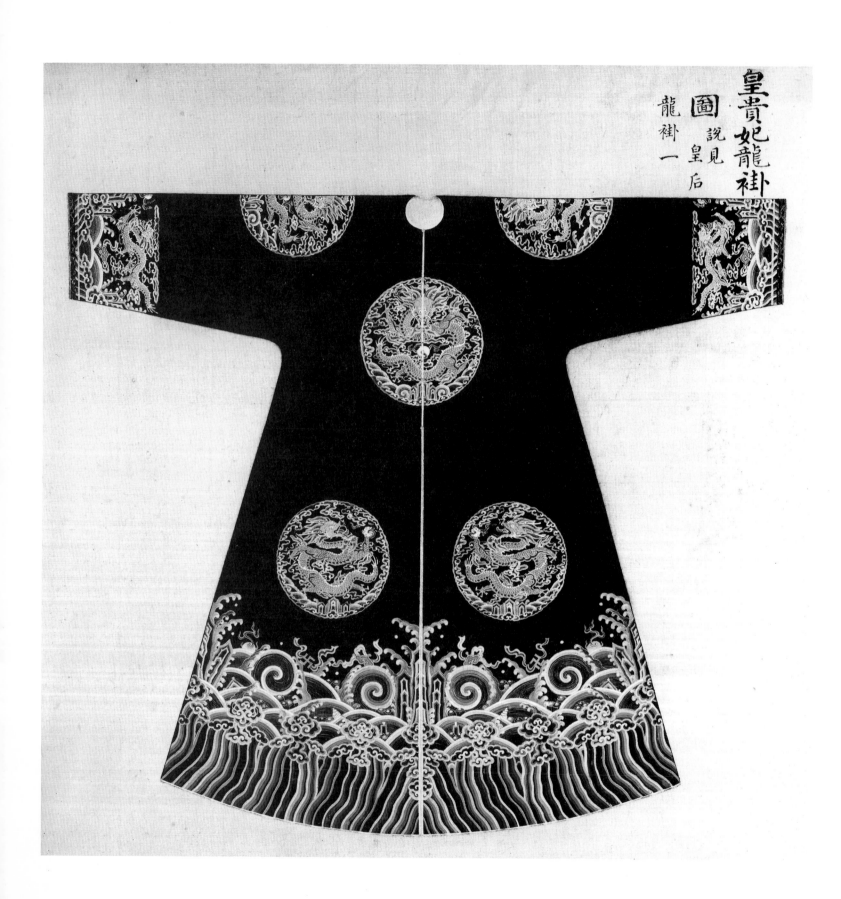

皇貴妃龍褂
圖說見皇后
龍褂一

Pl.170 First-rank imperial consort's _long gua_
Painting on silk of a first-rank imperial consort's
long gua.
V&A

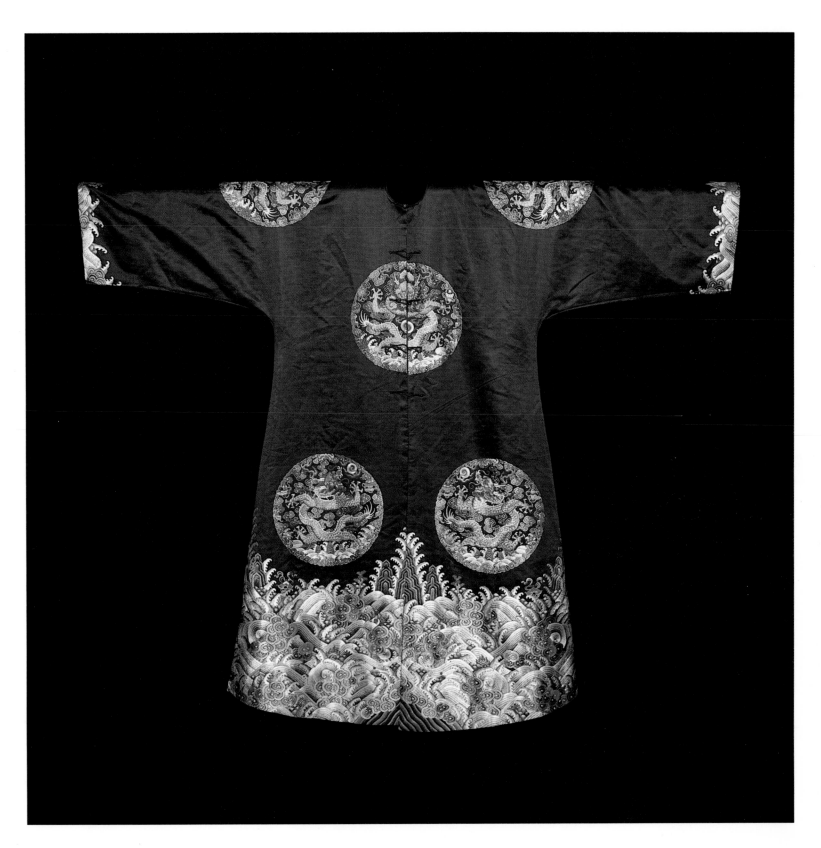

Pl.171 Imperial noblewoman's *long gua*
The dragon badges on this embroidered silk-satin
Manchu noblewoman's *long gua* suggests that it was
once worn by an empress or high-ranking imperial
consort.
Linda Wrigglesworth

Ji fu

Women were also permitted to wear *ji fu* or festive dress. Since many of their ceremonial duties were of a less formal nature, the range of festive robes of the imperial consorts is quite broad and appears to cater for more subtle degrees of formality than those of the emperor. The wives of imperial princes and other nobles were not strictly permitted to use some types though, in practice, they appear to have done so.

Ji guan

The *ji guan* of the emperor's wives were similar in style to the emperor's own winter hat. During the summer months his consorts wore the same type of hat but the brim was faced with satin. The empresses and *huang gui fei* could wear a pearl as hat insignia. Other ranks of imperial consort could only use the pearl if they had gained their husband's favour and had been given the right to do so. Their *ji guan* were worn over a silk headband decorated with a jewelled ornament.

Imperial princesses and the wives of other Manchu noblemen wore a much more elaborate *ji guan*. These hats lacked the red silk tassels and the crown was covered with either red or blue silk-satin. Instead of the jewel of rank, the hat was surmounted by a large red silk knot. The crown was decorated with semi-precious stones and ornaments inlaid with brilliant blue kingfisher feather. Two broad ribbons, embroidered with dragons and other popular motifs, hung down at the back of the hat.

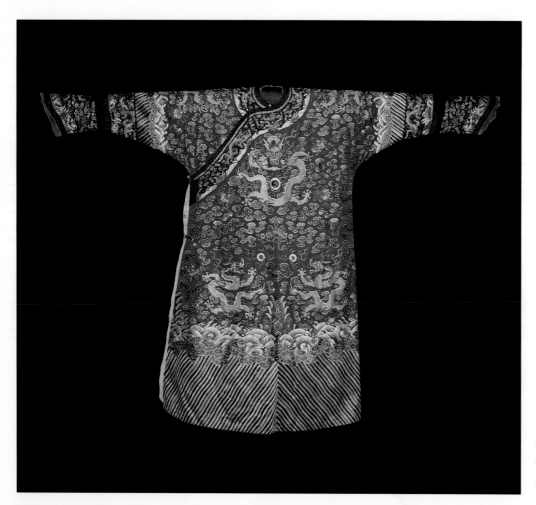

Pl.174 Imperial noblewoman's dragon robe
This Manchu noblewoman's winter dragon robe is lined with squirrel and the cuffs trimmed with sable. The robe's reddish brown ground indicates that it was probably worn by the consort of an imperial prince.
Linda Wrigglesworth

Pl.172 Inauguration Portraits
Castiglione's portrait of one of the Qianlong Emperor's secondary consorts wearing *ji fu*. Cleveland Museum of Art

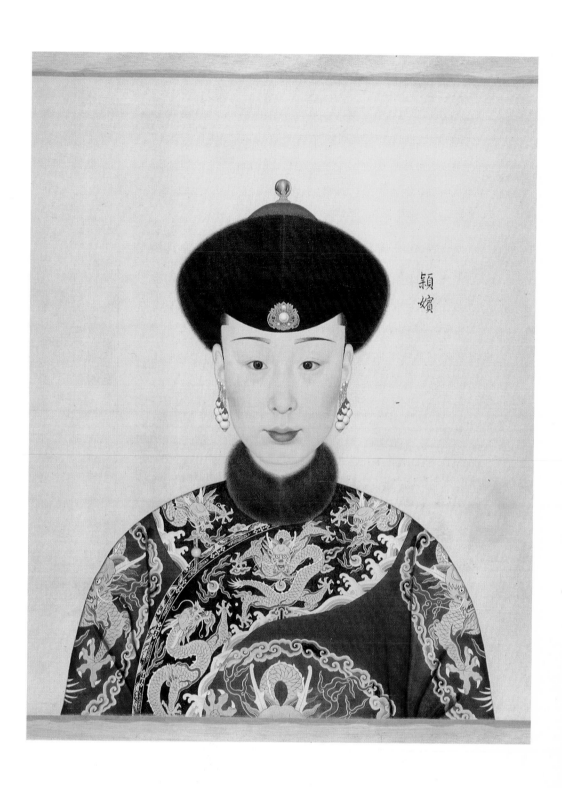

颖
嫔

Long pao

The empress dowager and empress had three types of *long pao* or dragon robe. All these robes were tailored in the same fashion: a full-length, side-fastening coat with composite sleeves. Unlike the *chao pao*, the upper sleeves of women's dragon robes were integral to the body of the robe. They also had the additional bands of dragons at the elbow, between the upper and lower sleeves. Only imperial consorts and the crown princess were allowed these bands on their dragon robes. Other noblewomen and the wives of officials were not supposed to use them. In practice all Manchu women seem to have used the first two types of dragon robe with additional sleeve bands. All women's robes are vented at the sides only and lack the centre front and back vents that were features of men's less formal court dress.

The first type of dragon robe, which could be worn by all women, was patterned all over with dragons, clouds and other motifs. The colour of the robe and the number and disposition of the dragons varied according to the rank of their husband (see Table 21). Only the empresses could wear the second and third types of *long pao*. The patterns of these two types of robe were very similar to their *long gua* or dragon coats. Both had plain grounds decorated with eight roundels displaying dragons. Front-facing *long* were placed on the chest, back and shoulders. Profile dragons were enclosed in medallions on the lower part of the robe at the front and back. The second type of *long pao* had the wave border that was also a feature of the first style of *long gua*. However, like the second kind of *long gua*, the third type of *long pao* lacked this characteristic.

The second style of *long pao* was officially restricted to the wardrobe of the empress. However, one often encounters semi-formal court robes of similar type, with roundels enclosing dragons or floral motifs and a wave border at the hem, which were not made for an empress. One particular example has a number of interesting features. The body of the robe appears to be earlier in date than the cuffs and facings. The distinctive horsehoof shape of the cuffs has been exaggerated, a fashion that came into vogue during the last decades of the nineteenth century. The originally tapered sleeves of the robe have been widened with insets of silk to accommodate these large cuffs. However, the style of embroidery suggests that the robe itself dates from the early nineteenth century.

On the lower part of the robe are pairs of roundels containing the archaic and highly stylized *gui long* dragons. As we have seen, imperial consorts of the fourth and fifth degrees were permitted to use this two-toed creature on their *long gua*. The presence of *gui long* on this robe suggests that it may originally have been made for a low-ranking imperial consort and either tailored from unused yardage or altered at a later date to suit a current fashion.

Table 21: Women's Dragon Robes

Rank	Colour	Dragons
Empress dowager, empress & *huang gui fei*	yellow	9 *long*
Second- & third-degree imperial consorts	golden-yellow	9 *long*
Other imperial consorts	incense colour	9 *long*
Consort of the crown prince	apricot-yellow	9 *long*
Wives of first- & second-rank princes	brown	9 *mang*
Wives of other nobles	blue	9 *mang*
Wives of officials of the first three ranks	blue	9 *mang*
Wives of officials of the fourth, fifth & six ranks	blue	8 *mang*
Wives of officials of the seventh, eighth & ninth ranks	blue	5 *mang*

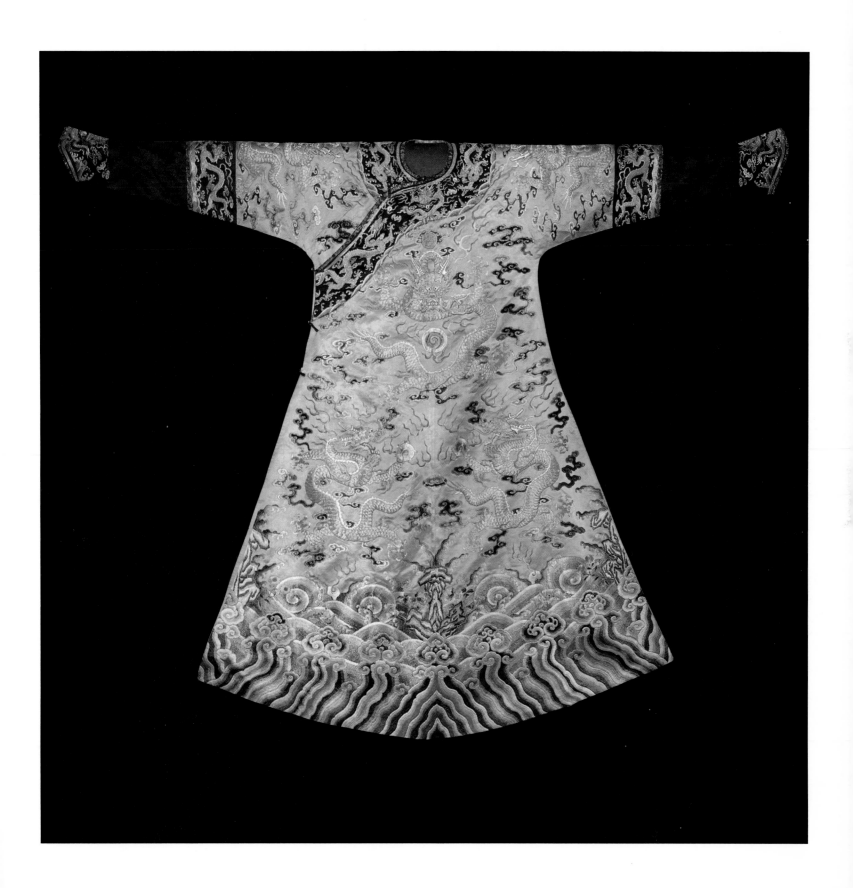

Pl.173 Imperial noblewoman's _long pao_
The first style of _long pao_ worn by an empress or
imperial consort of the highest degree.
Private collection

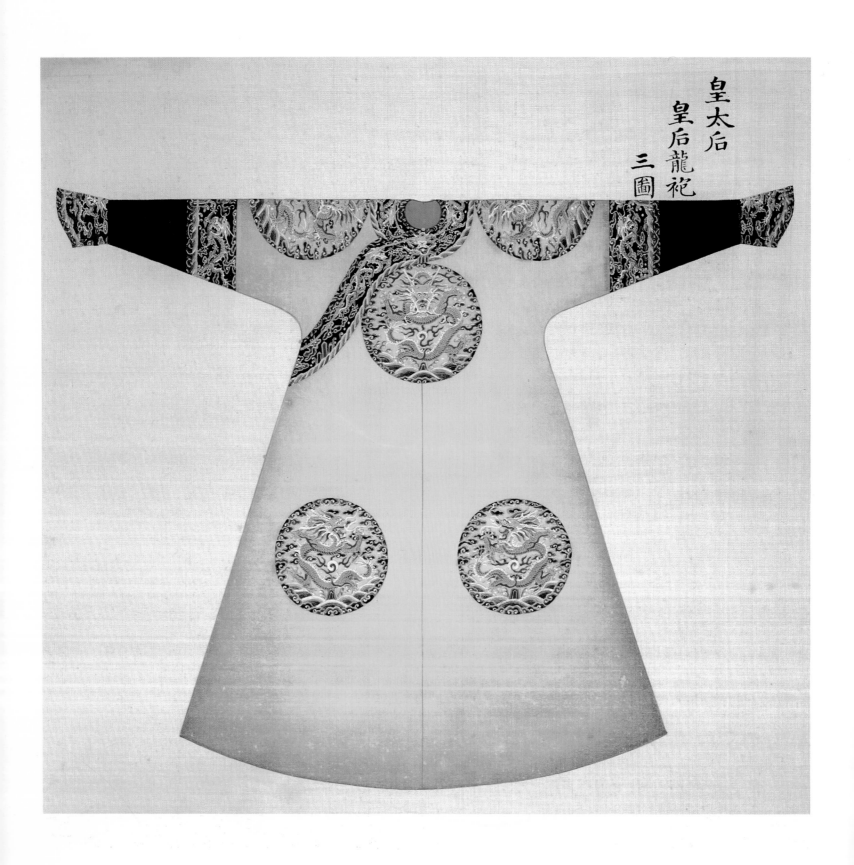

皇太后
皇后龍袍
三圖

Pl.175 Empress' *long pao*
Painting on silk of the third style of *long pao* worn by
an empress or empress dowager.
British Library

Pl.176 Empress' *long pao*
Example of the empress' third style of *long pao*.
Private collection

Pl.177 Imperial consort's semi-formal robe
On semi-formal occasions Manchu noblewomen
wore plain robes with embroidered cuffs and
facings. The turquoise-green ground of this example
indicates that it was probably made for an imperial
consort.
Private collection

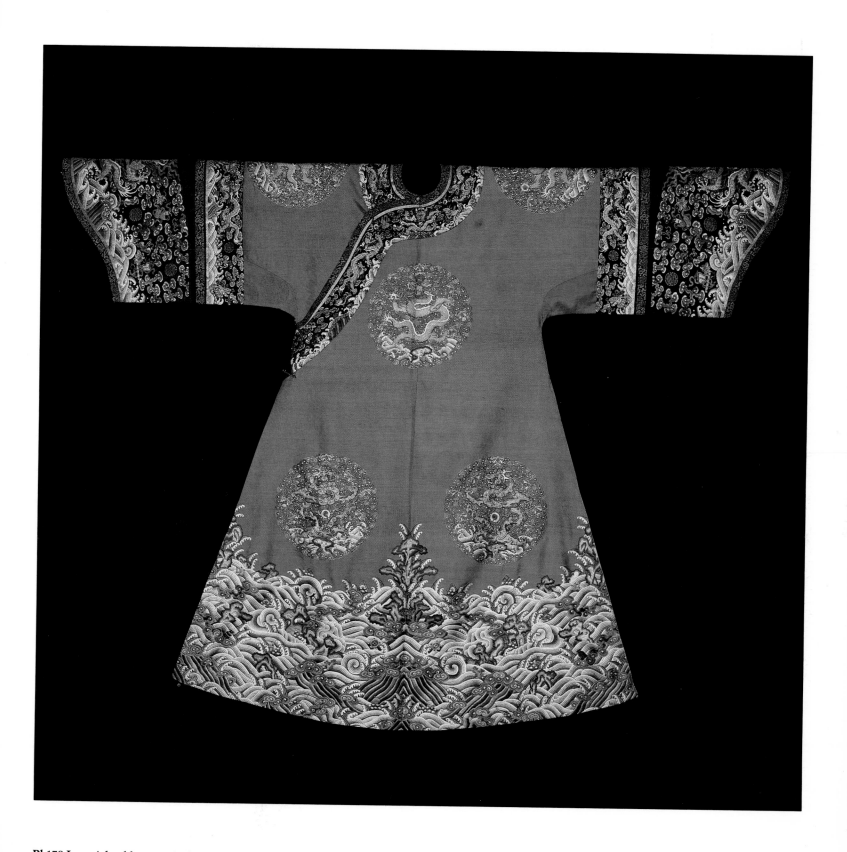

Pl.178 Imperial noblewoman's dragon robe
The turquoise-green ground of this dragon robe
suggests that it was worn by a low-ranking imperial
consort or an imperial daughter-in-law. The
exaggerated horsehoof cuffs became fashionable
during the regency of the Empress Dowager Cixi.
Spink & Son Ltd

Afterword

Examples of court dress, such as the women's *long pao*, raise important questions about how strictly the designs laid down by *Huangchao liqi tushi* were adhered to, particularly during the nineteenth century. Such questions are not easy to address since the rules of dress etiquette seem to have been almost as dependent on unwritten conventions as they were on centrally imposed sumptuary laws. Although it did in fact establish what can be described as the developed forms of court dress, *Huangchao liqi tushi* itself does not appear to have been regarded as the last word on the subject. It was rather a set of precedents on which Qianlong's successors could base their own dress regulations.

An important factor to be taken into account when considering the practical application of court dress laws is that the majority of nobles, officials and their wives had to provide their own costumes. We do not know whether court robes were made to order or supplied from stock. Probably both systems applied as we do know that even the imperial silkworks were allowed to undertake private commissions once they had completed orders for the court. Personal taste may, therefore, have played a role. However, as the cost of court robes was astronomically high, access to this type of market must have been restricted to those with sufficient financial resources. It seems very likely that most courtiers were dependent on the stocks available from merchants specializing in official costume, who in turn relied on the manufacturer. In this case, it was probably the availability of a particular pattern rather than personal taste that determined how closely the design of the robe fitted the specifications laid down in sumptuary law.

It is important to realize that exceptions to the rule did exist, even within such an apparently rigidly defined structure as the Qing official wardrobe. But it must also be said that most of the surviving examples of articles of court dress do appear to comply with *Huangchao liqi tushi*, although this does not mean that they were used by the person for whom they seem to be appropriate. The value of a work such as *Huangchao liqi tushi* is not that it allows us to identify the rank of the original owners of these articles of dress; more importantly it gives us an insight into the Qing wardrobe in its entirety and the method of classifying dress adopted by the Chinese themselves.

Glossary

Bai shou yi a type of burial garment decorated with 100 longevity signs.

Bei le an imperial prince of the third degree.

Bei zi an imperial prince of the fourth degree.

Biao a panther-like animal used as rank insignia by military officials of the fifth rank.

Chang fu 'ordinary dress', everyday costume worn by the upper classes of Qing society.

Chao dai 'court belt', a cloth belt with four belt-plaques and ceremonial kerchiefs worn as part of *chao fu*.

Chao fu 'court dress', the most formal costume in the Qing wardrobe.

Chao gua 'court vest', a long sleeveless garment worn by women over the *chao pao*.

Chao guan 'court hat', a hat worn as part of *chao fu*.

Chao pao 'court robe', a full-length, side-fastening robe worn as part of *chao fu*.

Chao zhu 'court necklace', a type of necklace based on the Buddhist rosary.

Da chao 'Grand Audience', a formal audience ceremony held by the emperor at the palace.

Duan zhao 'ceremonial overcoat', a three-quarter-length, front-opening surcoat completely faced with fur.

Fei an imperial consort of the third degree.

Fu 'blue and black stripes', one of the Twelve Symbols.

Gong fu 'public dress', a costume worn at official ceremonies by graduates in the government examinations and other persons without rank.

Gong fu guan 'public dress hat', a hat worn as part of *gong fu*.

Gui long a highly stylized form of two-toed dragon.

Gui fei an imperial consort of the second degree.

Gui ren an imperial consort of the fifth and lowest degree.

Gun fu 'royal robes', a term used to describe the surcoat displaying the emperor's insignia badges.

Hai ma 'sea horse', used as rank insignia by military officials of the ninth rank.

Huangchao liqi tushi 'Illustrated Precedents for the Ritual Paraphernalia of the Imperial Court', title of an illustrated catalogue of the ceremonial trappings of the Qing court commissioned by the Qianlong Emperor in 1759.

Huang di the emperor.

Huang gui fei an imperial consort of the highest degree.

Huang hou the empress.

Huang ma gua a yellow riding jacket.

Huang tai hou the empress dowager.

Huang tai zi the crown prince or heir apparent.

Huang zi a son of the emperor.

Ji fu 'festive dress', the less-formal style of Qing court costume.

Ji fu dai 'festive dress belt', a cloth belt decorated with plaques, kerchiefs and purses, worn as part of *ji fu*.

Ji guan 'festive hat', a hat worn as part of *ji fu*.

Jin huang 'golden-yellow', an orange colour worn by the emperor's sons.

Jin shi a graduate of the metropolitan government examination.

Jin wang an imperial prince of the highest degree.

Jin yu a golden diadem worn by imperial noblewomen as part of *chao fu*.

Ju ren a graduate of the provincial government examination.

Jun wang an imperial prince of the second degree.

Kesi 'cut silk', a tapestry technique.

Li shui 'standing water', diagonal stripes around the hem of a court robe.

Ling yue a golden collar worn by imperial noblewomen as part of *chao fu*.

Ling zhi a hat decoration made of feathers.

Long a five-clawed dragon.

Long gua 'dragon coat', a full-length, front-opening surcoat decorated with dragon roundels worn by imperial noblewomen.

Long pao 'dragon robe', a full-length, side-fastening robe decorated with five-clawed dragons, worn as part of *ji fu*.

Ma gua 'horse jacket', a waist-length, front-opening type of surcoat.

Ma ti xiu 'horsehoof cuffs'.

Ma xue 'horse boots', knee-high riding boots with thick inflexible soles.

Mang a four-clawed dragon.

Mang ao 'dragon jacket',a side-fastening jacket decorated with dragons worn by the wives of Chinese officials.

Mang chu 'dragon skirt', a pleated skirt worn by the wives of Chinese officials.

Mang pao 'dragon robe', a full-length, side-fastening robe decorated with four-clawed dragons, worn as part of *ji fu*.

Ming huang 'brilliant yellow', a clear yellow colour reserved for use by the emperor, the empress dowager, empress and imperial consorts of the highest degree.

Nei tao 'inner tunic', a full-length, side fastening garment worn as part of *chang fu*.

Pao a long robe.

Pi ling a wide, flaring collar invariably worn with the *chao pao*.

Pin an imperial consort of the fourth degree.

Pu fu 'coat with a patch', a front-opening surcoat decorated with insignia badges.

Pu zi 'coat patch', a term used to describe the insignia badges applied to the *pu fu*.

Qi lin a fabulous creature used as rank insignia by military officials of the first rank.

Ren the small square flap on men's *chao pao*.

Ru jiao 'Path of the Wise', the state religion of the Qing period.

Shen yi a capacious garment with wide sleeves used as a burial robe.

Sheng yuan a candidate for the government examinations.

Shi zi a son of a first-degree prince.

Shi zi a lion-like animal used as rank insignia by military officials of the second rank.

Shou 'longevity'.

Wai tao 'outer tunic', a front-opening surcoat worn over the *nei tao* as part of *chang fu*.

Xi niu a rhinoceros, used as rank insignia by military officials of the seventh and eighth ranks.

Xia pei a sleeveless garment worn by the wives of Chinese officials.

Xiang si 'incense colour', a greenish-yellow colour worn by imperial consorts and some ranks of imperial princess.

Xie zhai a fabulous creature used as insignia of rank by censors.

Xing huang 'apricot-yellow', a colour reserved for the use of the *huang tai zi* and his consort.

Xing long a five-clawed dragon represented in profile.

Zai shui a ceremonial kerchief worn by women as part of *chao fu*.

Select Bibliography

Schuyler Cammann

China's Dragon Robes, New York, The Ronald Press, 1952

'Chinese Mandarin Squares; brief catalogue of the Letcher collection', *University Museum Bulletin*, vol. 17, no. 3, University of Philadelphia, 1953

'Development of the Mandarin Square', *Harvard Journal of Asiatic Studies*, vol. 8, no. 2, Harvard Yenching Institute, 1944

Young Y. Chung

The Art of Oriental Embroidery, New York, Scribner, 1980

J. J. M. De Groot

The Religious System of China, I-VI, Leyden, E. J. Brill, 1892–1910

Helen C. Fernald

Chinese Court Costumes, Toronto, Royal Ontario Museum, 1946

Alexander Hosie

Report by Consul-General Hosie on the Province of Ssuch'uan, London, His Majesty's Stationery Office, 1904

Lindsay Hughes

The Kuo Ch'in Wang Textiles, New York, The Gallery Press, 1945

Reginald F. Johnstone

Twilight in the Forbidden City, London, Gollancz, 1934

Jean Mailey

Manchu Dragon; Costumes of the Ch'ing Dynasty 1644–1911, New York, Metropolitan Museum of Art, 1980

William F. Mayers

The Chinese Government, A Manual of Chinese Titles, 3rd edn, London, Kegan, Paul, Trench, Trubner & Co, 1897

Margaret Medley

The Illustrated Regulations for Ceremonial Paraphernalia of the Ch'ing Dynasty, London, Han-Shan Tang, 1982

Alan Priest

Costumes from the Forbidden City, New York, Metropolitan Museum of Art, 1945

William E. Soothill

The Hall of Light, A Study of Early Chinese Kingship, London, Lutterworth Press, 1951

John E. Vollmer

Decoding Dragons; Status Garments in Ch'ing Dynasty China, Eugene, Museum of Art, University of Oregon, 1983

Five Colours of the Universe; Clothes and Fabrics from the Ch'ing Dynasty, Edmonton, Edmonton Art Gallery, 1980

In the Presence of the Dragon Throne; Ch'ing Dynasty Costume in the Royal Ontario Museum, Toronto, Royal Ontario Museum, 1977

Edward T. Williams

'State Religion of China during the Manchu Dynasty', *Journal of the North China Branch of the Royal Asiatic Society*, Shanghai, vol. xliv, no. 2, 1913

Verity Wilson

Chinese Dress, London, Victoria and Albert Museum, 1986

Credits

Illustrations credited in the text as 'V&A' are reproduced by courtesy of the Board of Trustees of the Victoria & Albert Museum, London. Details of the *Inauguration Portraits* handscroll, purchase of the John L. Severance Fund, are reproduced courtesy of the Cleveland Museum of Art. Illustrations credited as 'SOAS' are by courtesy of the School of Oriental and African Studies, University of London. Illustrations credited 'British Library' are by courtesy of the Board of Trustees of the British Library. Plate 78, 'winter hat', credited Royal Ontario Museum is from the George Crofts Collection. Illustrations credited 'Freer Gallery of Art' are reproduced by courtesy of the Freer Gallery of Art, Smithsonian Institute, Washington D.C. Illustrations credited 'Palace Museum, Peking' are reproduced by courtesy of the Commercial Press Ltd, Hong Kong.

Photographs

Cleveland Museum of Art, Ohio	Pls. 6, 7, 37, 172
Commercial Press Ltd, Hong Kong	Pls. 40, 130, 151, 160
British Library, London	Pls. 17, 18, 32, 99, 104, 112, 131, 135, 158, 164, 165, 175
British Museum, London	Pl. 127
Field Museum, Chicago	Pl. 86
Freer Gallery of Art, Washington D.C.	Pls. 75, 142
General Gordon's Boys School, Woking	Pl. 27
Linda Wrigglesworth, London	Pls. 23, 26, 29, 35, 45, 46, 49, 50, 54, 58, 59, 61, 65, 76, 79, 90, 101, 106, 109, 111, 113, 116, 121, 122, 123, 124, 128, 143, 144, 163, 167, 168, 169, 171, 174
Martyn Gregory Ltd, London	Pl. 39
Metropolitan Museum of Art, New York	Pls. 2, 48, 85, 134, 137
Musée Guimet, Paris	Pl. 41
National Palace Museum, Taipei	Pls. 42, 81, 83, 152
Nelson-Atkins Museum, Kansas	Pls. 55, 56
Palace Museum, Peking (Courtesy of Y. Mayuyama)	Pl. 36
Private collections	Pls. 4, 15, 22, 25, 28, 52, 53, 57, 62, 63, 64, 66, 67, 68, 69, 70, 71, 72, 73, 74, 89, 94, 95, 105, 145, 147, 148, 153, 155, 157, 173, 176, 177
Ron & Susan Sloman, Brighton	Pl. 3
Royal Engineers Museum, Chatham	Pls. 87, 96, 97, 98, 119, 139, 141
Royal Ontario Museum, Toronto	Pls. 78, 166
School of Oriental & African Studies, London	Pls. 5, 21, 60, 92, 100, 132, 136, 150
Sotheby's, London	Pls. 8, 156
Sotheby's, New York	Pl. 51
Spink & Son Ltd, London	Pls. 24, 30, 31, 33, 38, 77, 88, 103, 178
Victoria & Albert Museum, London	Pls. 9, 10, 11, 12, 13, 14, 16, 19, 20, 43, 44, 47, 80, 82, 84, 91, 93, 102, 107, 108, 110, 114, 115, 117, 118, 120, 125, 126, 129, 133, 138, 140, 146, 149, 154, 159, 161, 162, 170

Drawings

G. W. Dickinson	Pls. 1, 34